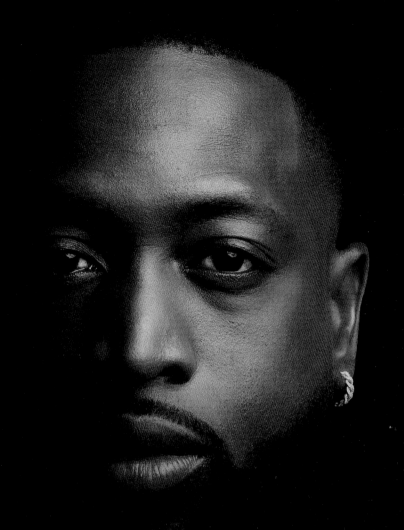

DWYANE

HarperCollins books may be purchased for educational, business, or sales promotional use. For information, please email the Special Markets Department at SPsales @harpercollins.com.

FIRST EDITION

Designed by Danelle Gilles Designs

Library of Congress Cataloging-in-Publication Data has been applied for.

ISBN 978-0-06-296835-7

21 22 23 24 25 TC 10 9 8 7 6 5 4 3 2 1

I'm nothing without the love and support from my wife, Gab, Zaire, Dahveon, Zaya, Xavier, Kaavia, my family, friends, and fans!

Dyvane Wade

CONTENTS

PREGAME 1

FIRST QUARTER 23

SECOND QUARTER 57

HALFTIME 109

THIRD QUARTER 159

FOURTH QUARTER 197

POSTGAME 227

PREGAME

Here's a secret I learned a long time ago. The success I craved was always found in the work I was willing to put in. A lot of people first discovered who I was in the Elite Eight versus Kentucky in 2003. Everyone picked them to beat Marquette, and to be honest, I can't even be mad. It's hard to pick against a team that had won 26 games in a row, but it was our time. My time. Every once in a while we hear stories that give us all hope. It's when someone does something so incredible that no one saw coming or no one knew you were capable of. It's the story of the underdog.

Those long hours in the gym prepared me. Not just for Kentucky, but life. I didn't know what I was gearing up for. I just knew that whenever the time came I'd be ready. Opportunities aren't bills. They aren't guaranteed to come around once a month. If I expected to be able to perform when the lights were brightest, I had to feel confident moving around in the dark. When a thousand jumpers felt like a thousand too little. The sting of sweat drenching my eyes. When the only soundtrack was the bouncing of the ball, the swish after a crisp jumper, and the squeaks from my shoes. If I never had a moment when I wanted to give up, I didn't work hard enough. It wasn't tough enough. It didn't hurt enough.

Confidence is the precursor to dominance. Before running onto the court, I always thought back to those moments in the summer in those hot-ass gyms with no lights with Gary Adams, my high school assistant coach, and the moments in my backyard when I would visualize playing with and against the greats. Or crashing to the concrete playing my dad when I was younger—seeing blood on the pavement, but understanding that what I obsessed over was on the other side of pain. Playing basketball for a living is in the past, but the lessons I've learned along the way are forever. Be committed. Be the hardest worker. Lead by example. Adjust on the fly. Take responsibility. Stay hungry. Stay focused. Because before you know it, it's showtime. It's no turning back from there. Either be great or be forgotten. Only one of those was an option for me.

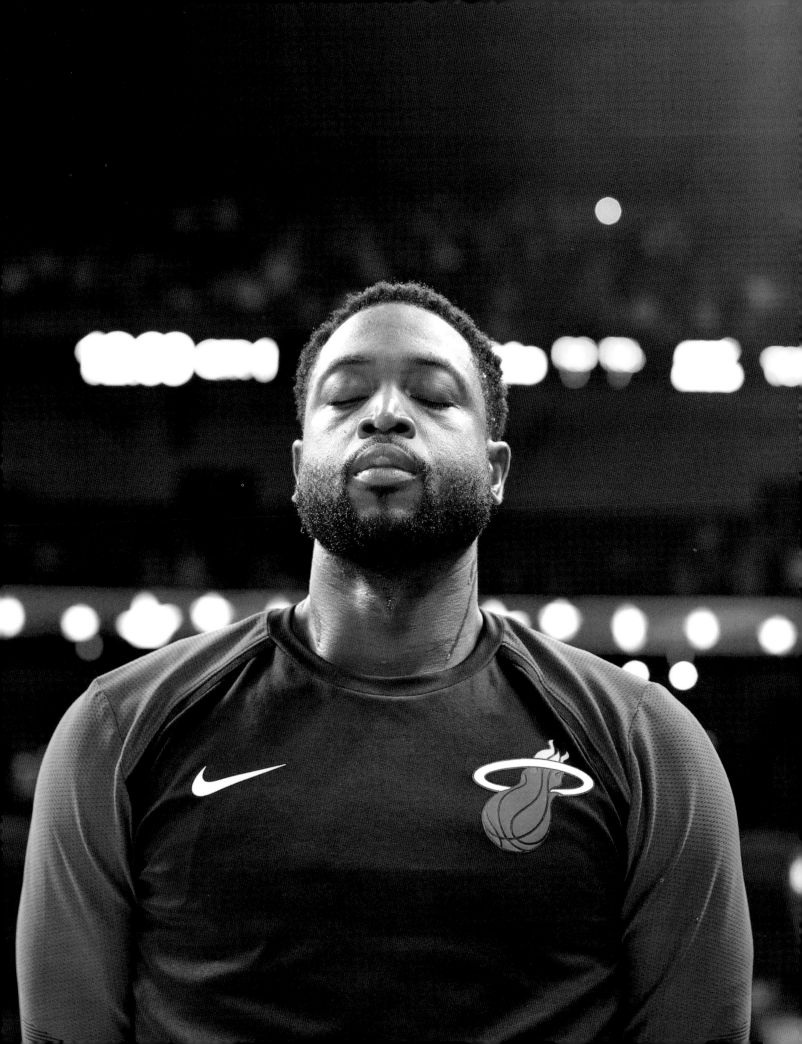

Before every tip-off, I had the same routine. I'd close my eyes and bow my head while the national anthem was played. That was my time to really be completely present in the moment. It was my chance to talk with God. I won't turn this into a sermon, but to even make it to the NBA is God's will. To play 16 seasons and leave the game as one of its best players ever is nothing but God's confidence in me to use my platform in the most impactful way. I feel I did that—and I'm still doing it even in retirement.

Only the greats live up there. Under those lights you either SHINE or fold. And folding isn't how I was raised.

My career wasn't always easy, but I had long since learned nothing in life was. I'm thankful for what the game of basketball brought to my life, my family's life, and how it allowed me to be connected to so many people's lives along the way. So, if you were ever wondering what was going through my mind, that's it. The wins, the losses, the boos on the road, the chants of my name, every person wearing my jersey or my shoes—that all came with the blessing. How could I not say thank you for that?

All I ever wanted to do when I got to Miami in 2003 was leave a legacy that couldn't be replicated. There's no magic formula, though. No matter how good the team around you is, you still have to do the work. All of it.

UNSTOPPABLE

PRACTICE MAKES YOU

This is shortly after I signed with my hometown team, the Chicago Bulls, in the summer of 2016. Growing up idolizing those legendary Bulls squads, I'd be lying to you if I said putting on that jersey wasn't a lifetime dream. All the go-to moves that I've had over my basketball career were developed in the gym with no fans, no cameras (well, besides Bob capturing these moments), and no bright lights. The countless hours working on my floater, step back, post work, footwork, hitting clutch free throws, and defensive drills gave me the confidence for when the lights came on and I had to do it for real.

But more importantly, here's some free game. To every young player out there, take it and do what you will with it. You can never cheat the game—you can only cheat yourself. Getting to the next level took thousands of hours working on my craft. There wouldn't be screaming crowds. There would only be me, alone in the gym.

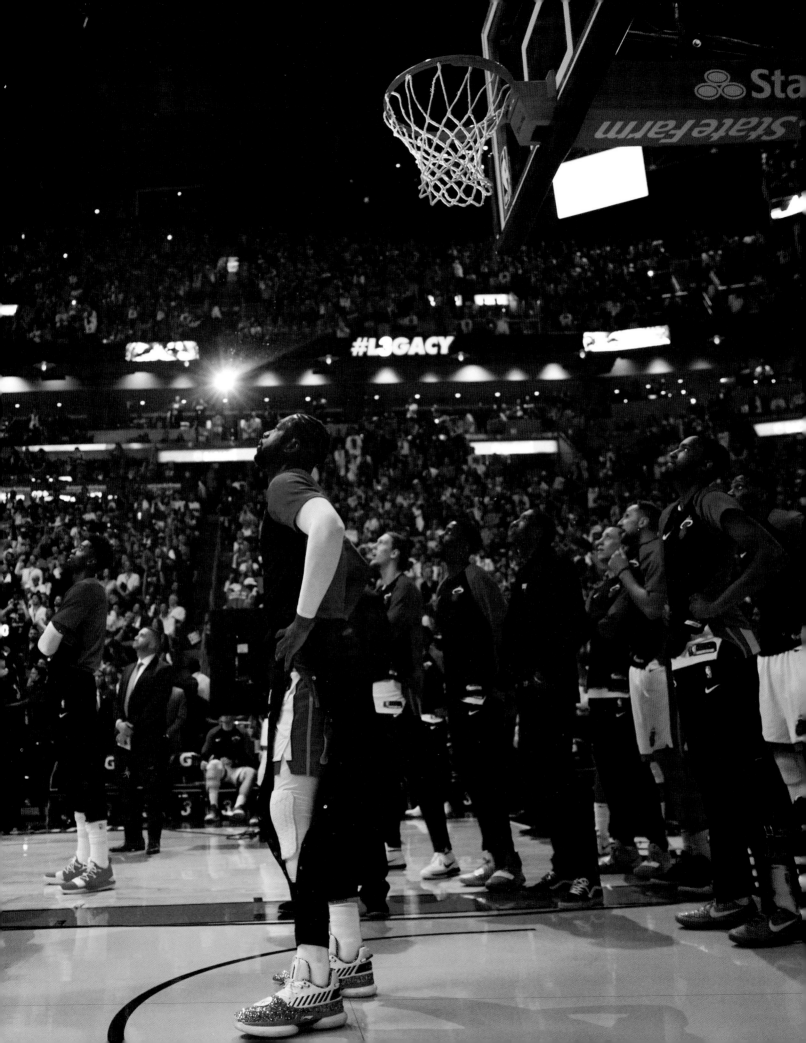

Training is a long journey toward a far-off gain. I knew I couldn't get to where I ultimately wanted to be in one workout. Or ten. Or a hundred. I strived for perfection knowing I could never reach it, but it didn't stop me from trying. If I reached for the moon, I'd come down with a few stars.

Michael Jordan first introduced Tim Grover to the world. After M.J. took too many beatings in the playoffs from Isiah Thomas and the Detroit Pistons, he turned to Tim, or T.G., as I call him. T.G. got me ready for the NBA Draft and continued to work with me on and off throughout my sixteen-year career. When it comes to training, he's the OG—the GOAT! No days off, but I look like I needed one.

It takes a village to raise a child. I think it also takes a village to keep an NBA player going.

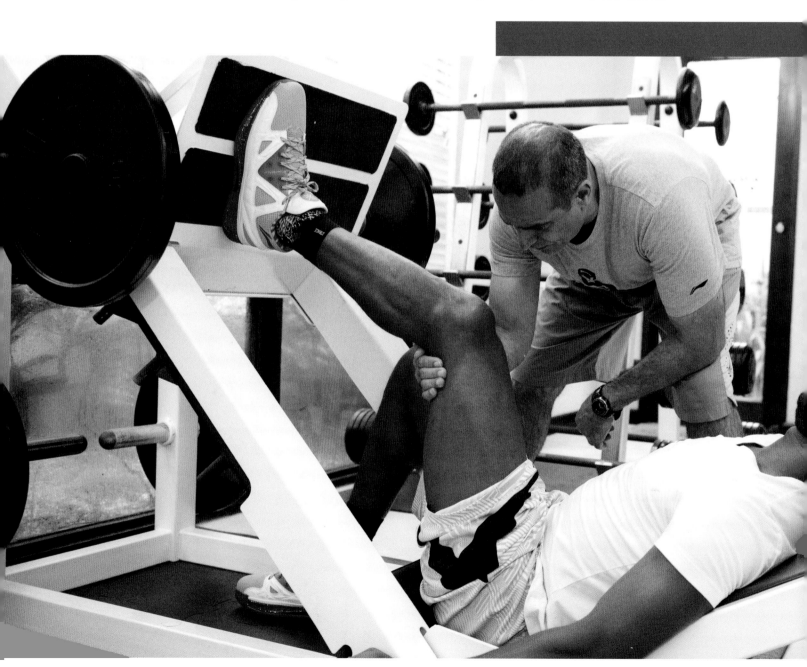

I can think of a few guys I've wanted to square up with back in my day! I'll keep that to myself, though. Think about how many people play basketball professionally all around the world. Think about how many talented players are out there who never got the chance to advance their career for one reason or another. There's only a few hundred players in the NBA. To not only be in the NBA but one of the top players, that's both a daunting responsibility and a blessing. I saw so many guys come and go, a lot of them talented, because doing this job takes dedication that not everyone can maintain. I always knew that the moment I slacked off was the moment someone else was taking my spot. But I also wasn't the only one keeping me focused.

David Alexander saved me from retiring in 2015.

TRAINING

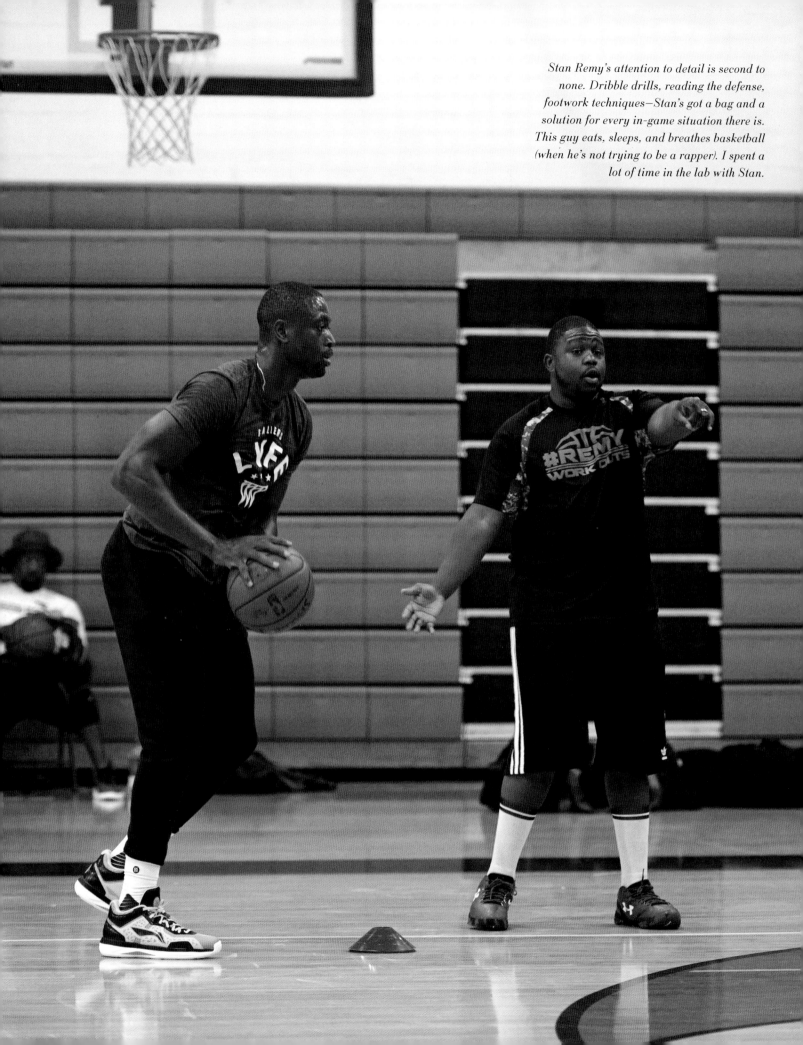

Stan Remy's attention to detail is second to none. Dribble drills, reading the defense, footwork techniques—Stan's got a bag and a solution for every in-game situation there is. This guy eats, sleeps, and breathes basketball (when he's not trying to be a rapper). I spent a lot of time in the lab with Stan.

As a professional athlete, you have to
TRUST
a lot of people with your body.

That's not exactly the easiest thing in the world to do. So the people who entered my life became family because I had to trust them. Nicole Halkides was one of those people I trusted. This is how we always ended our massage sessions.

Also, this is just a dope-ass picture and I know y'all see that Bears rug. I stay repping for the crib.

PAIN

The players get the endorsements, the glitz, and the glamour. But the people behind the scenes are the silent heroes. My pregame stretch routine was super elaborate. It had to be if I was going to be chasing around the best athletes in the world three times a week, nearly nine months out of the year. For sixteen years. If it wasn't for Shelly, I wouldn't have been able to play in my last game. More on that later.

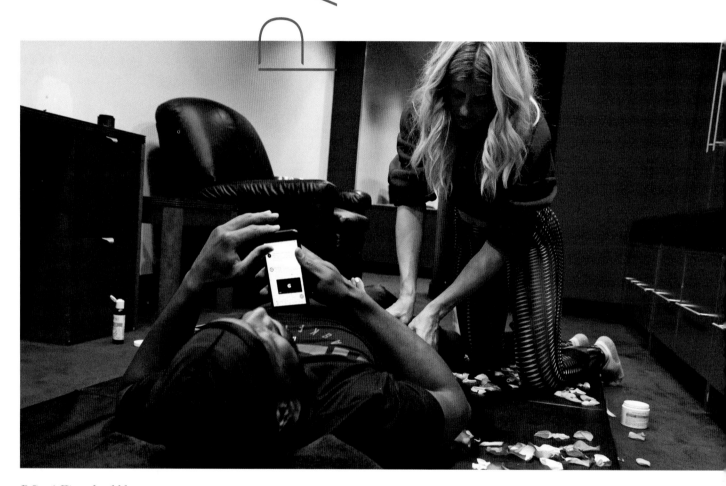

P.S.—A King should lay on roses.

The results you want are going to come with a lot of pain, but it's worth it at the end of the day. I loved the pain because it meant that I was working, and that I was getting better at my craft. Sometimes, I miss the pain. As crazy as that sounds, I'm just being honest. Like they said in some movie, pain doesn't hurt. I loved the work.

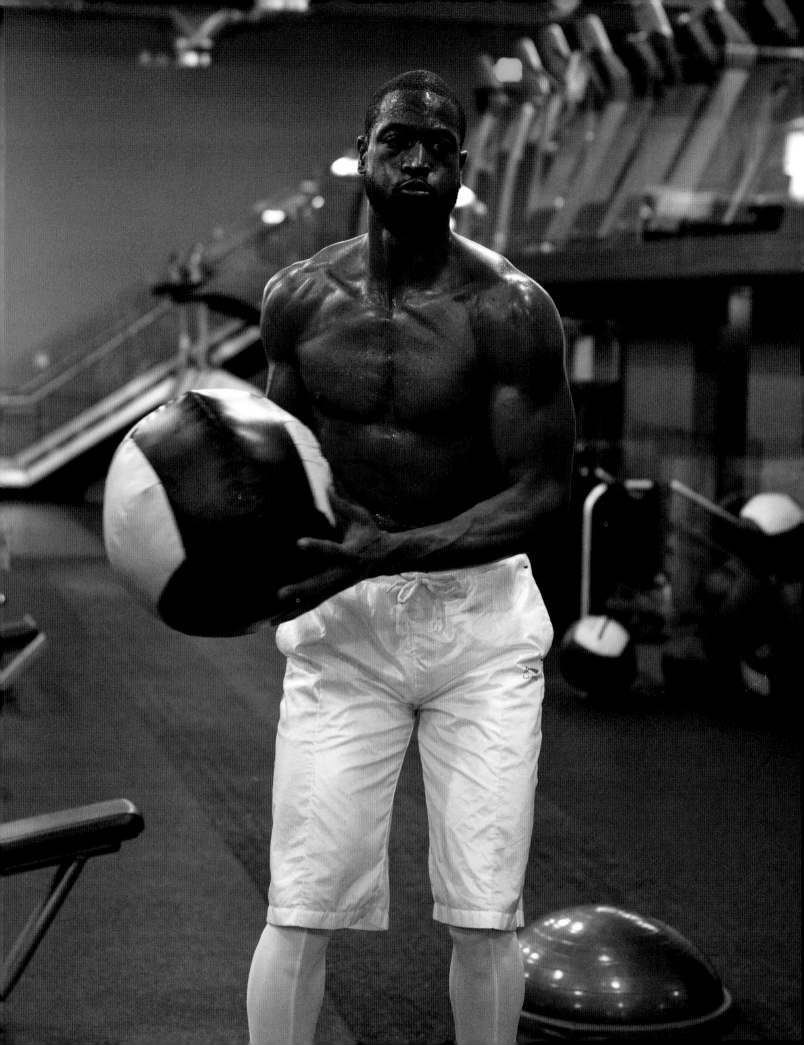

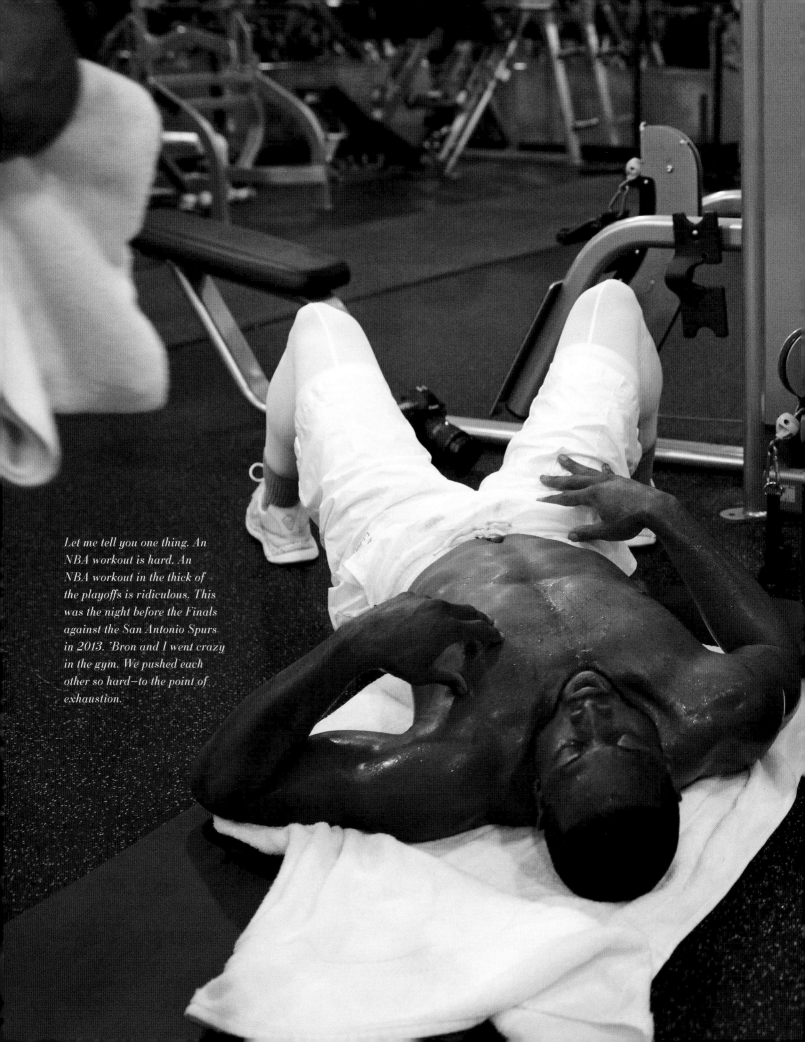

Let me tell you one thing. An NBA workout is hard. An NBA workout in the thick of the playoffs is ridiculous. This was the night before the Finals against the San Antonio Spurs in 2013. 'Bron and I went crazy in the gym. We pushed each other so hard—to the point of exhaustion.

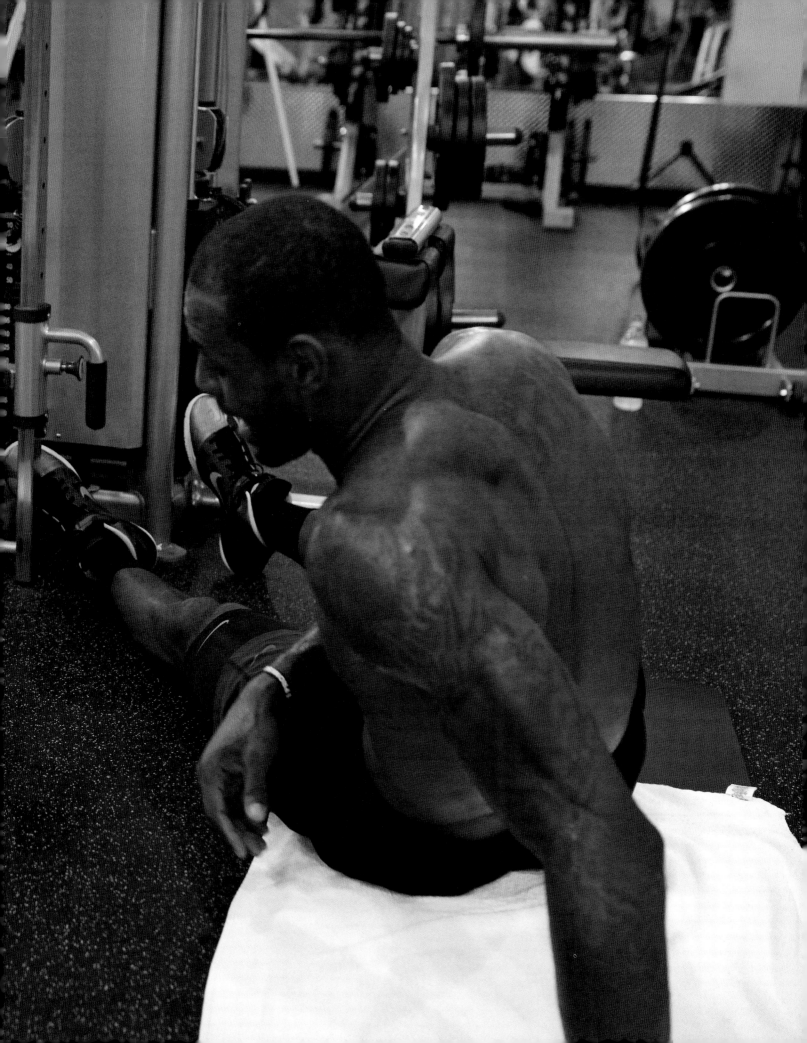

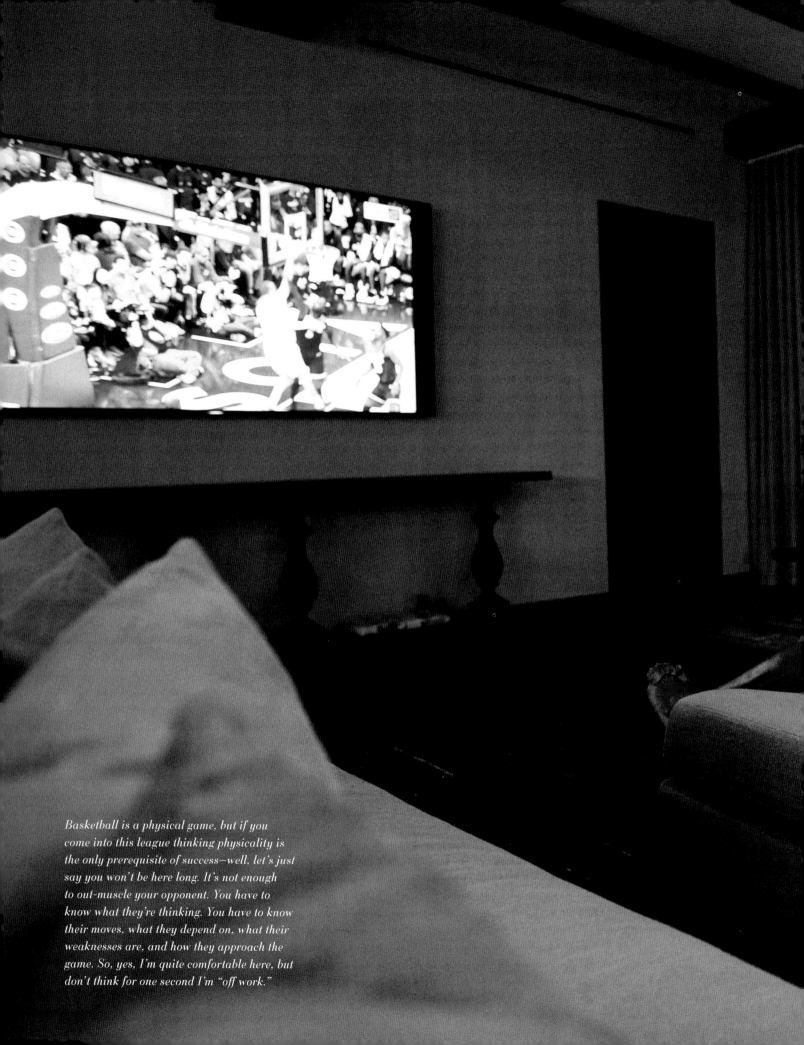

Basketball is a physical game, but if you come into this league thinking physicality is the only prerequisite of success—well, let's just say you won't be here long. It's not enough to out-muscle your opponent. You have to know what they're thinking. You have to know their moves, what they depend on, what their weaknesses are, and how they approach the game. So, yes, I'm quite comfortable here, but don't think for one second I'm "off work."

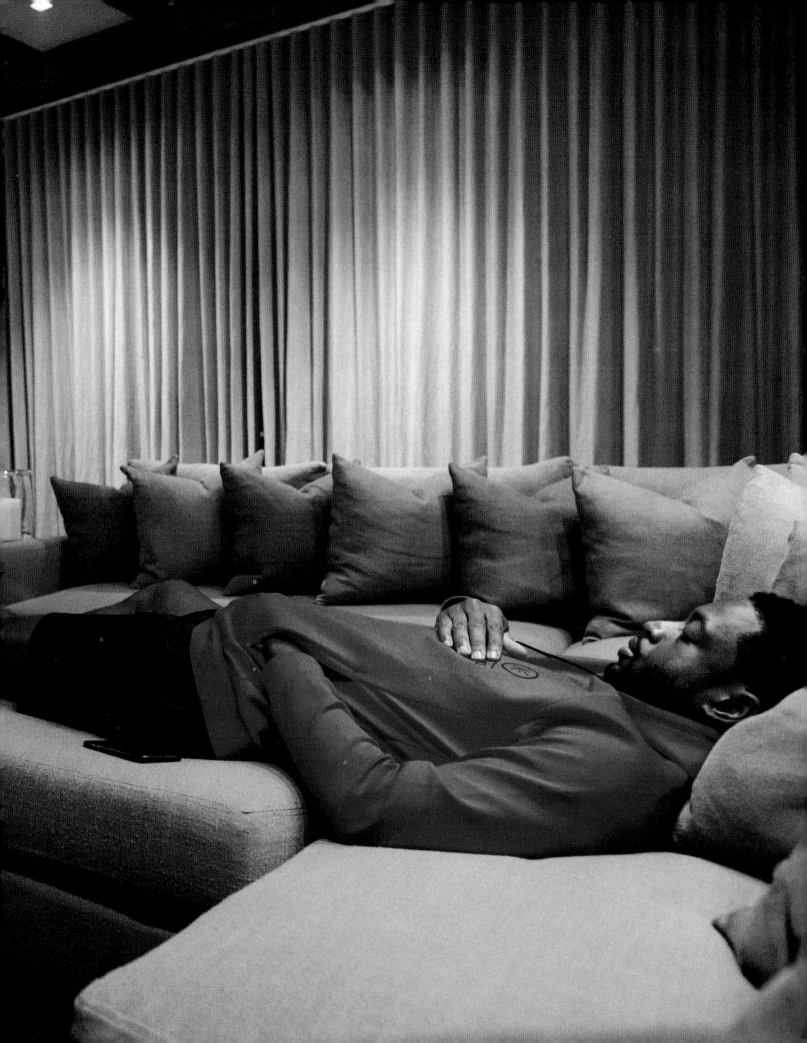

Lacing up your own sneakers for the very first time is an out-of-body experience.

I grew up understanding that a player having his own shoe came with a certain level of dominance. Michael Jordan, Penny Hardaway, Allen Iverson, Grant Hill, Kobe Bryant—those were all guys who'd not only tear you up on the court, they did it in style, too. So, when I got a chance to link up with Li-Ning in 2012 to create the Way of Wade brand, the feeling I got walking on the court for the very first time wearing my signature shoes is one that made the transition worth it. Because, trust me, I heard everything people were saying. We'll address that in a little bit.

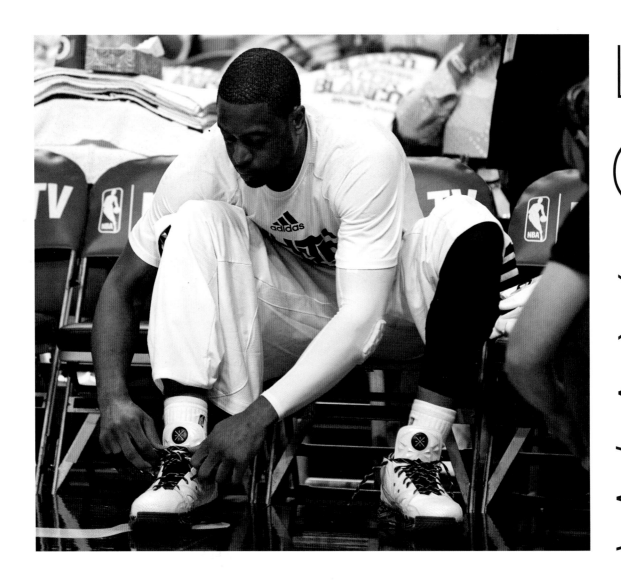

This is where the greats really write their story. Anyone who's ever been in those trenches will tell you— it's a different type of energy come playoff time.

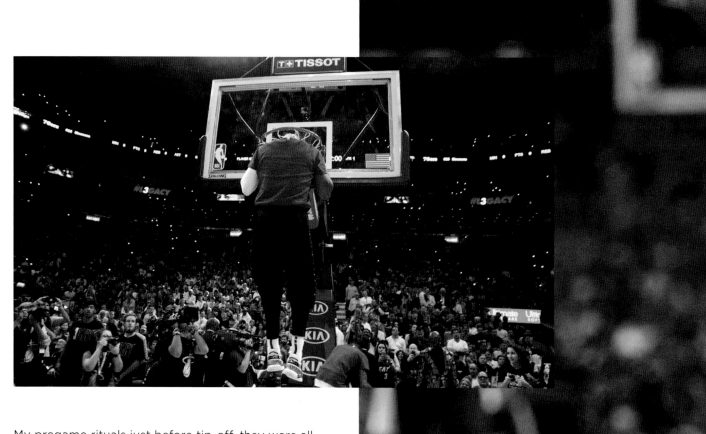

My pregame rituals just before tip-off, they were all for the fans. Going around the arena, acknowledging the fans, getting them excited, pumping them up, getting everybody ready.

GAME
TIME

I'd do pull-ups on the rim, and that was when I would turn into someone else. That was a way to wake up my body, wake up my mind: Let's go, it's time to work! I jumped over a security guard for a little while. The fans loved it. It became a thing. Whatever it took. I drew off that energy.

You might be one of those people who gave me motivation on those nights, my fuel to perform. Thank you for that. I needed it.

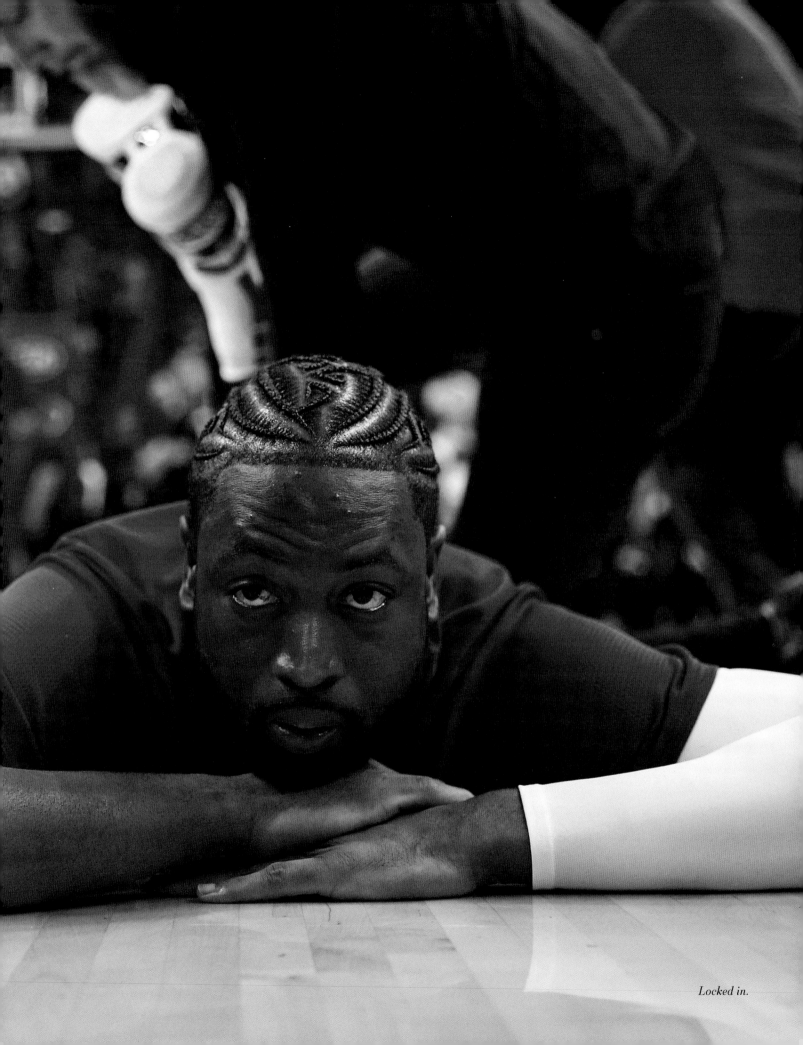

Locked in.

FIRST
QUARTER

Very few games are ever won at tip-off. There's a feeling-out process at the beginning of the game that always amused me. It's like going to a school dance. Yeah, the music is playing. Yeah, everyone's there. But everyone's just waiting for that moment when everything pops off. No one's going to show their full hand right away. I'm trying to figure out the game plan of my opponent—and they're trying to do the same with me. At some point—and when it happens you know it—someone budges. A lot of times all it takes is one steal, one block, or one dunk to set the tempo for the rest of the quarter. And what was once a high school dance suddenly becomes a heavyweight title fight.

Patience is always the hardest virtue to learn. From the moment I watched the '91 Chicago Bulls win their first championship and the first for the city of Chicago in basketball, I had dreams of what I wanted to do and where I wanted to go. But nothing worth having ever appears overnight. That patience will be tested. I'm a living testament of that. If I told you about every time I was looked over or told that the percentage of me making it was one in a million, I'd be here forever. I didn't second-guess myself. I third-, fourth-, and fifth-guessed myself at times. Tough times, though, can never outrun tough people. And I knew that dreaming wasn't the only thing that I needed to make it. I knew I had to put in the work that was needed.

A basketball game is long. Life is even longer. It's not about figuring it out within the first minute. Time is the one gift none of us can get back. Time doesn't care about your bank account, how many followers you have on social media, or what you do for a living. Time only cares about one thing—how you use it.

You can't tell a story without the beginning, and mine began at the corner of 59th and Prairie on the South Side of Chicago. Was it tough growing up there? Hell yeah. Was it scary at times? Absolutely. Between seeing what crack cocaine did to the 'hood, the violence in the streets, and then dealing with the police, I think everyone who lived there grew up quick. We had no choice.

But I'll say this, too. Chicago gets a stereotype that it's all just criminals who live there—at least in the parts I grew up in. I've lost loved ones because of that violence. I know that pain firsthand. But it's not all despair there. Good men and women live there. Happiness, in spite of everything, lives there. Innocence lives there. Wherever life takes me, I stand with pride that I'm a product of South Side Chicago. Without 59th and Prairie, these words you're reading right now never happen.

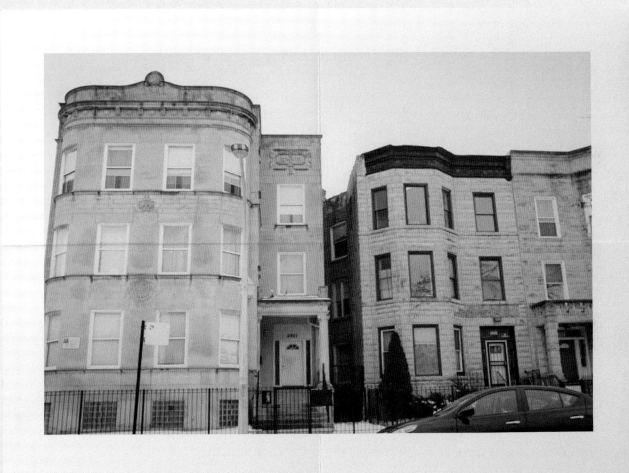

If I close my eyes, I can still see the cracks in the concrete. I can still feel the rust on the gates. And I can still hear the people outside. I'm a long way away from 5901 S. Prairie in Chicago. But I can never leave it. It wasn't always easy living there. If I close my eyes, I can still remember the scary times. But if I close my eyes, I can still feel the love that lived in that building and protected the people in it. I cherish everything I was able to accomplish in my career and the places it took me. But none of that is possible without this place. It's forever in my heart.

When I had my visit with Tom Crean, I knew I was going to Marquette. On that first visit, he brought me a piece of the Bradley Center floor. He also brought me a cap and gown.

He believed that I could be something more than just a

BASKETBALL PLAYER

He taught me a ton about basketball, as he promised when he was recruiting me—but many of the most important lessons I learned from Coach Crean were far away from a basketball court.

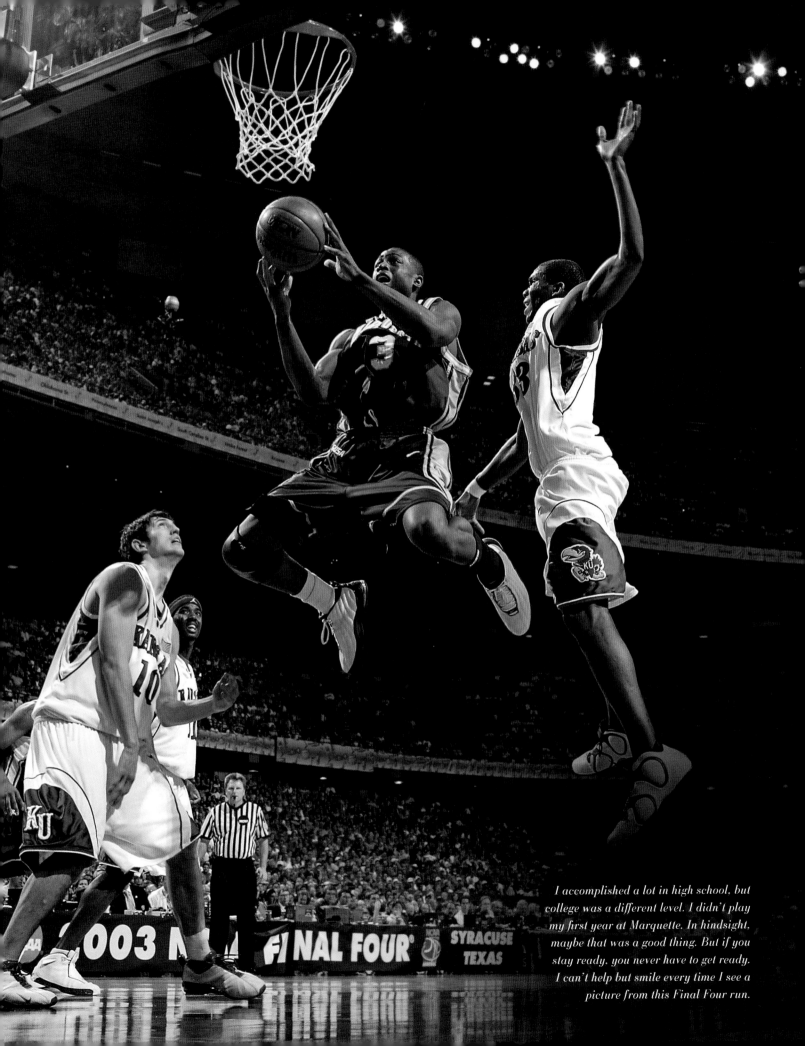

I accomplished a lot in high school, but college was a different level. I didn't play my first year at Marquette. In hindsight, maybe that was a good thing. But if you stay ready, you never have to get ready. I can't help but smile every time I see a picture from this Final Four run.

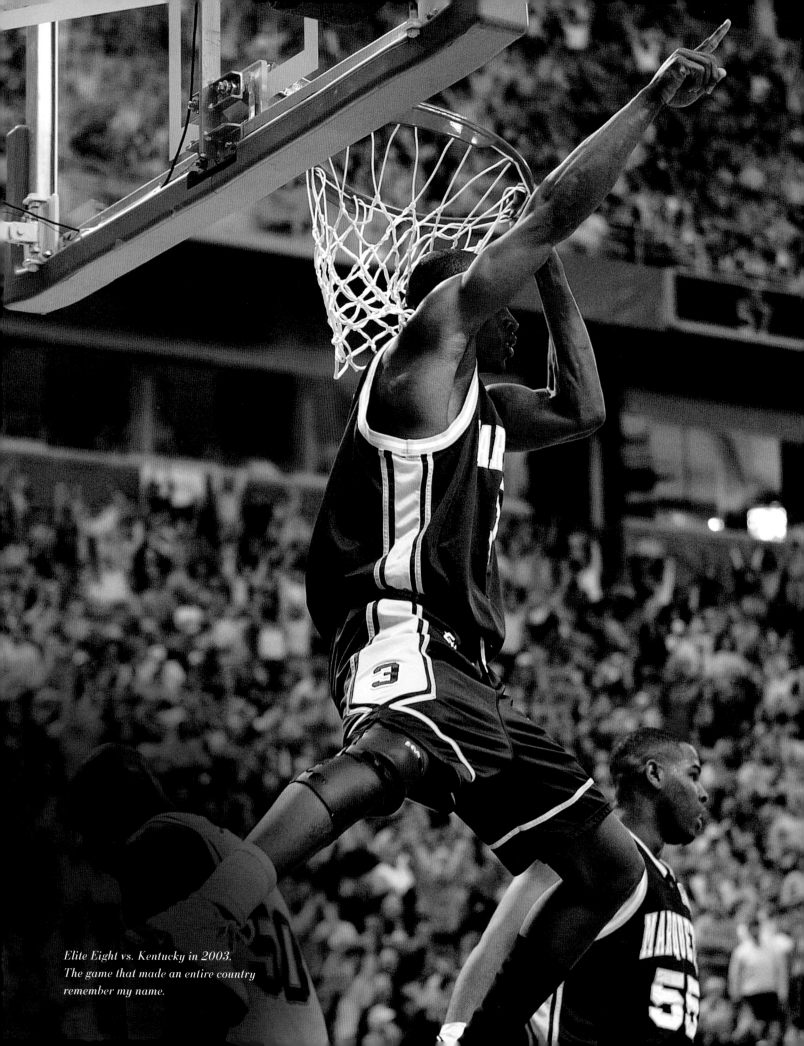

Elite Eight vs. Kentucky in 2003.
The game that made an entire country
remember my name.

MARQUETTE

My mom had been released from jail three days earlier. She wasn't supposed to travel. We begged her parole officer—whose name was Wade, believe it or not—to let her come up to Milwaukee for the game. Thankfully, he did.

She's the one with the No. 3 on the jersey.

I had a great game that night: 26 points, 10 rebounds, and five assists. After the game, my mom was in the stands screaming and crying and hugging my sister, Tragil. The crowd rushed the floor and hoisted me up. But the whole time I was looking at my mom.

It was the first time she saw me play basketball since I was young.

My mother, Jolinda, is my biggest fan and it's not even close.

Every year around March I see the clips. People start asking me about that 2003 Final Four run. They love talking about the Kentucky game. And honestly, I'd be lying to you if I said I didn't love talking about it every year as well.

THAT TOURNAMENT RUN IS

MY FAVORITE BASKETBALL MEMORY

No one expected us to do that, except us. Kentucky was this Goliath, and we were David. They had Keith Bogans, who was a dog that year. I remember, during warm-ups, looking down the court at Kentucky. They were acting like pros! You know how NBA players warm up—trying to be real cool. I turned to my teammates and was like, "Look. They're not taking us seriously."

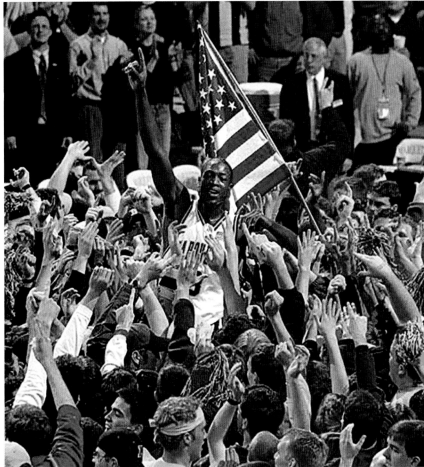

I zoned out that game. I remember it because I've seen the highlights, but I don't remember playing in it. When I walked off the floor they told me I had a triple double and I was like, "What the f**k?" I think they got me on video saying that.

Kentucky was the No. 1 team in the country, they'd just won 26 straight, and we blew the doors off their ass.

Pat Riley went to Kentucky. You hear what I'm saying? This game got me drafted to Miami!

I hate to call Henry "Hank" Thomas my agent because he was so much more than that. When I was trying to sign with an agent before the draft, I had no idea what I should be looking for. But I'm someone who trusts my gut. Hank was the first person I interviewed. Just like I knew about Tom Crean, I knew that Hank was the one.

HANK

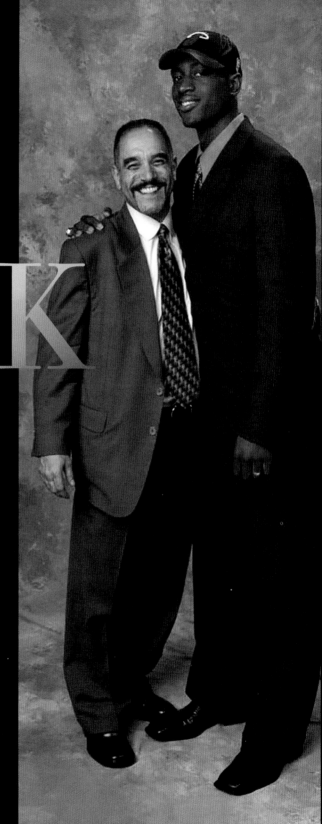

That first meeting with Hank, I'm sitting there, twenty-one years old. Somehow, I ended up asking Hank his age. Hank said he was fifty. At the time, fifty seemed old as dirt. I asked him, "So, how long you plan on doing this? Because I plan on at least being around for ten years!"

He laughed and said I have kids that's the age of your son Zaire who was a year old at the time (he was talking about his son, Ryan Thomas). He said he planned on being around for a while. And, to his word, he was. Hank passed away in 2018, and not a day goes by that I don't think about him.

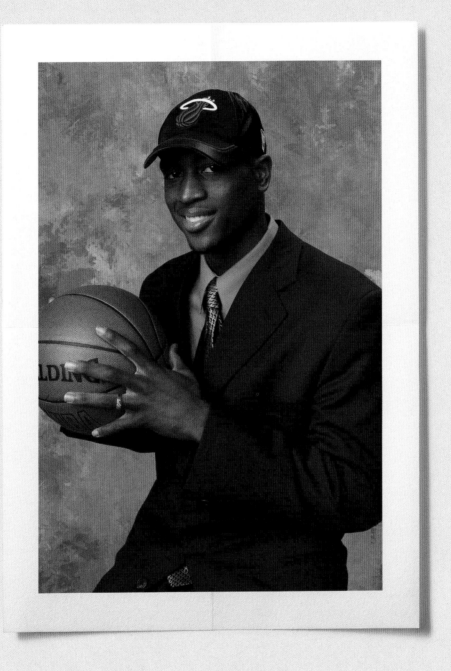

Those weeks before the draft are a haze. Between workouts, media commitments, negotiations, and everything in between, you have to remember to just take a step back and breathe. And when you do, that's when it hits you all over again—"I'm about to be drafted into the NBA."

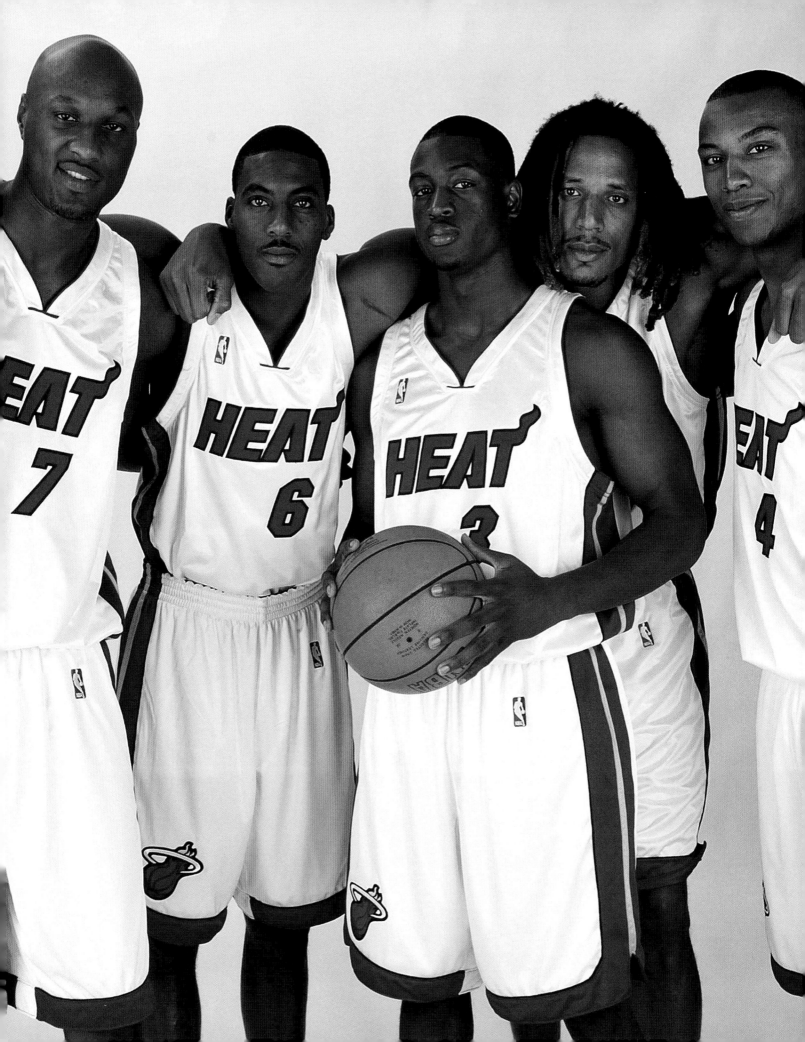

Caron Butler is only a year older than me. He was drafted in 2002. But that dude was so important in helping me find my place in this league as a rookie. He felt like a ten-year vet.

This journey is ultimately about the DECISIONS YOU MAKE and the work you put into your craft.

Caron constantly gave me game about how to adapt to life in the NBA away from the lights and the cameras. He was the one who told me about how to treat people behind the scenes for the Miami Heat. Say thank you and show your thanks.

I remember conversations we had over dinner during my rookie summer league like it was yesterday. This journey is ultimately about the decisions you make and the work you put into your craft. Life, like basketball, is a team-based sport. You can't forget the people who genuinely helped you along the way. And Caron is damn sure one of them.

Lamar Odom signed with the Heat the same summer they drafted me. He was brought in to be our best player and our leader. He was a vet but he was only twenty-four years old. I had just watched him play alongside two good friends of mine in Darius Miles and Quentin Richardson. L.O. was like a celebrity to me, he always talked about how he made it cool to be an L.A. Clipper. I loved sitting behind him on the plane because he would turn around and give me so much game.

Rookie year vibes with some of the OG's like Brian Grant and Eddie Jones, who helped put me on game to this NBA life.

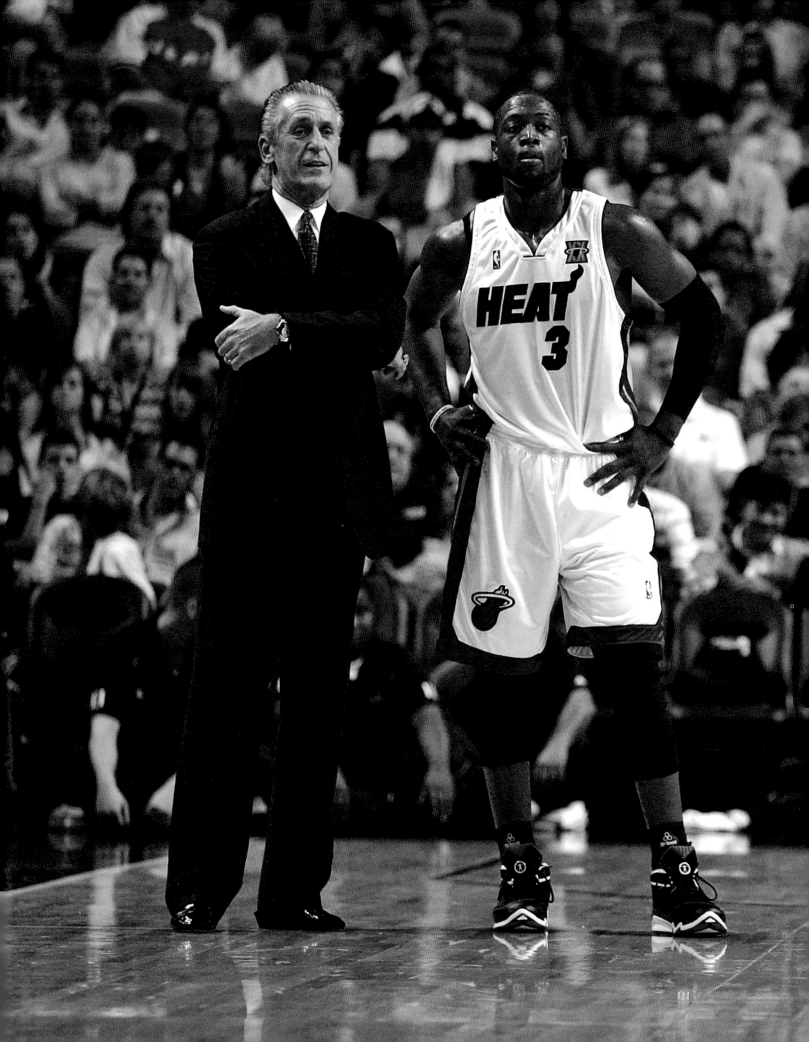

During my rookie year, Pat Riley coached us all the way through training camp. A couple of days before opening night we had a big team meeting. Riles gave a speech that lasted about three hours. He's talking about growing up in New Jersey. He's talking about his relationship with his dad. I'm looking around confused, but some of my vets were like, "He does this a lot." He told us basically his life story. Then all of a sudden, Pat's like, "I say all that to say I am stepping down as head coach of the Miami Heat." Then he walked out. I'm sitting in the locker room like, "What the entire f**k just happened?!"

PAT RILEY

And then, 21 games into my third season, Stan Van Gundy steps down and Pat's my coach again. For anyone keeping score at home, along with Shaq, that's two first-ballot Hall of Famers on the team who want nothing more than to add another trophy to their mantels. I was a kid when Riley, Magic, and Kareem were running "Showtime" back in the '80s. And as a Jordan fan growing up in the '90s, Pat's Knicks teams were the Bulls' rivals. I never thought I'd play for the guy, but there I was.

Riley's no joke as a coach either. Practices aren't relaxed run-throughs—they're game simulations. I'm a naturally competitive guy. Heading into that 2005–06 season, I was ready to go get it. That turned out okay, I'd say . . .

Stan Van Gundy was a yelling coach. He yelled in practice, he yelled in games. I had never had a coach yell at me during a game. It took some getting used to—and also I was running point for the first time in my life.

This wasn't the Dame Lillard, Steph Curry, Russell Westbrook, Ja Morant golden era of point guards, where your job is to get buckets. This was when point guards took the ball up the floor, dumped it to the big man, and sat your ass in the corner.

STAN VAN GUNDY

I'm serious. Stan's an incredible guy, but one thing anyone who has ever played for him can never say is they never heard him in the huddle. Love that dude, though!

I remember around Thanksgiving during my rookie year we were in Seattle and I went to Stan and asked him to allow me to play my game. At first he gave me that coach-speak about playing team basketball, but he ended up saying, "OK, show me what you got." I scored 18 that night and at least 20 points in each of the next three games. From that point on, it was over. It wasn't my team yet, but this was why they drafted me. After that, Stan was the one who demanded the ball be in my hands in the fourth quarter. Stan allowed me to play my game, grow, and learn from my mistakes.

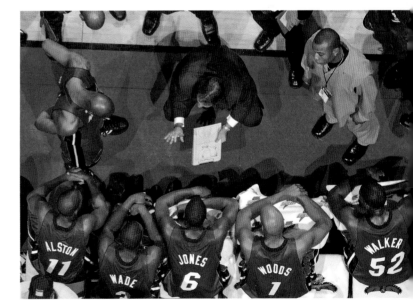

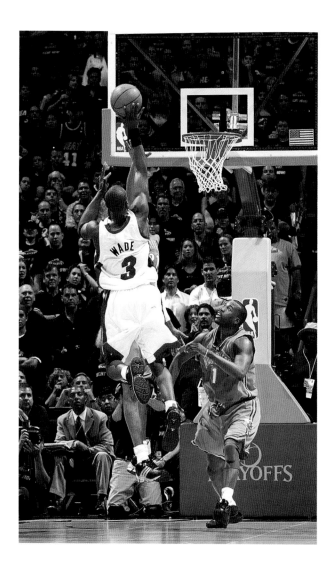

There was nothing in the world that could prepare me to play with Shaquille O'Neal my second year in the NBA. My rookie year had been a learning experience and I thought we were moving in the right direction. But when you add Shaq to your team, you know what the goal is. Championships!

Shaq had Penny in Orlando, and they're the last team to beat Michael Jordan in the playoffs. Then he won three titles with Kobe in Los Angeles. So, yeah, no pressure on me at all. Big Fella didn't come to South Beach just for the weather. We all knew he wanted more hardware. The energy was different. I could feel a sense of urgency in practice. This is the most dominant big man ever, and he's looking at me to help carry the load. Shaq helped me open up. From the moment he got to Miami, he told me I could be the best guard in the game. Like Stan that night in Seattle, Shaq helped build my confidence.

MY MOMENT

By the time the playoffs started, I knew I had earned my teammates' trust. The franchise believed in me. The entire city of Miami believed in me.

When my first playoff game, against the Hornets, came down to the final seconds, Coach Van Gundy drew up a play to get the ball in my hands. I knew exactly what I had to do. Jordan. Kobe. A.I. They'd become legends in moments like these.

Hitting this shot changed the arc of my entire career. The league was now on notice. If you were playing the Miami Heat, watch out for No. 3.

I loved having that target on my back.

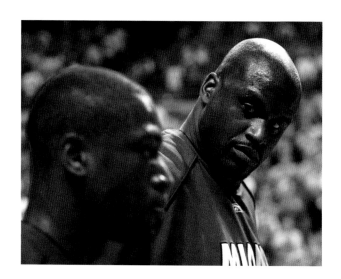

Shaq is giving me that "Flash, you better be ready" face. Best believe I felt that stare. And good thing for him, I was. I'm thinking, "I've been waiting to eat like this my entire life!"

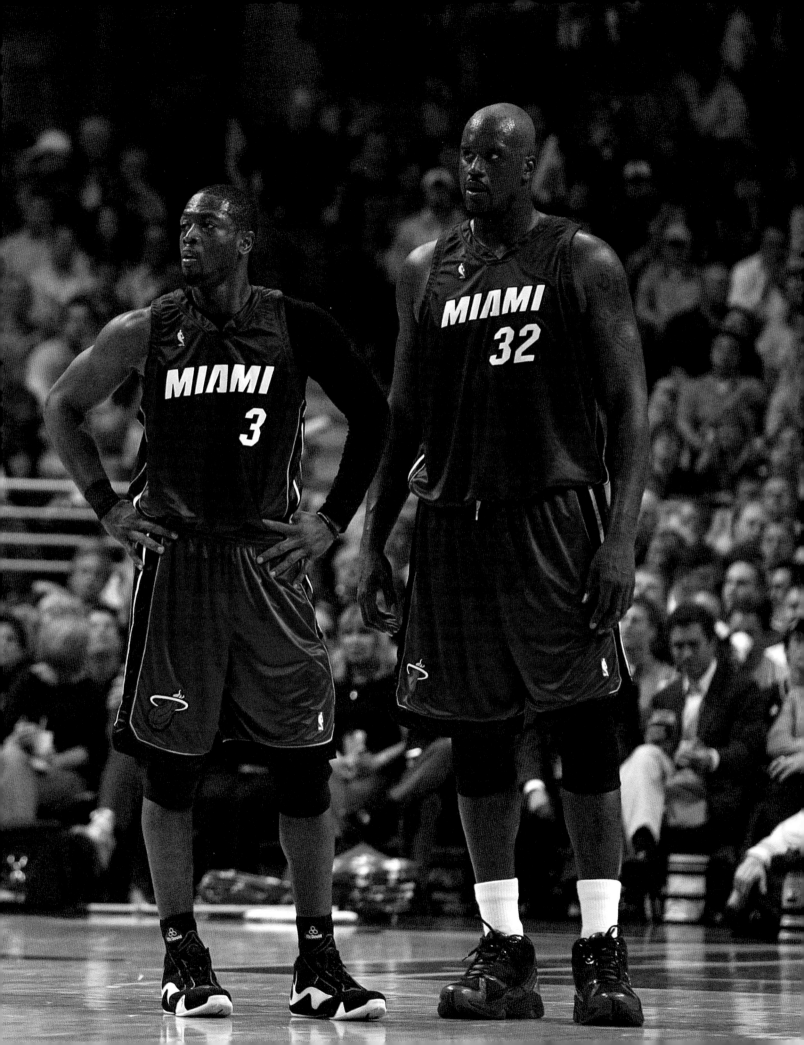

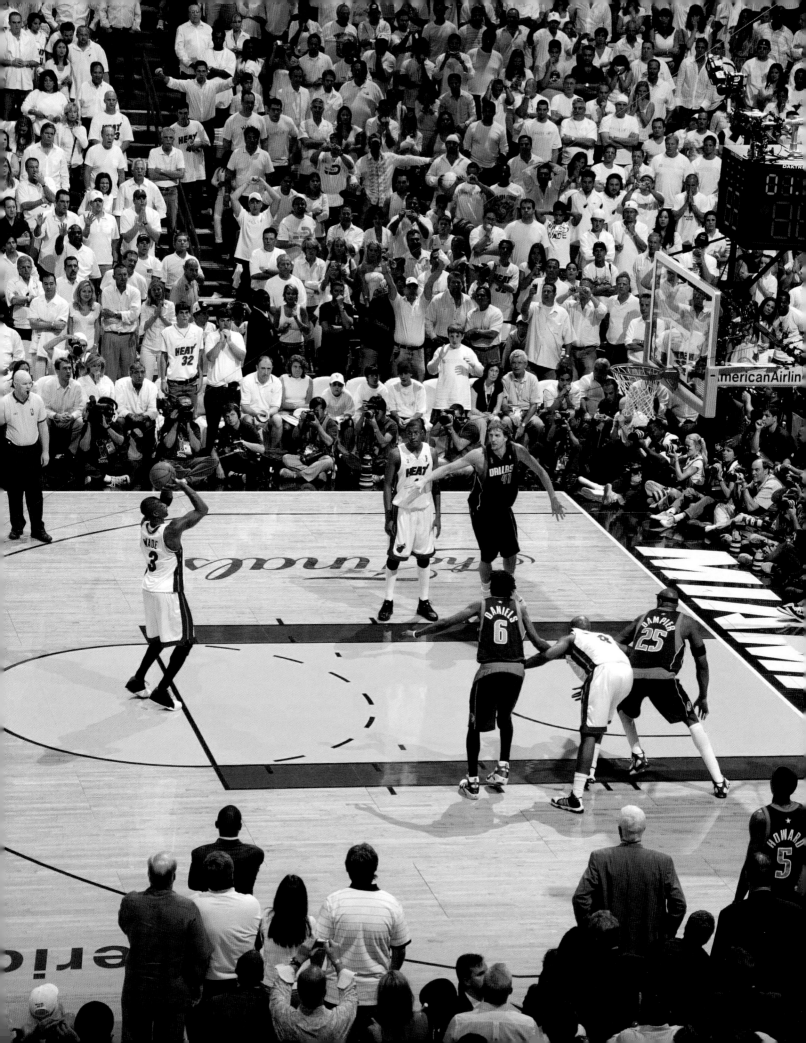

Regardless of what anyone will ever say, I earned every single last one of those free throws in that 2006 Finals.

As any kid who hoops knows, the Finals are the mountaintop. Those who ball out there join an exclusive basketball club. I wanted membership in that club bad.

The city of Miami and I came up together. It was our first NBA title in 2006. Shaq told me to take over in those Finals—and that's exactly what I did in Game 3. When somebody like the Big Fella tells you he's gonna follow your lead, just know that energy hits different.

I can still taste the champagne and smell the cigar smoke. I still see the excitement on Gary Payton, Antoine Walker, Jason Williams, James Posey, Shandon Anderson, and Alonzo Mourning's faces. They had been in the league for so long chasing this moment, and I'm glad to say I was a big part of delivering that.

'Zo used to tell me all the time the NBA doesn't last forever, so it's about living in the moment. It takes years of wisdom and life experience to understand that. On everything I love, celebrating in that locker room in Dallas, it felt as if the ride would never end.

FINALS

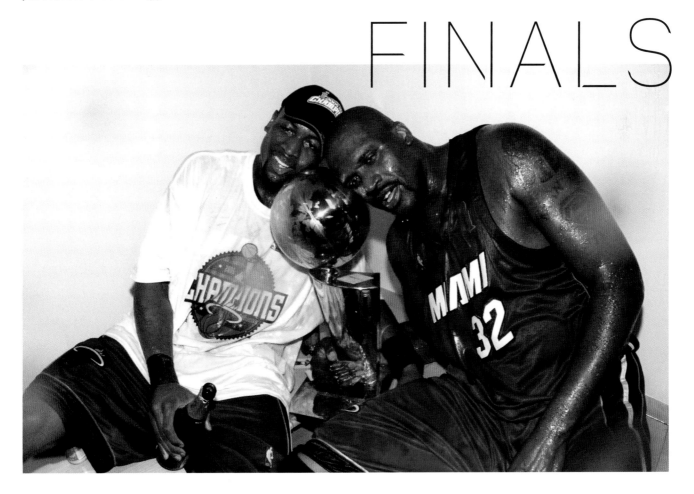

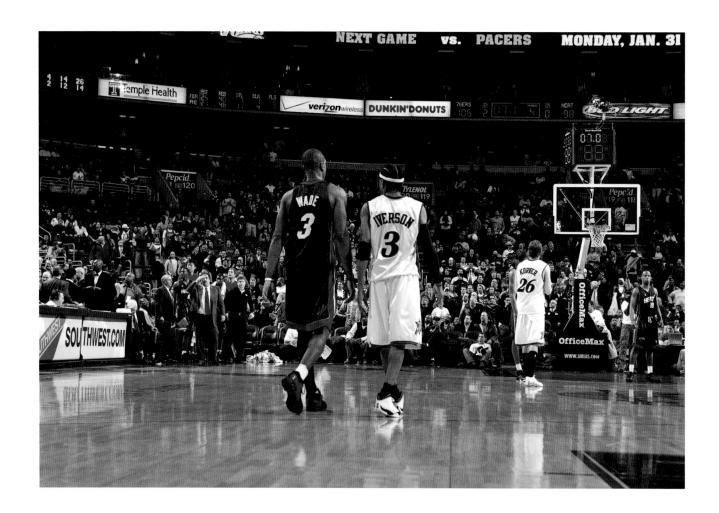

Being in the league was already surreal. Now imagine your first regular-season game being in Philly. I grew up idolizing Allen Iverson—now I'm on the same court as him.

There were real butterflies in my stomach that night.

A.I.'s part of the reason I wore No. 3. After Jordan, it was Kobe and Iverson as 2a and 2b. A.I. put it on the line every night. I was that kid in the driveway trying to do the Iverson crossover. A.I. took a lot of criticism back in the day so future generations in the league could enjoy the creative expression they have now.

Anyway, I'm on the floor with this guy, and while I know I'm going to go right at him, I'm also in awe. You know the real reason why guys like myself, 'Bron, 'Melo, C.P., Steph, and more love this dude so much? Because he always shows us love. I can't think of an OG who is more willing to give you your flowers while you can smell them more than Bubba Chuck. There's no animosity in his heart because there's nothing fake about Allen Iverson.

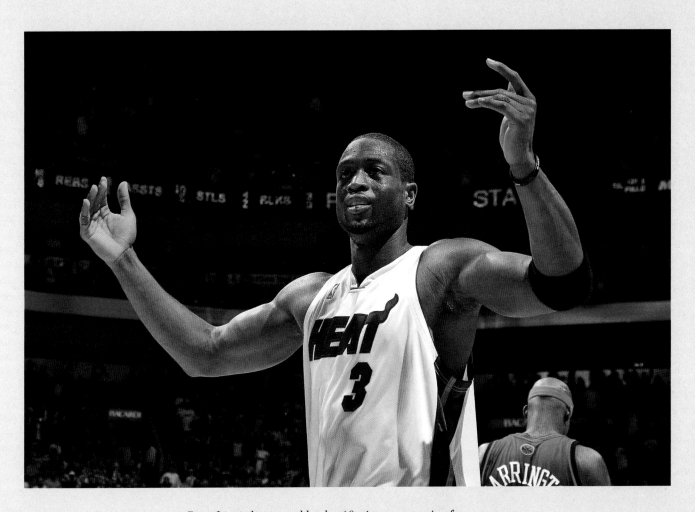

Once I tasted my own blood a 40-piece was coming for your ass.

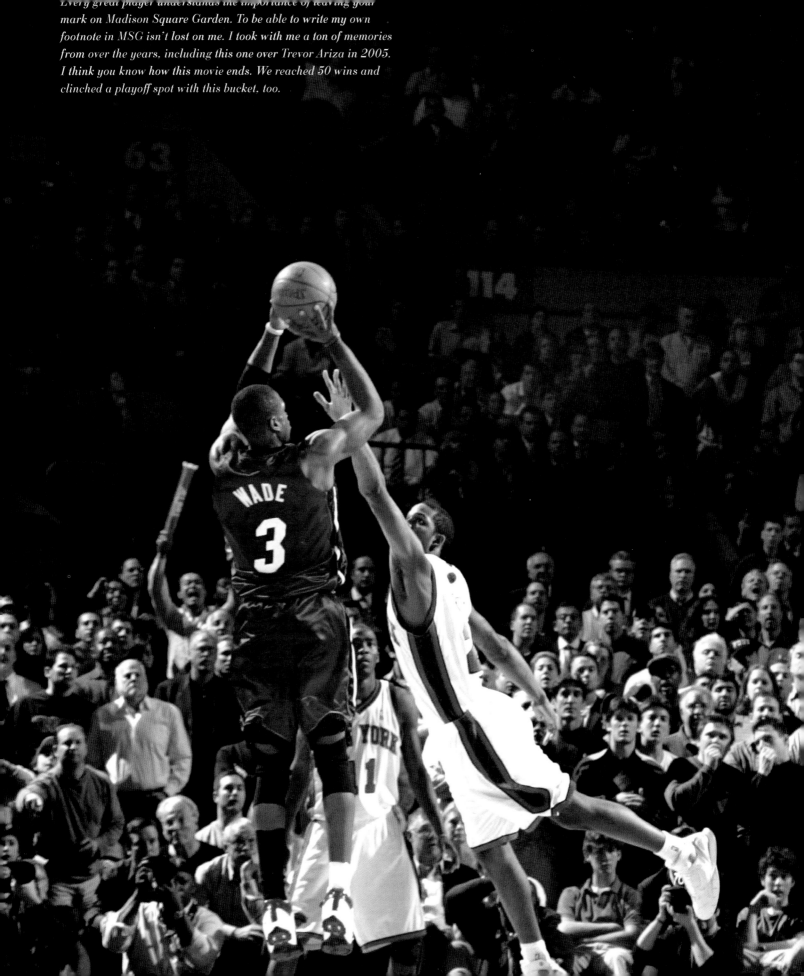

Every great player understands the importance of leaving your mark on Madison Square Garden. To be able to write my own footnote in MSG isn't lost on me. I took with me a ton of memories from over the years, including this one over Trevor Ariza in 2005. I think you know how this movie ends. We reached 50 wins and clinched a playoff spot with this bucket, too.

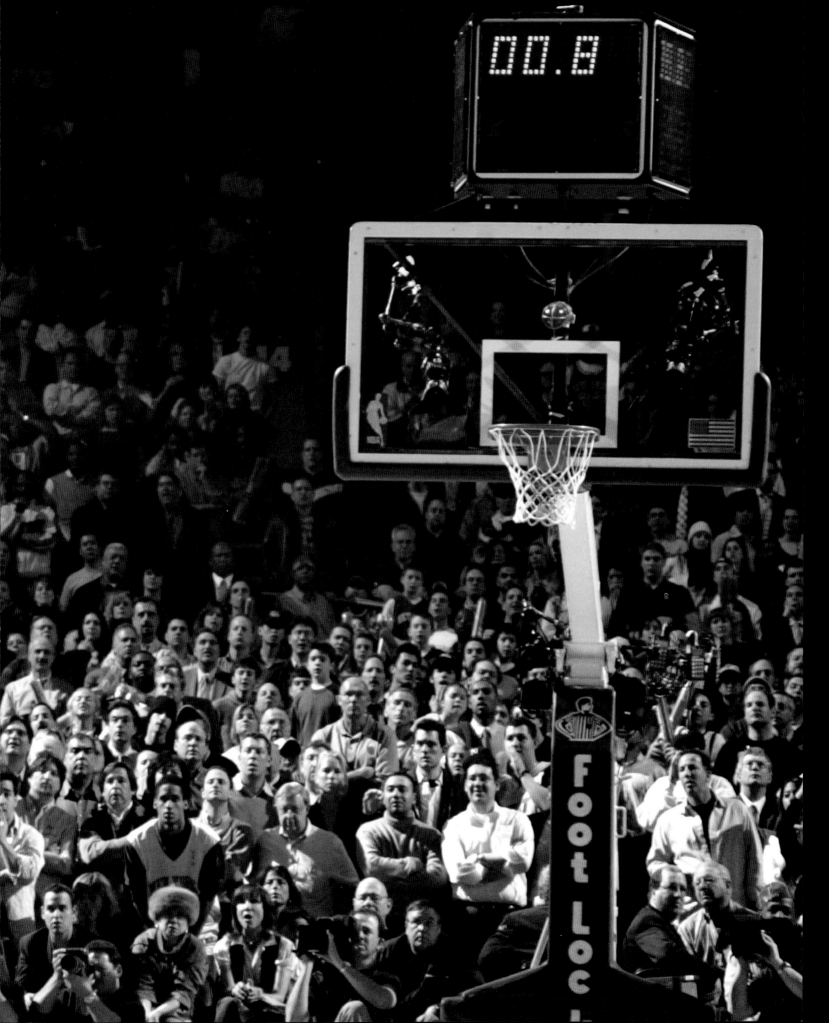

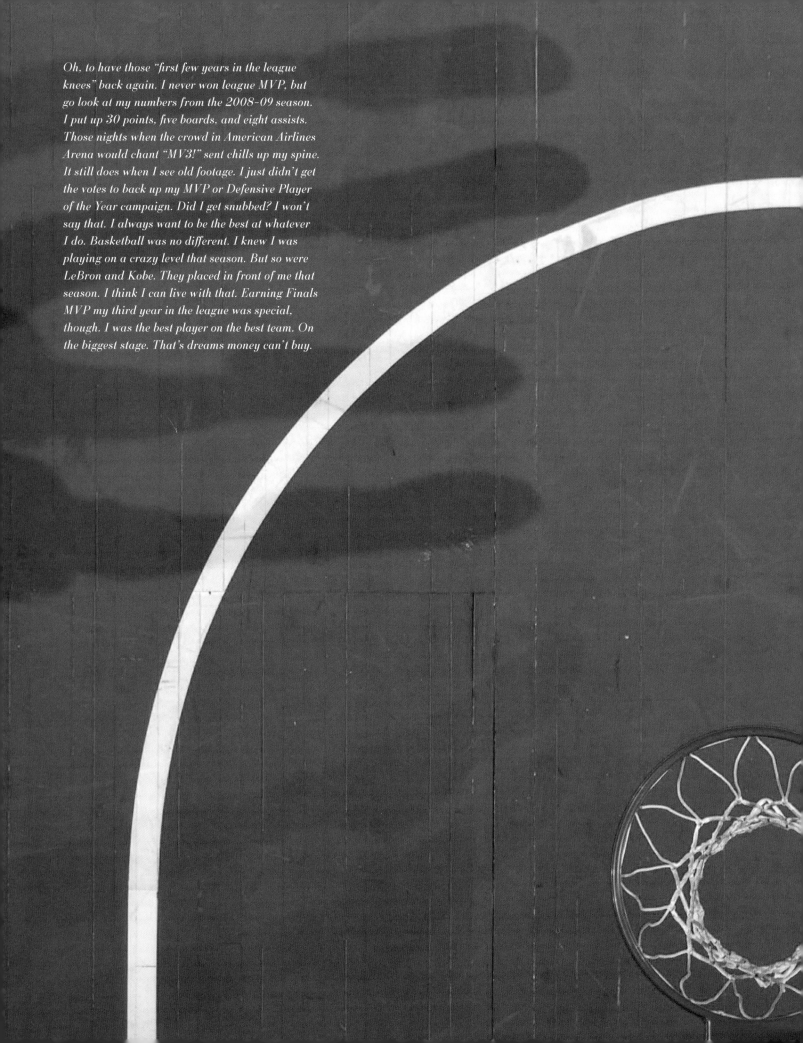

Oh, to have those "first few years in the league knees" back again. I never won league MVP, but go look at my numbers from the 2008–09 season. I put up 30 points, five boards, and eight assists. Those nights when the crowd in American Airlines Arena would chant "MV3!" sent chills up my spine. It still does when I see old footage. I just didn't get the votes to back up my MVP or Defensive Player of the Year campaign. Did I get snubbed? I won't say that. I always want to be the best at whatever I do. Basketball was no different. I knew I was playing on a crazy level that season. But so were LeBron and Kobe. They placed in front of me that season. I think I can live with that. Earning Finals MVP my third year in the league was special, though. I was the best player on the best team. On the biggest stage. That's dreams money can't buy.

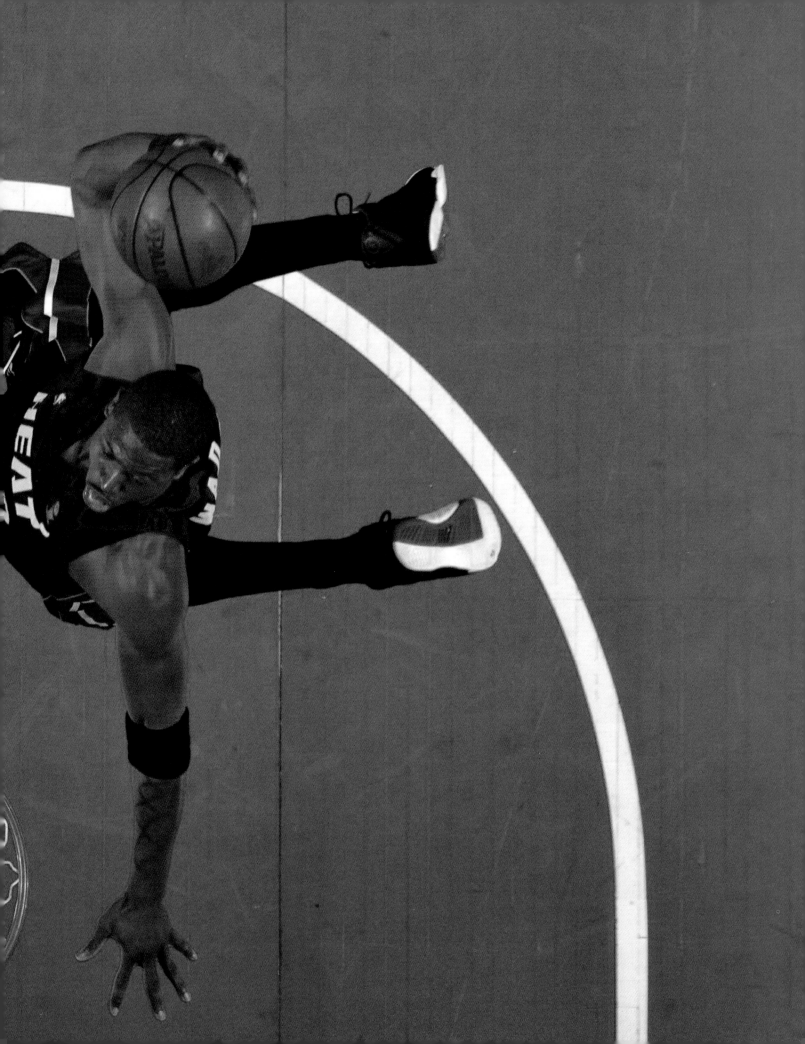

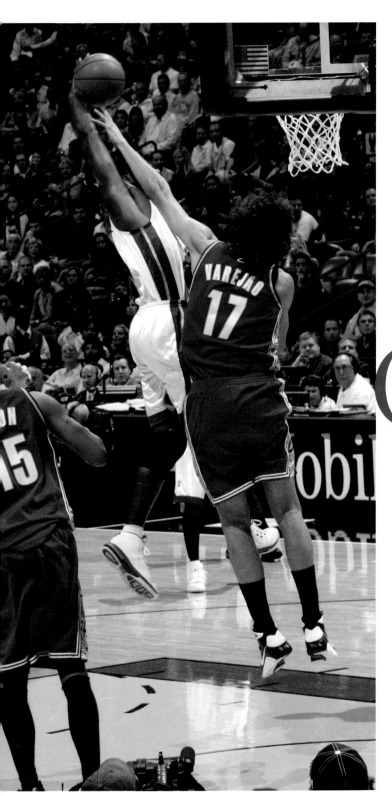

This is the signature dunk of

MY CAREER

This is the signature dunk of my career. November 12, 2009, Miami: the scene of the crime. Playing LeBron always gave me that competitive boost, and he had just missed a dunk on Cleveland's last possession. Michael Jordan was sitting courtside, too. Anderson Varejão was just in the wrong place at the wrong time. To this day, I watch that replay, and I'm like, "Damn, I did that." Sorry, Andy.

Actually, no, I'm not.

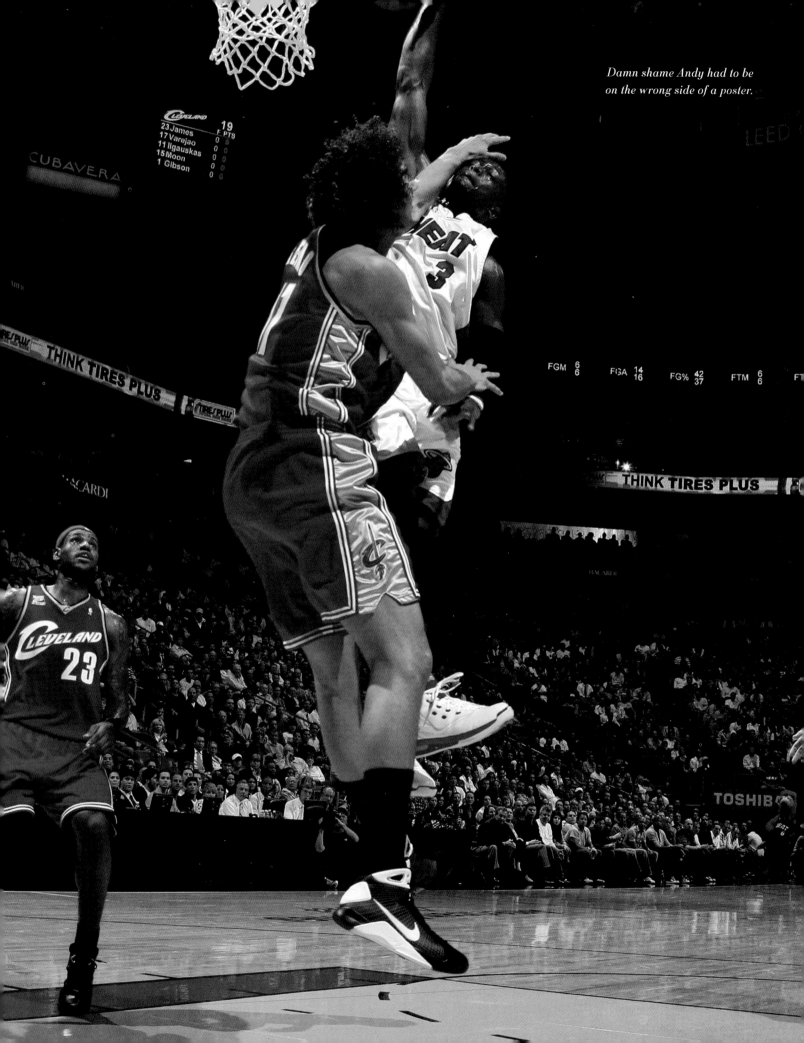

*Damn shame Andy had to be
on the wrong side of a poster.*

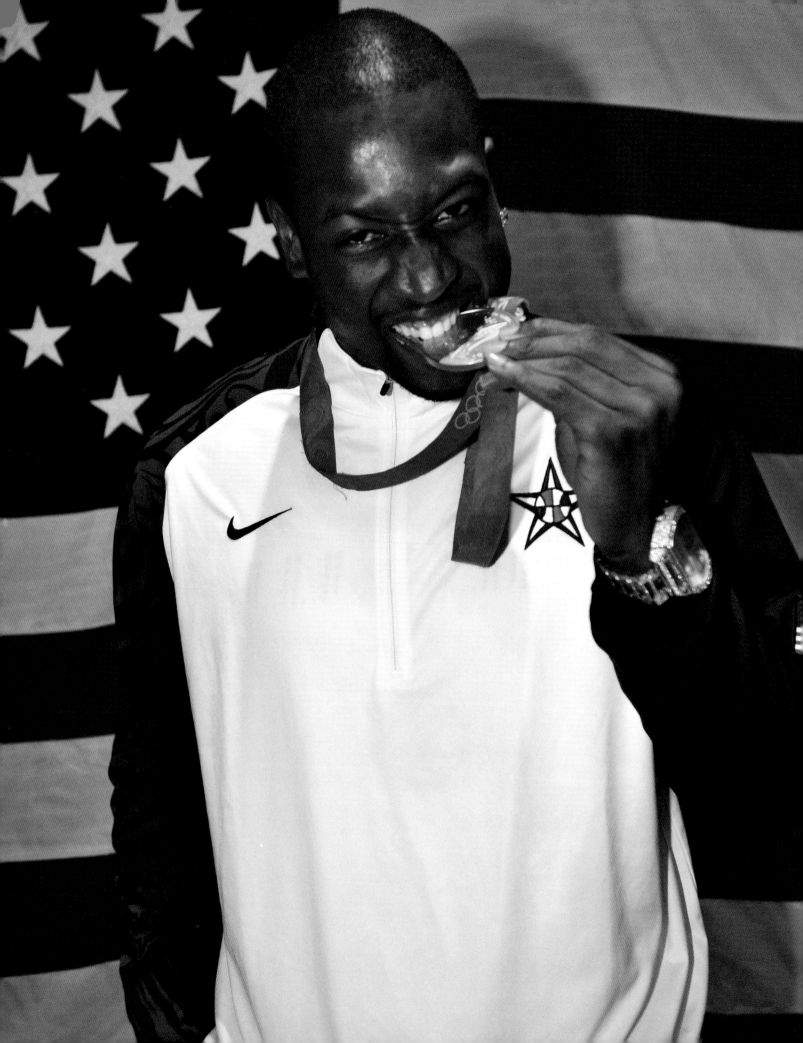

The "Redeem Team" had to win the gold medal in 2008. When you put

Kobe, LeBron, 'Melo, Chris Bosh, Chris Paul, Dwight Howard, Jason Kidd,

Trust me, these posters travel internationally, too.

myself, and a ton of All-Stars on the same squad, there's no other option. And that bronze medal from 2004 was still on everyone's mind. Anything less than gold would be a loss. That Redeem Team summer of 2008 was one of the most special experiences of my life.

I spent a lot of time talking with Kobe during those Olympics—and only about defense. We never had one conversation about offense. Our defensive scheme was all about applying pressure and turning our opponent. I was like a linebacker, roaming the court and playing passing lanes.

It's crazy that within five years, I had been part of a legendary Final Four run, been drafted fifth overall, been blessed to call Miami my new home, made the All-Star Team, won Finals MVP—and now I had won a gold medal for my country. To quote Drake, this was all God's doing. You can't plan it!

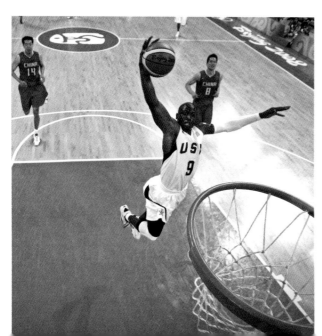

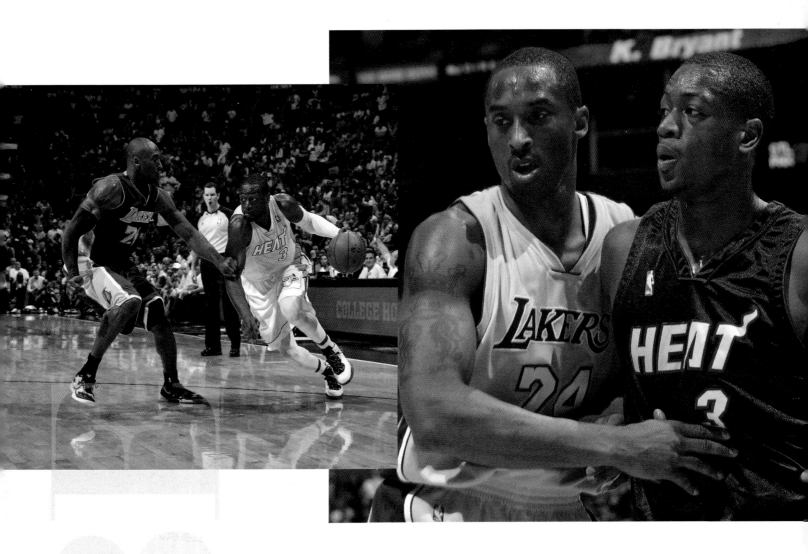

I only played Kobe twice a year, but those two nights were always special. All I ever wanted was for him to work as hard guarding me as I did with him. When I came into the league, I wanted Kobe to feel like he had to get some sleep the night before he played me. But above all, being on the same floor with Kobe was a privilege. He made me a better player, and I hope he felt the same about me.

We had a lot of battles over the years that built into a healthy respect for each other as competitors. I mean, I broke my guy's nose in an All-Star Game because that's how we competed against each other. I remember calling him up to apologize because I, of course, felt terrible. This man said, "I love it." I knew at that moment that the next game we played them he was coming for me. And he did. We ended up playing the Lakers a week later in L.A., and they beat us.

Kobe dropped 33.

Losing Kobe last year is a wound that'll never heal for me. Doing the *Inside the NBA* special shortly after Kobe's death was one of the hardest things I've ever done. He was a competitor of the highest level. He was a role model for those of us younger than him. But more than anything, I'm blessed to be able to say I could call him a friend.

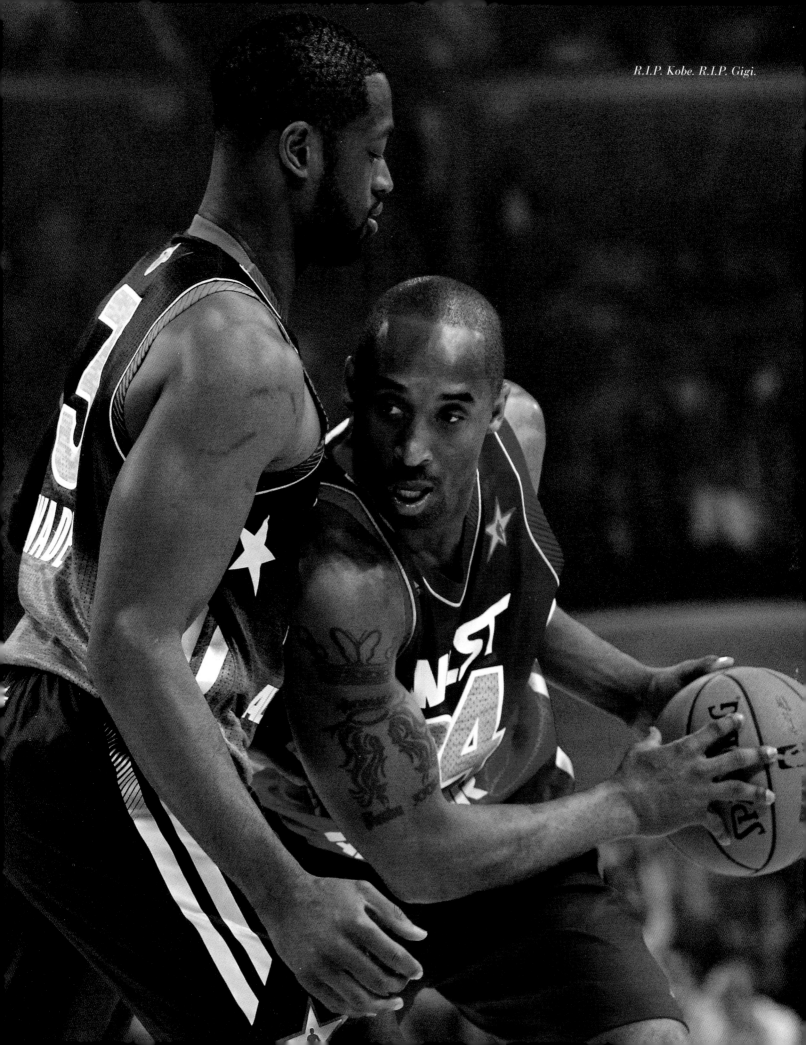

SECOND QUARTER

This is when things start to get INTERESTING...

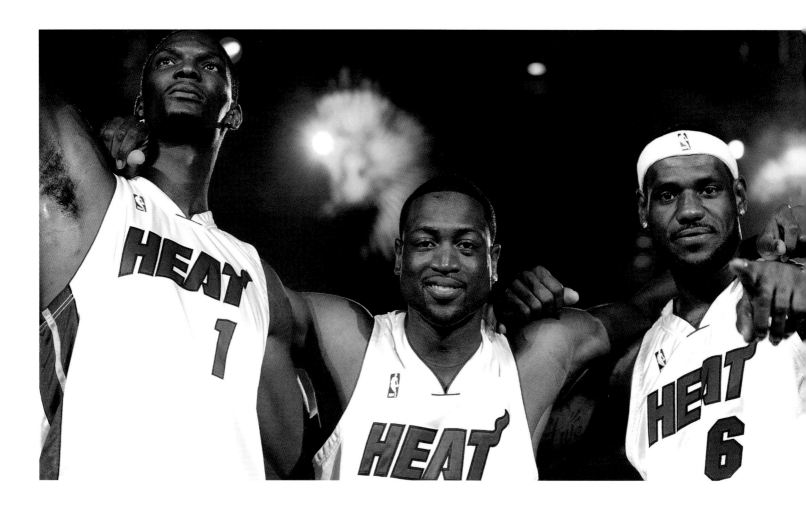

It's about closing the half strong. Letting your opponent know that it's 24 more minutes of this ass-whoopin' on the other side whenever they're ready. There's moments when it's nothing they can do to stop you. I love being in that zone. And it's other moments where nothing is feeling right and the defense came to shut you and you only down. For me those are called moments of growth.

I went against some dogs in my day. Kobe, LeBron, 'Melo, K.D., Steph, C.P., Westbrook, Harden, Tim Duncan, Dirk, Iverson, T-Mac, the Detroit Pistons, the Boston Celtics—the list goes on. There was a test every night I stepped on the floor. Basketball, especially in that sense, was no different than life for you, me, or the person next to you. Everything happens with a purpose and every decision comes with its own set of consequences. And whatever

they were, we have to live with them. Sometimes life is the 2011 or 2014 Finals. And other times it's the 2006, 2012, or 2013 Finals. Win or lose, it's never going to be given to you. But at the end of it all, it would always be worth it. And I always grew as a result.

You want to know the real story of how this photo happened? Here it is. From my perspective, at least. We all decided that if we were going to do this we needed to be in the same room to discuss it. That's what I remember about how the Big Three started— when we all got together the first time face-to-face. We all still had to go through our individual free agent processes. But if this was going to be something we thought about doing, we had to look at each other in the eye.

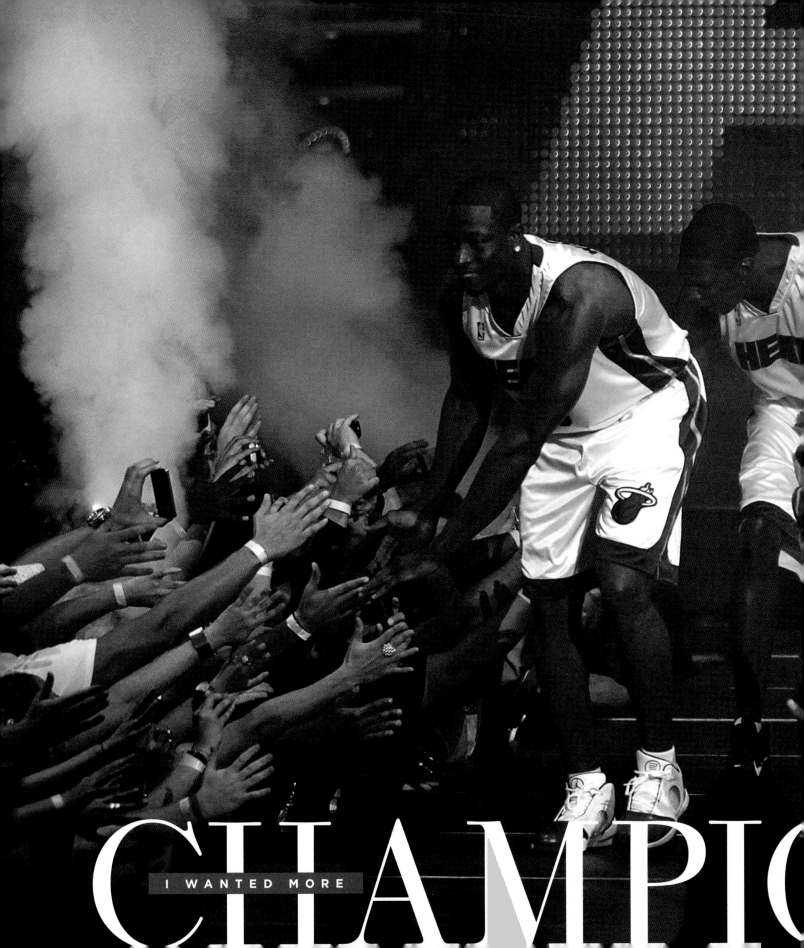

CHAMPIO

I WANTED MORE

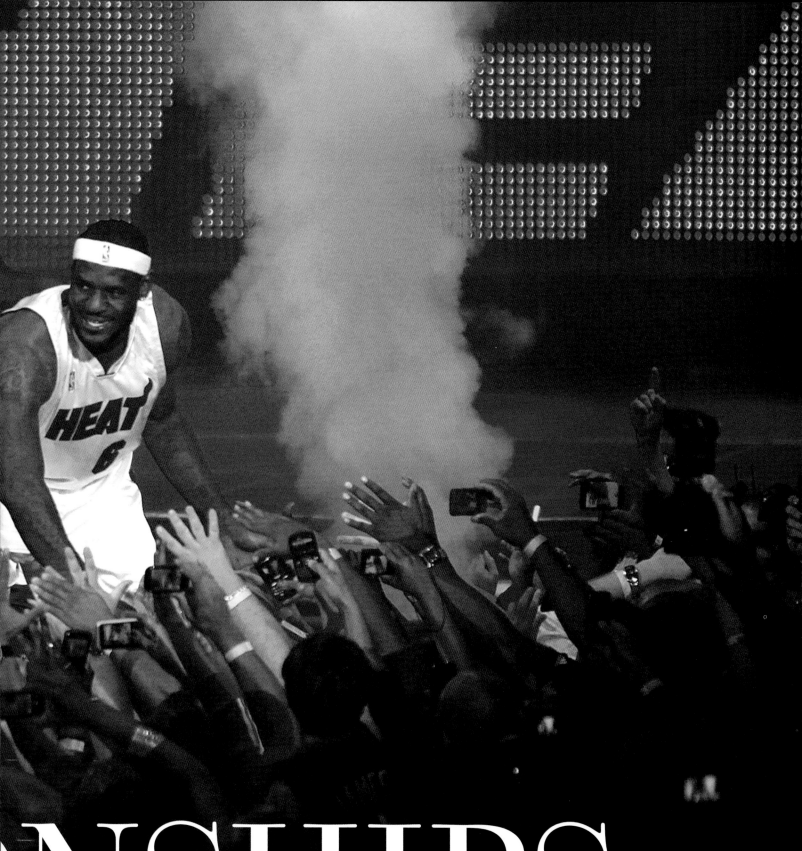

NSHIPS

At that time, we had just found out that the Miami Heat had max money for three players. We already knew they had two max slots, which is why LeBron and I were talking about playing together. But then when it came out that it was three, then it was about, "Well, who is that third guy?" LeBron and I were both like, "Chris Bosh."

I remember being in the meeting with Chris, and we're talking. Chris is just listening to me and 'Bron go back and forth. LeBron's like, "Listen, guys. I don't care about scoring titles anymore." At that point, 'Bron already had two MVPs. He wanted championships. Meanwhile, I had just come off a scoring title. I told both of them that at the end of my scoring title I didn't get anything. I thought I was going to get a car or something. I didn't get shit! All I got was a good season.

I wanted more championships.

But I remember Chris looking at us back and forth and not saying anything. Then he finally breaks his silence.

"Wait . . . this is for real?"

We're both looking at him puzzled as hell. In my mind, I'm thinking, "Bruh, we're all here together . . . to talk about this! Yes, it's real!" But, see, it took Chris until that moment to realize like, "Wait, y'all really thinking about this? Like for real?" 'Bron and I couldn't take it anymore. We bust out laughing. I'm talking the laugh

that eventually hurts your stomach and gives you a headache. In hindsight, it's how the world reacted to us.

Is this really happening? Did they just do this?

In that meeting, we knew that if we decided to play together, this is something that was going to change the NBA. If we were going to do this, this was going to be bigger than us. We took that responsibility in shifting the power into the players' hands. The three of us coming together was about something even bigger than titles. We wanted those, for sure, but it was about shifting the culture. That's what that meeting was about. It was nothing determined there, but it was about planting that seed.

A few days go by and we meet with our respective teams. Chris and I shared the same agent (Henry Thomas), so we'd always pass each other in the office. We'd just check on each other to see how the meetings went. But there were a few times where Chris and I would go to dinner together after meetings. It's hilarious looking back on it because during those dinner conversations we'd all be wondering what the other party was thinking. There was a respect there, so I wasn't going to ask Chris directly. But sometimes you'd get paranoid and be like, "Well, damn, I think Chris really liked New York." It was such an interesting dynamic going on. Our whole thing was, at the end of this— and this is something we still want to do—we'll decide at the very end of the process. But in the

I'M IN. . . .

meantime, go do your own homework and see where you eventually want to be.

During the free agency process, I had probably two conversations with 'Bron. Just regular friendship conversations. Nothing crazy. Just regular, "Hey, man. How are the meetings going? How's life going?" So fast-forward to the moment "The Decision" happened. Not the TV show, but the actual decision. I was in South Carolina because my wife was shooting a show there. I had just gotten to the beach because we had planned to watch the fireworks and barbecue there. Around this time, I got a text from 'Bron asking if I could get on a call. I say of course and we reach out to Chris to do the same thing. We wanted to get this out of the way and just say it to each other so we could all just enjoy our Fourth of July.

By then the rumors were already circulating about us playing together. So many people were asking me about it. I had to get away from everybody. I went to this little corner basically underneath the house and talked to these guys on the phone. We're on there and the million-dollar question is asked.

So, wassup? What y'all feeling?

I jumped in first. "Honestly, to me, out of my options, the best spot for me is either Chicago or Miami." Everyone said the teams they were considering. Then the question was do we want to play together in Miami.

"I'm in," I said.

"I'm in," 'Bron said a few seconds later.

So now you've got me and 'Bron going back and forth again. You never know what the other person is going to decide. There's this plan in place, but you never know if a team made someone a Godfather offer and they just couldn't refuse it. But here we are one more yes from completely changing the NBA as we know it. And I'm crouched under a damn house with my heart beating out my damn chest. Then C.B. gave his verdict.

"F**k it. I'm in!"

Those few seconds felt like time stood still. For a minute that's all any of us could say on the phone. Yo, we're really about to do this. We all get off the phone, and we're all still pretty stuck in a daze. But now I've got this excitement in me, but I can't tell anybody. My team knew. And I ran up to Gab like, "Come here! Don't say nothing!" I let my wife know, but I didn't tell anyone else until me and Chris went on TV on July 7 and announced. I had a camp that day. But that moment on July 4, 2010, is when we ultimately decided to form the Big Three. That's also the last time I'd talk to LeBron until he would get on TV announcing his decision.

No one had talked to 'Bron for a few days. Chris and I announced our decisions on ESPN on July 7, so now all we needed was that last piece to the puzzle. I wasn't paranoid that he'd back out at the last minute. But nothing's ever official until it's official. When you see my reaction the night LeBron announced he was taking his talents to South Beach, that's real joy because the nerves I had that night were out of this world. We did it. We actually did it. Everyone has this notion that this thing was predetermined, and that we had set this plan in motion years earlier. It was anything but that. We all had to go through our own separate journeys to end up where we did. It was the Miami Heat who made it so we could play together. That's my story.

And, dammit, I'm sticking to it.

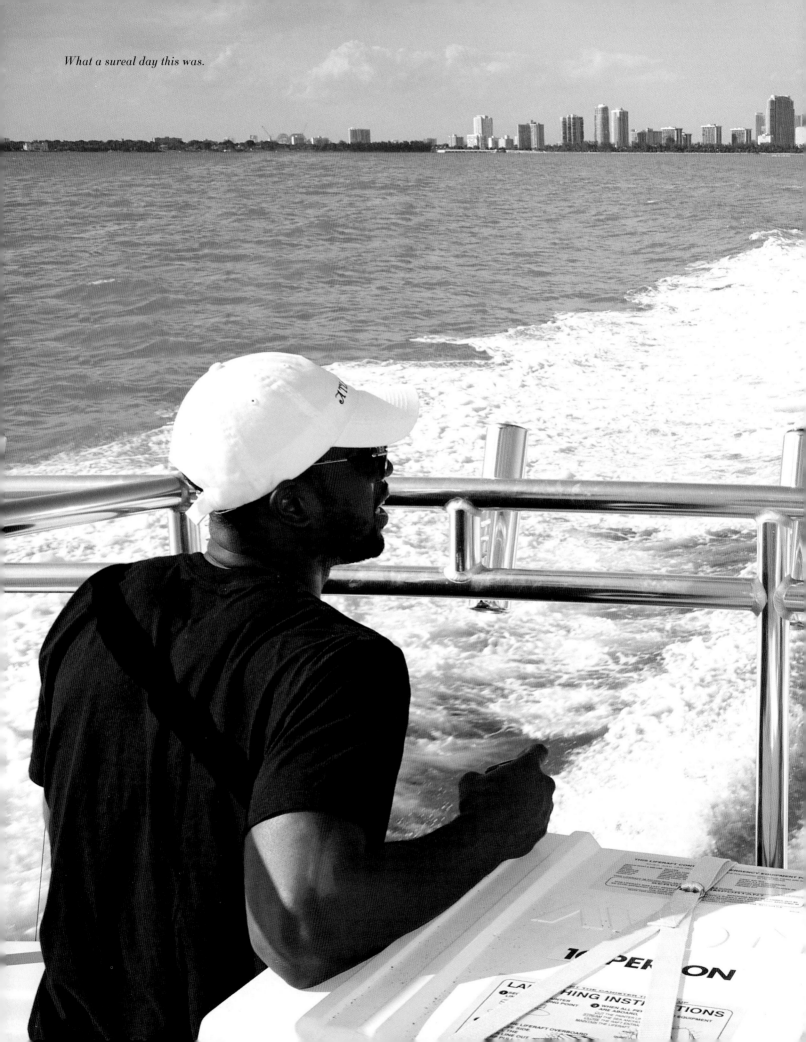

What a sureal day this was.

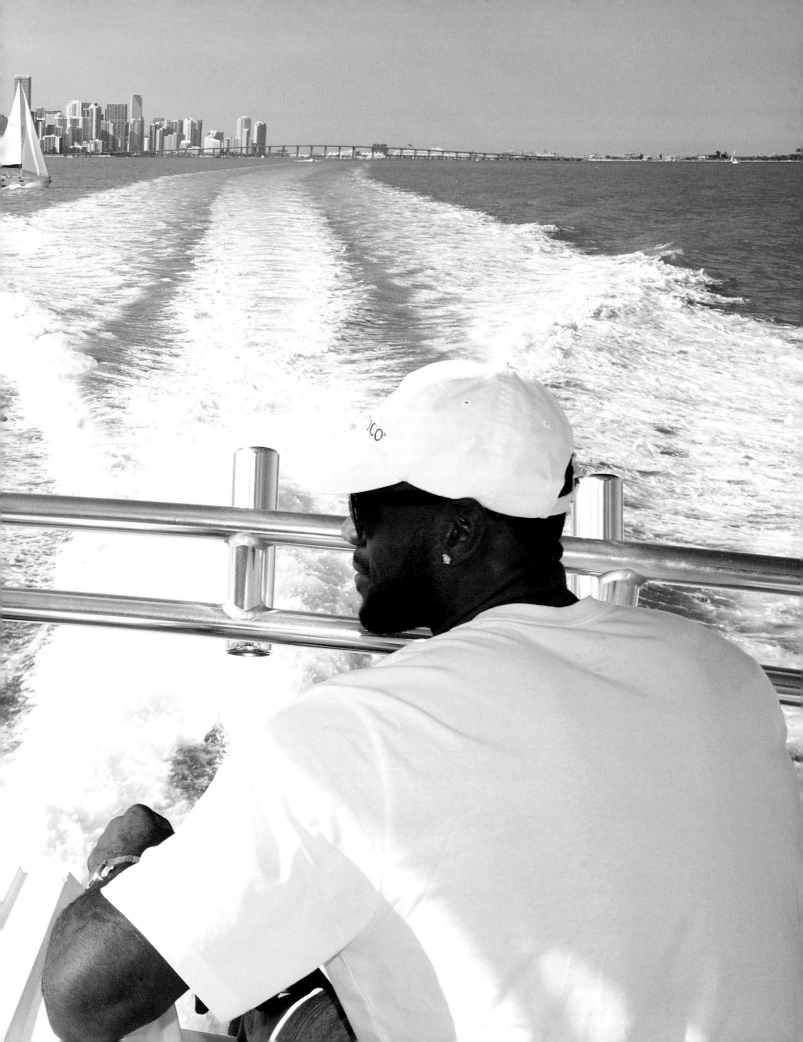

There was so much venom towards us that first year. Some of it was warranted. We knew a lot of people weren't going to be happy with our decisions. But some of it was just pure hatred. So many people rooted for our downfall, and we could've easily caved throughout the season. But we didn't, and when we beat Chicago in the Eastern Conference finals, we got too cocky. We just knew if we made it to the Finals that we were good. But that's one of the cardinal rules of basketball, and life: You can't take anything for granted. That loss to Dallas was a big slice of humble pie. And to make matters worse, now the NBA was locked out, so we were going to be sitting home thinking about that loss for one looooong summer.

We heard traffic was heavy to get to the Miami Open on Key Biscayne. So we found another way!

Those postgame sit-downs with 'Bron were always interesting. There was a ton of pressure on us every night during those years, a lot of which we knew we placed on ourselves. That's why we always sat with each other. It felt like us against the world,

and as long as we had each other we'd be alright. 'Bron and I know that our careers will always be intertwined. We knew the risk we took when the three of us teamed up together in 2010. LeBron sacrificed a lot by leaving Cleveland. Watching that backlash he took for "The Decision" wasn't easy. This is someone I care about, someone I call a brother, being destroyed—oftentimes unfairly and in a very ugly way, too—all because he said he wanted to play in a different city. Burning his jerseys. Dan Gilbert's letter. I could tell it hurt him. When we lost to Dallas in 2011, the governor of Ohio passed a resolution naming the Mavericks "honorary Ohioans." That's the type of hatred LeBron was dealing with. It hurt to watch it all play out, which is why I always wanted to make sure I had his back, because he always had mine.

But 'Bron also knew how much I sacrificed as well. It's not that I needed a gold star or anything. I did it because I wanted to, and I wouldn't change anything about how our time as teammates in Miami played out. 'Bron is one of those guys who's always going to have pressure on him to do the impossible. That's part of the cost of doing business when you're one of the greatest to ever pick up a basketball. But I'll never forget that look of relief on his face when we won that first one, and then came back and did it again in 2013.

You should always want to see your friends happy.

Since we're on the topics of brothers and favorite pictures, allow me to introduce this one. Trust me, I know exactly what you're thinking. C.B. is shirtless. I'm in a hoodie. What the hell is the actual temperature outside? I'm still trying to figure it out.

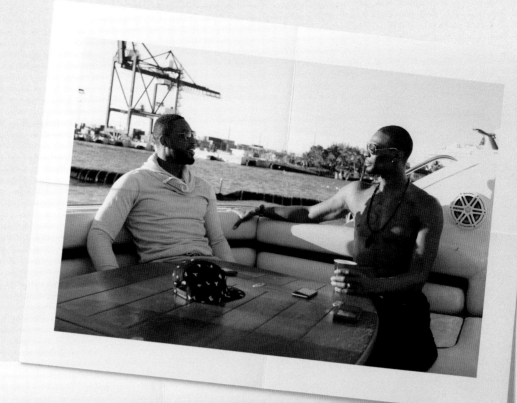

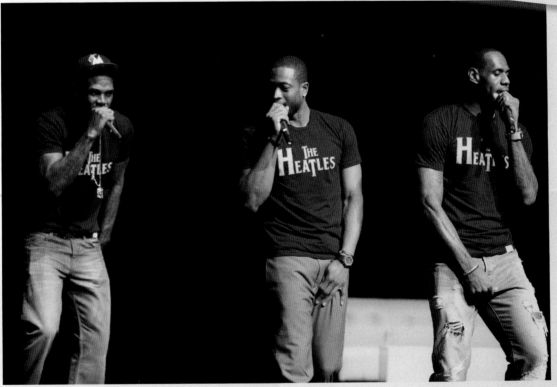

When the Heatles enter the building, it's always a show. Win, lose, or draw, you knew if we were in your city that night that nothing else mattered. If you know, you know.

THE BIG THREE

We all wanted championships. But Chris, LeBron, and myself really, really wanted to beat the Celtics. They didn't like us, we didn't like them. They had what we wanted—a title. And they weren't going to lie down just because we were the hottest ticket in the league.

This is exactly why the Big Three came together.

To put Boston in situations like this.

Those playoff series with P.G. and the Pacers were as tough as they looked on TV.

Paul George was such a fierce young competitor in those battles we had with the Pacers in the playoffs. If I had to pick one other guy's game, I'm taking P.G.'s. The effortless range, the ball-handling ability, the athleticism, the big-shot making, but most importantly the lockdown defender. He has the perfect combination of height, speed, athleticism, and flair—and he's a dog on both ends of the floor. Not many guys can give you 35 or 40 and still go out and guard LeBron. Paul George has been my favorite young player to watch for years in the NBA.

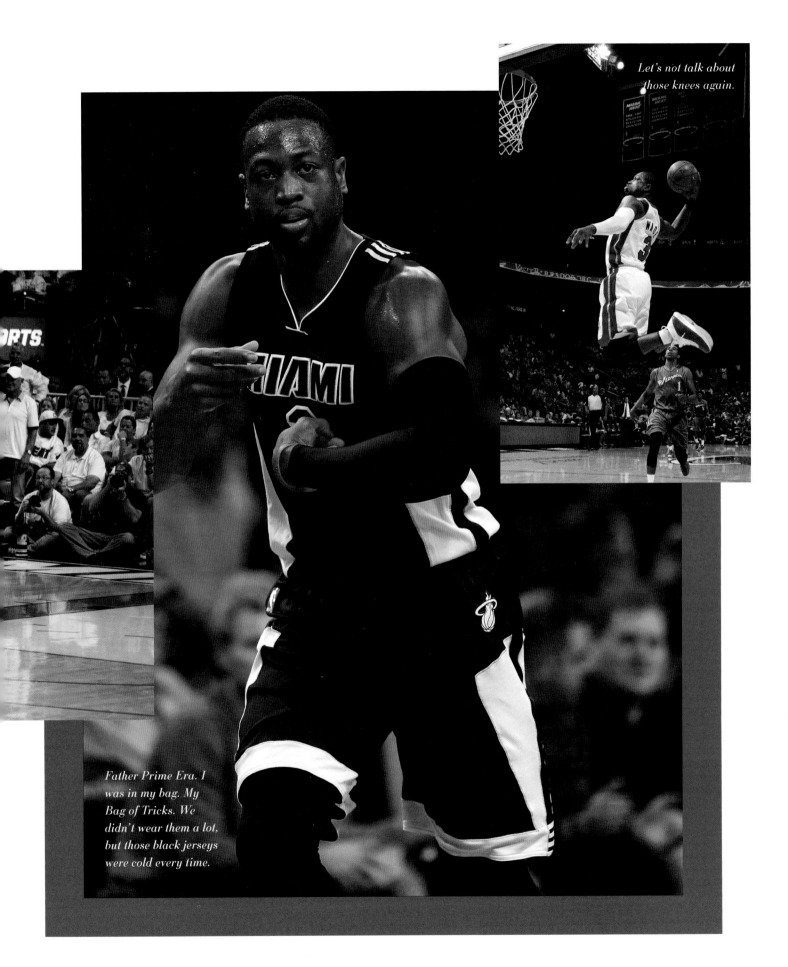

Let's not talk about those knees again.

Father Prime Era. I was in my bag. My Bag of Tricks. We didn't wear them a lot. but those black jerseys were cold every time.

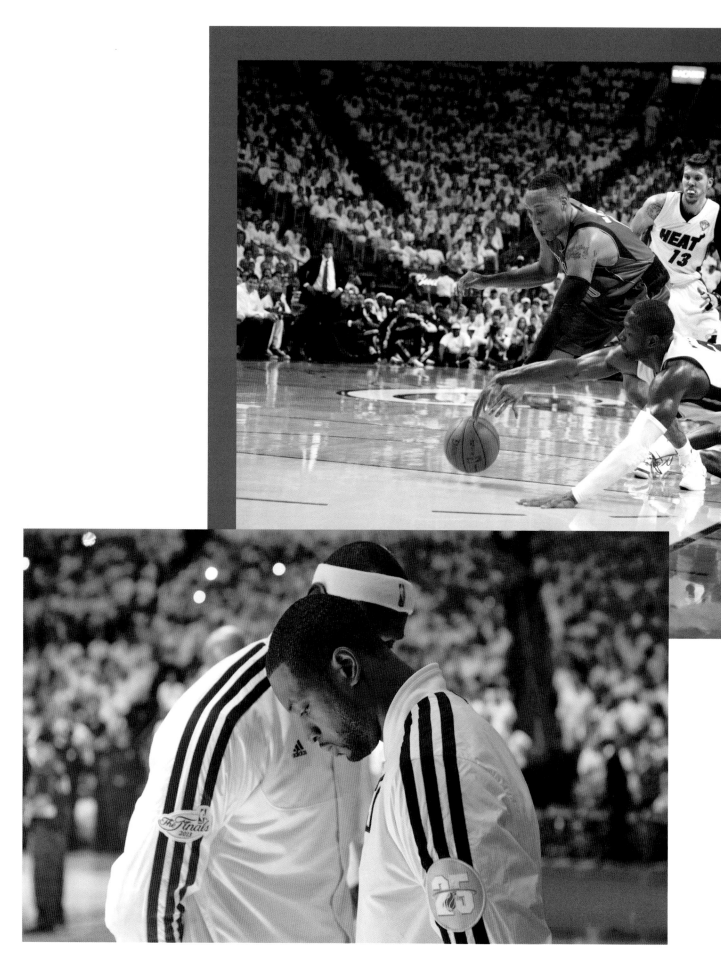

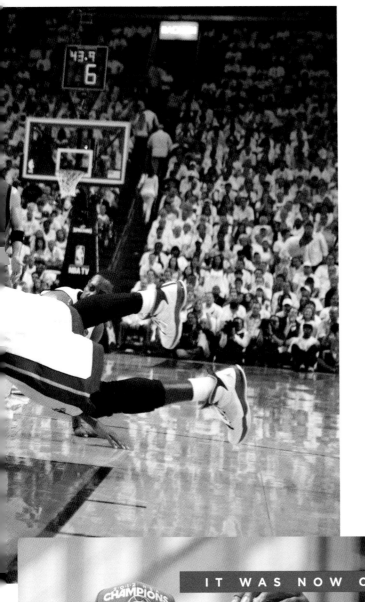

This backstory is well known at this point. After the 2011 Finals loss to Dallas, I told 'Bron that he had to be the leader of this team. Was that easy for me to do? Hell no. We all have egos and pride, but I knew it was bigger than me or any individual goal in mind. LeBron knew this was my team, my city, and neither one of us wanted to jeopardize our friendship.

But we both wanted to win.

I knew to get to that level LeBron was going to have to be the conductor. And I knew LeBron needed that for himself. That moment changed everything in Miami for us. Both of us knew after that Finals loss to Dallas that we were stuck together for at least the next three years. If we didn't win a title, this thing would always be remembered as a disaster. Probably the biggest on-court disaster in NBA history. LeBron was twenty-six, and he'd never really been physically hurt at all. I knew he had more years left in him than I did.

IT WAS NOW OR NEVER.

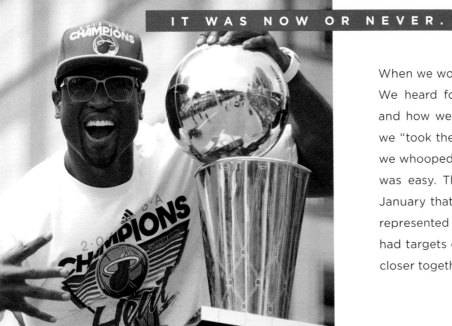

When we won that first title in 2012, I felt validated. We heard for so long how we ruined the game, and how we didn't deserve to win a title because we "took the easy way out." Look, we had fun and we whooped a lot of ass along the way, but nothing was easy. There were so many random nights in January that had playoff atmospheres because we represented something to the rest of the league. We had targets on our backs. All that did was bring us closer together.

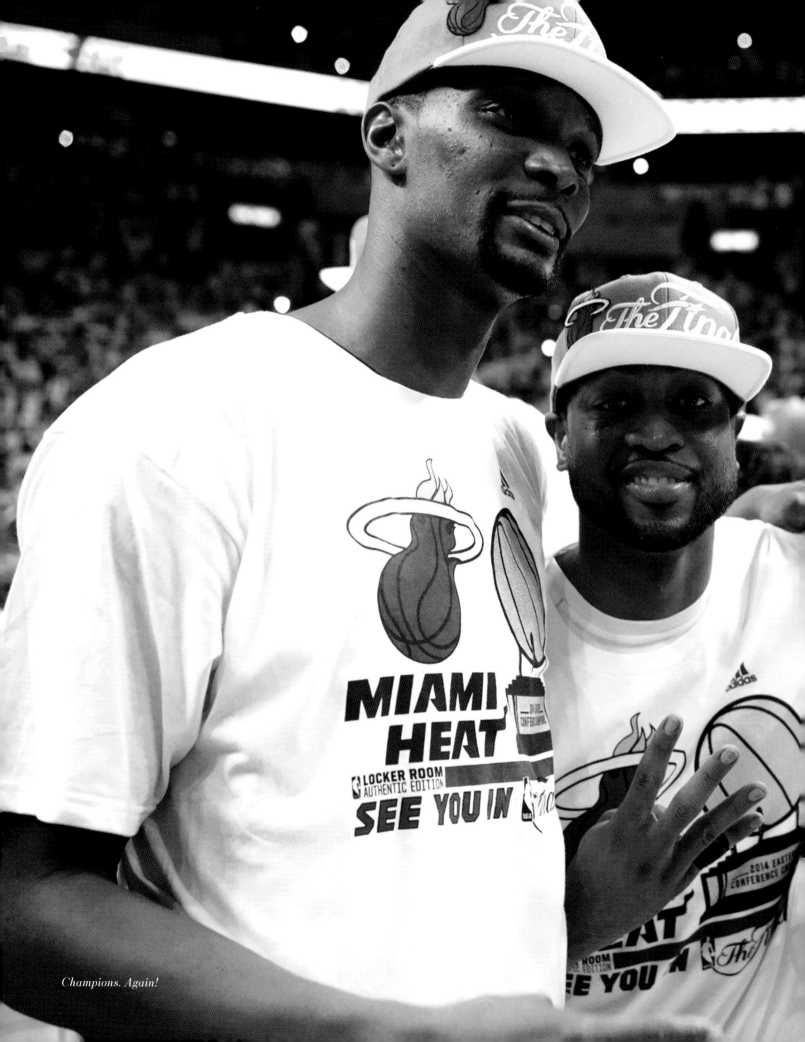

Champions. Again!

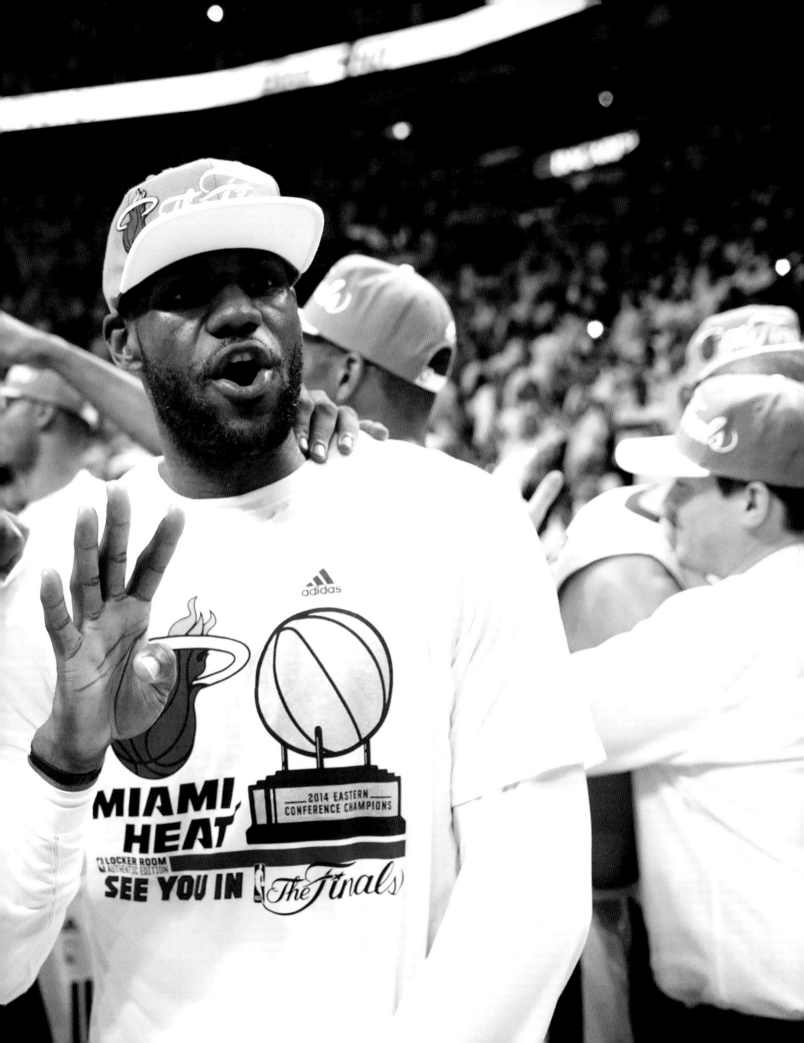

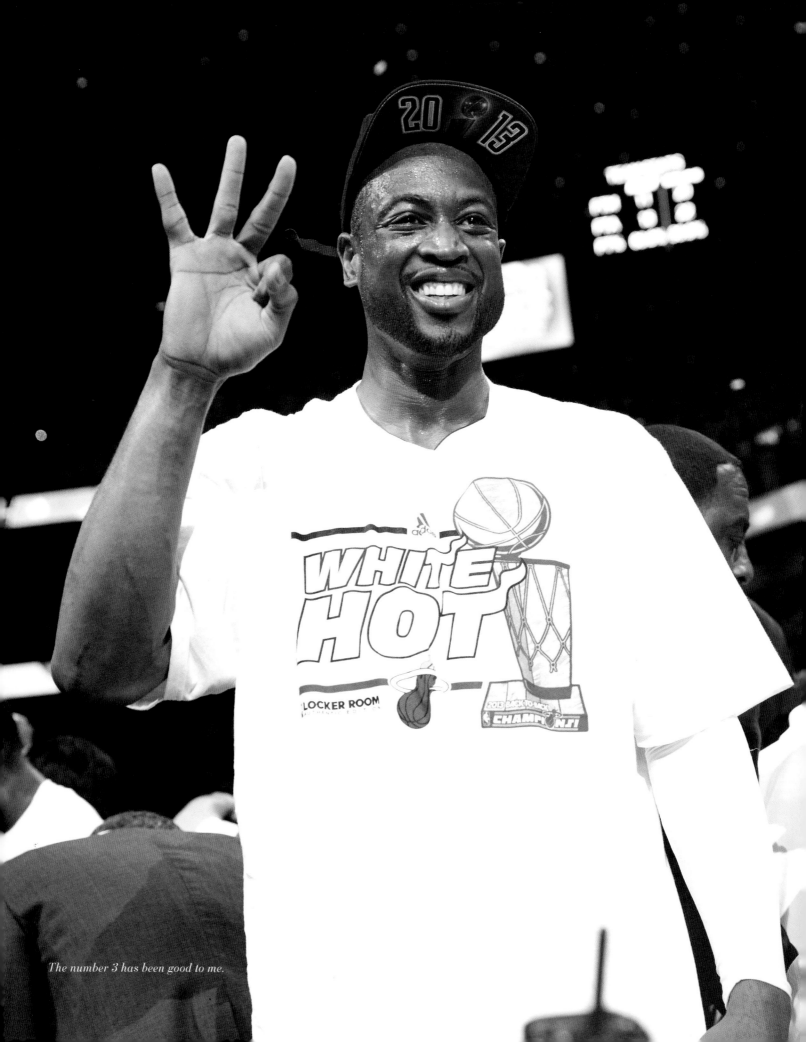

The number 3 has been good to me.

Lamar Odom told me something my rookie year that I never forgot. This ball will take you to the highest of highs and the lowest of lows in the blink of an eye. It meant a lot coming from Lamar, because he lived that. So, during the Big Three era, I tried to cherish every moment, because I knew they wouldn't last forever. The joy on our faces. The thrill of the competition. The euphoria of accomplishing our goals.

I can still see the confetti falling.

I remember the excitement of our 27-game winning streak. I can still feel that trophy in my hands while I'm looking at Hank like, "We did it!" To accomplish all this with some of my closest friends, you can't put a price tag on that.

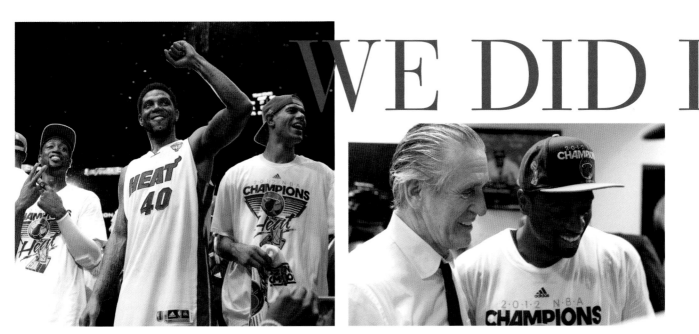

WE DID IT

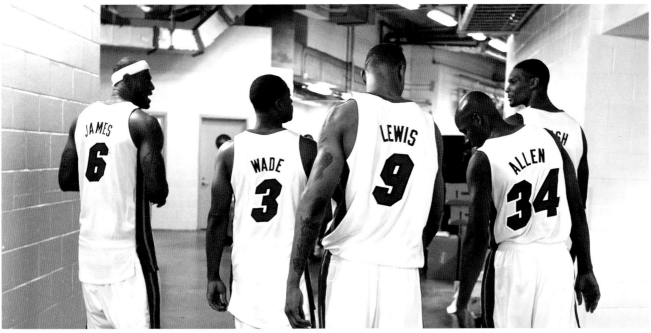

2012-13. Pick Your Poison.

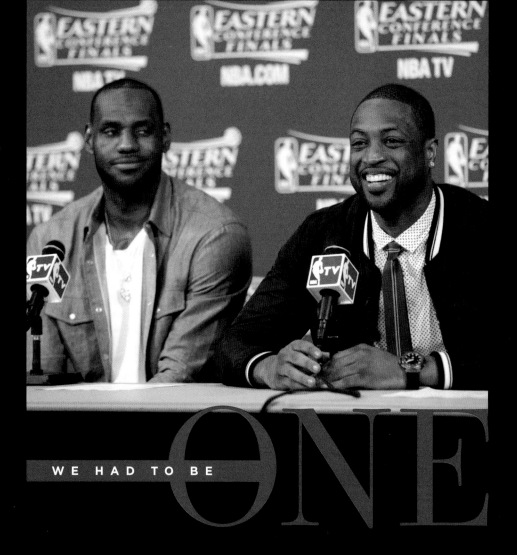

WE HAD TO BE **ONE**

For anyone in or around the league who was looking for moments of jealousy or weakness in our relationship, we never gave it to them. If you saw 'Bron, you saw me. And if you see me, you see 'Bron. As the two best players and leaders of our squad, we knew we had to be one.

From dual press conferences after every playoff game, spending off days together, always working out together, to celebrating the biggest moments together. That's how Peanut Butter and Jelly was born.

Whatever I said—'Bron's side-eye be damned—I was right.

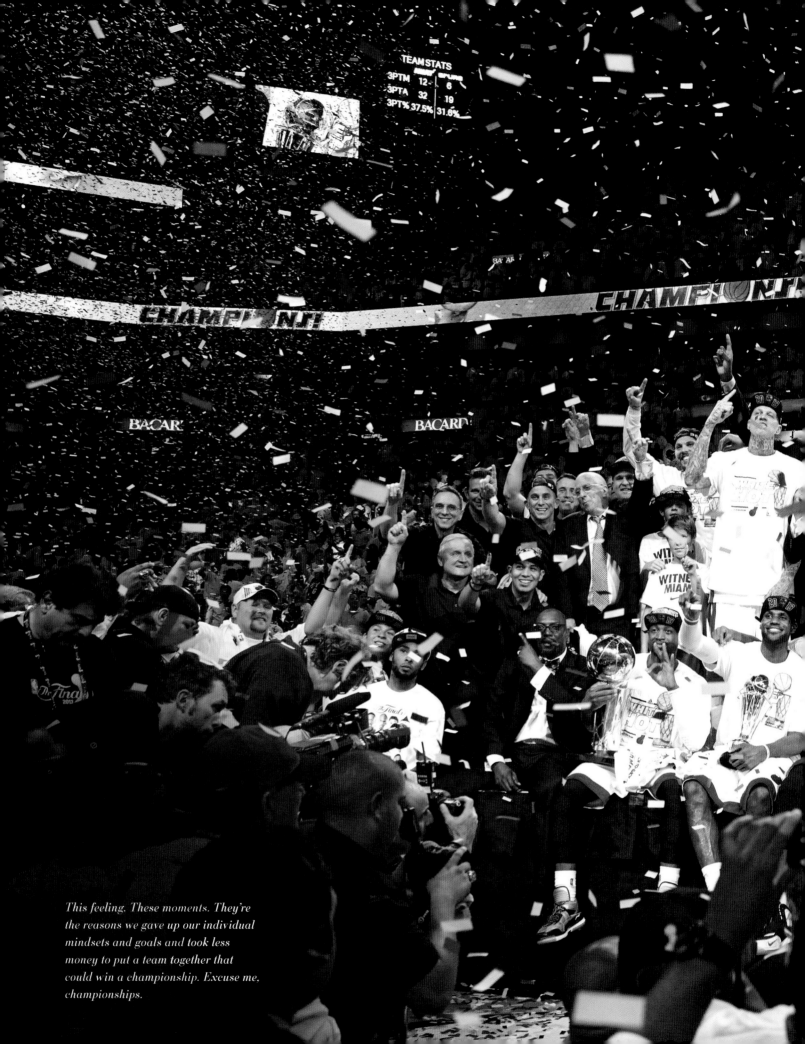

This feeling. These moments. They're the reasons we gave up our individual mindsets and goals and took less money to put a team together that could win a championship. Excuse me, championships.

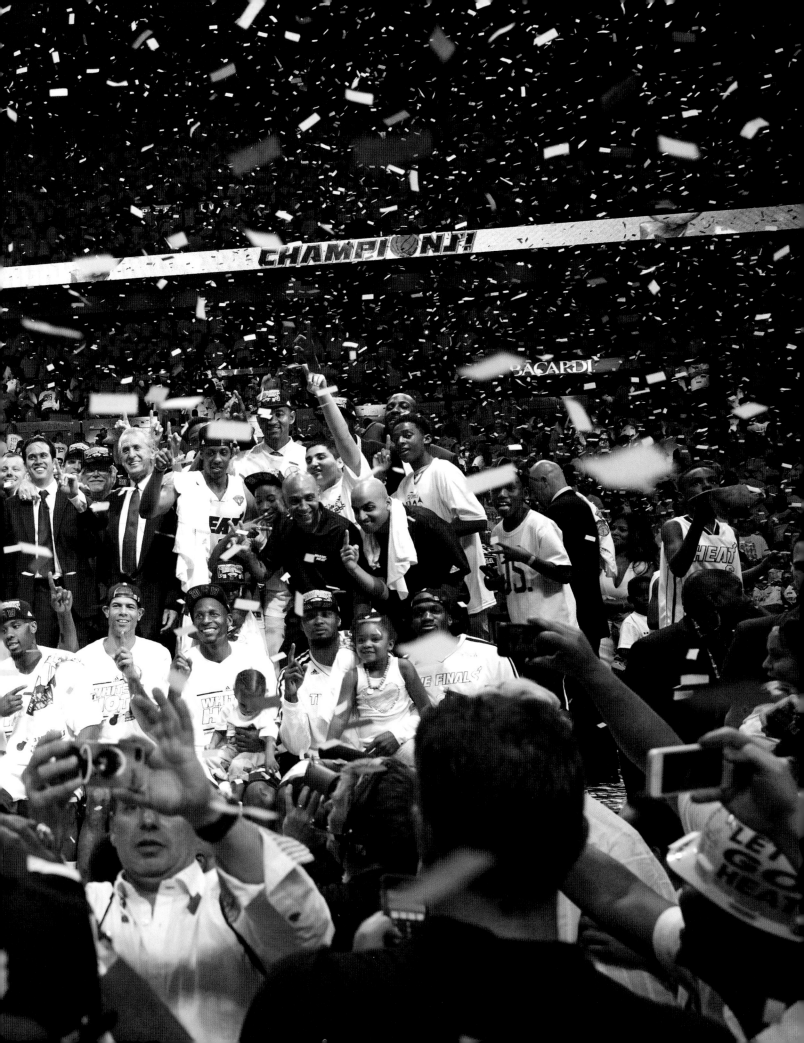

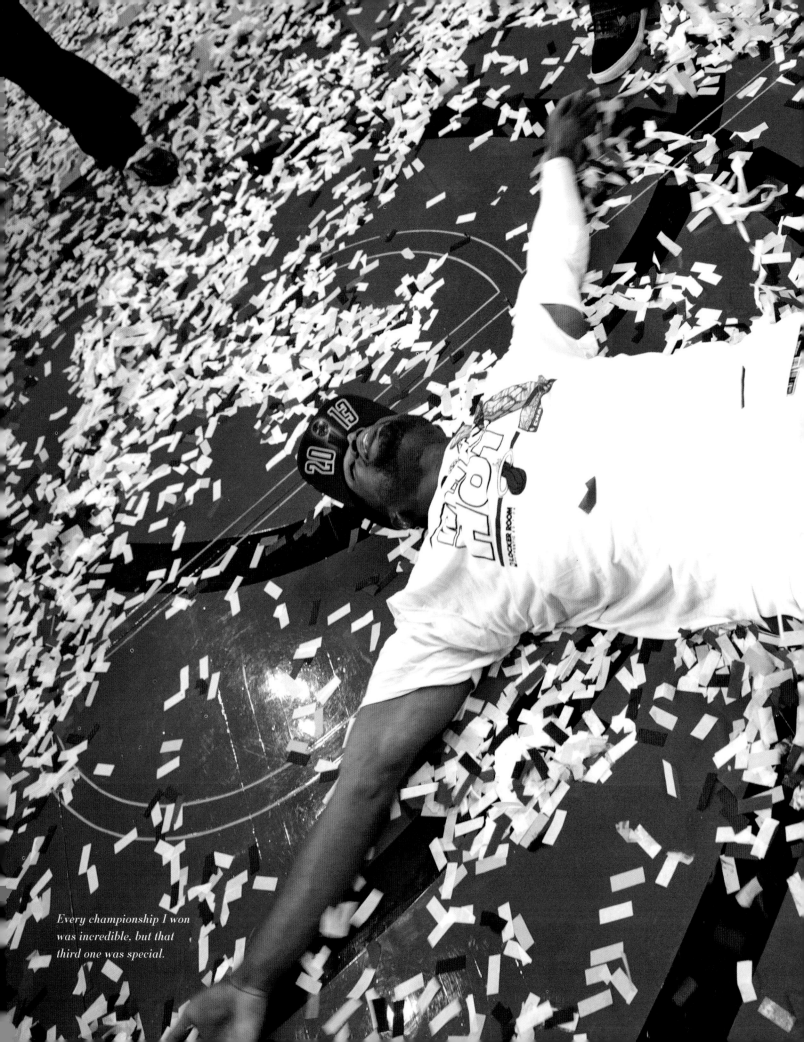

Every championship I won was incredible, but that third one was special.

Erik Spoelstra became my head coach shortly after the 2007–08 season when we went 15–67. I was hurt for much of the year and there was a feeling around the organization that we needed a change. I've known Spo since I came into the league, but when he first took the head job, I won't lie, we had our ups and downs. But nothing teaches you how to evolve like adversity. Spo and I both grew a lot.

In 2016, when I left Miami for Chicago, and had no clue if I'd ever wear a Heat jersey again, Spo and I, believe it or not, got super close. He'd text me. I'd text him. I'd call him. He'd call me. It wasn't just basketball. We were confiding in each other as friends. That's a large part of what made coming back to Miami so special. Not only would I retire with the team that drafted me, but I'd be doing it with Spo along for the ride. Spo always made the right decision for the team.

I respect that.

ERIK SPOELSTRA

This picture is the epitome of who we were and why we came together. It was right after we beat the Spurs for our second title of the "Big Three" era. I was sitting on the floor with the trophy just taking in the moment. C.B. and 'Bron were in the locker room doing interviews. Once they were done, they just came over and sat beside me. C.B. had arguably the biggest rebound, assist, and block in Heat history—and he did it all in Game 6. Ray Allen making one of the biggest shots of all time in Game 6. Full stop, we're not celebrating this title without Chris or Ray. Watching Chris grab that rebound and Ray backpedal to the three-point line, I swear that moment, in real time, went in slow motion. The ball was up in the air for what felt like an eternity. Nor are we without Shane Battier's six threes in Game 7. Or 'Bron and I combining for 60 points and 22 rebounds in Game 7. Simple as that. We knew we earned the hell out of that title. That's where those smiles come from.

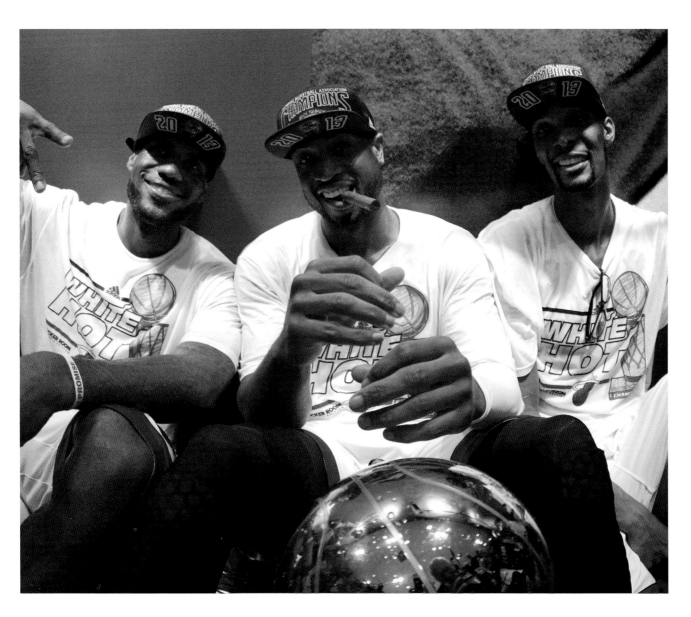

Not bad for some guys who ruined the league, huh?

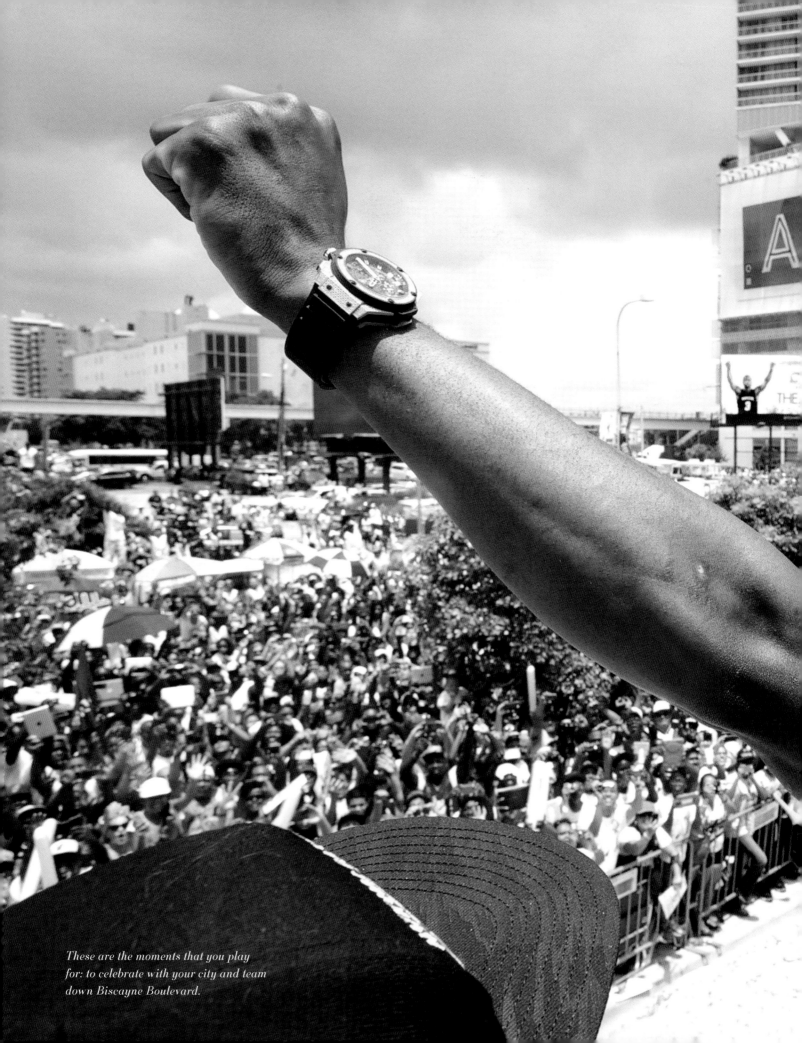

These are the moments that you play for: to celebrate with your city and team down Biscayne Boulevard.

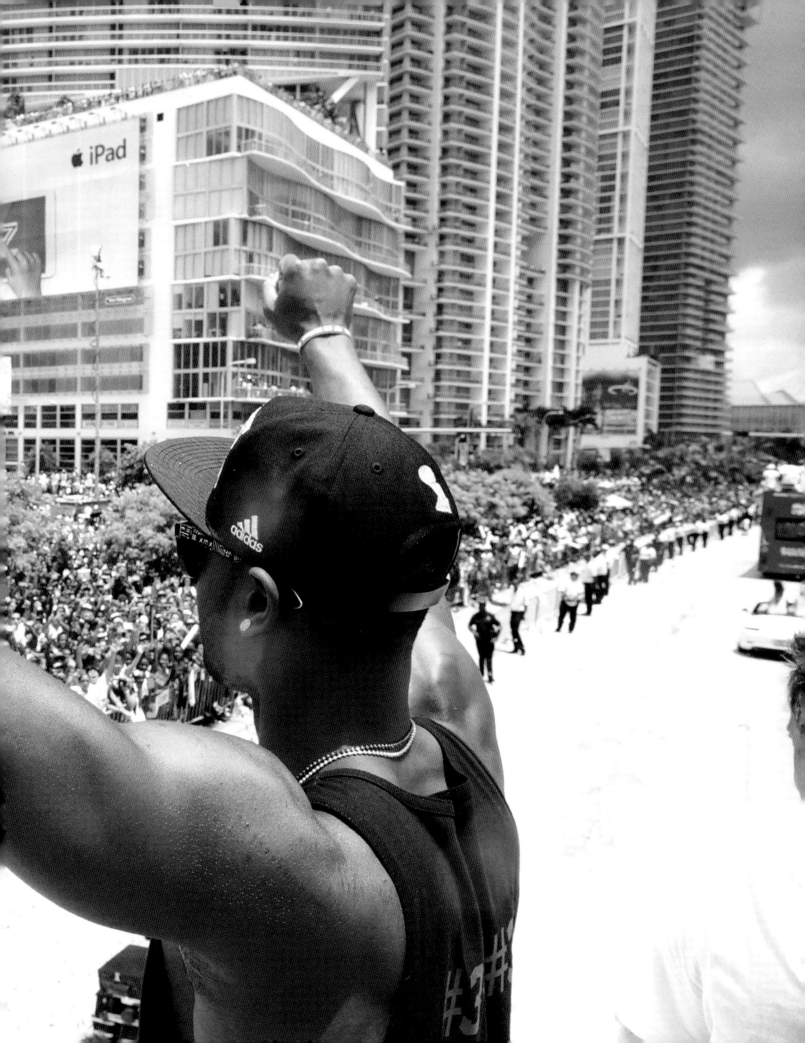

"All I need is the love of my crew / The whole industry can hate me / I thugged my way through."

Jay-Z wasn't lying when he said that. My body was falling apart as the years went on. Four consecutive Finals appearances means no real time for your body to heal. Eventually, we all committed to doing a little more to care for our bodies. After every game we would meet in the cold tub. Some games we wouldn't say much to each other, and other moments like this one we just enjoyed being the rock stars of our league.

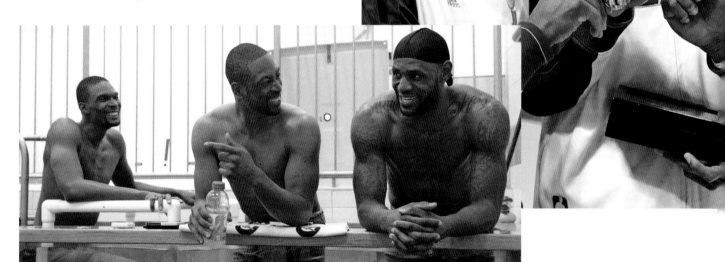

This pool photo was right after we won the Eastern Conference finals in 2014. It was one of those last times the three of us just laughed together as teammates. I think we all sort of knew 2014 was the end of the run, but none of us really addressed it throughout the season. Again, it's all about living in the moment—and I think all of us did that during those years.

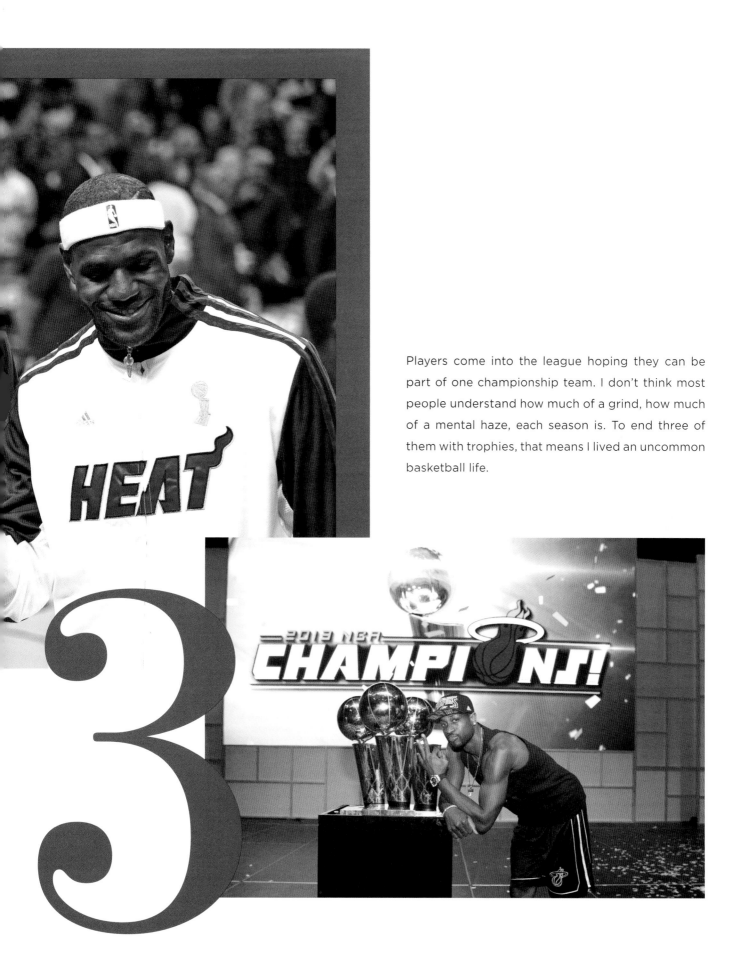

Players come into the league hoping they can be part of one championship team. I don't think most people understand how much of a grind, how much of a mental haze, each season is. To end three of them with trophies, that means I lived an uncommon basketball life.

My basketball story started here. Chicago is where I was introduced to the game. It's where the game allowed me to escape from the realities of my life growing up. And it's where I was taught to play the game in the way that I did. I'm home. All my life I had dreamed of walking out to that Alan Parsons Project song. You know it—trust me, you do. It's the theme song that's been the Bulls' intro for years. The one that Jordan, Pippen, and all those great Bulls teams made famous. The one that all of us young hoopers imagined being called out to.

Signing with the Bulls was a very personal experience. It's something I had to do in a lot of ways. Getting a chance to play in front of my mother and family every night was a dream come true.

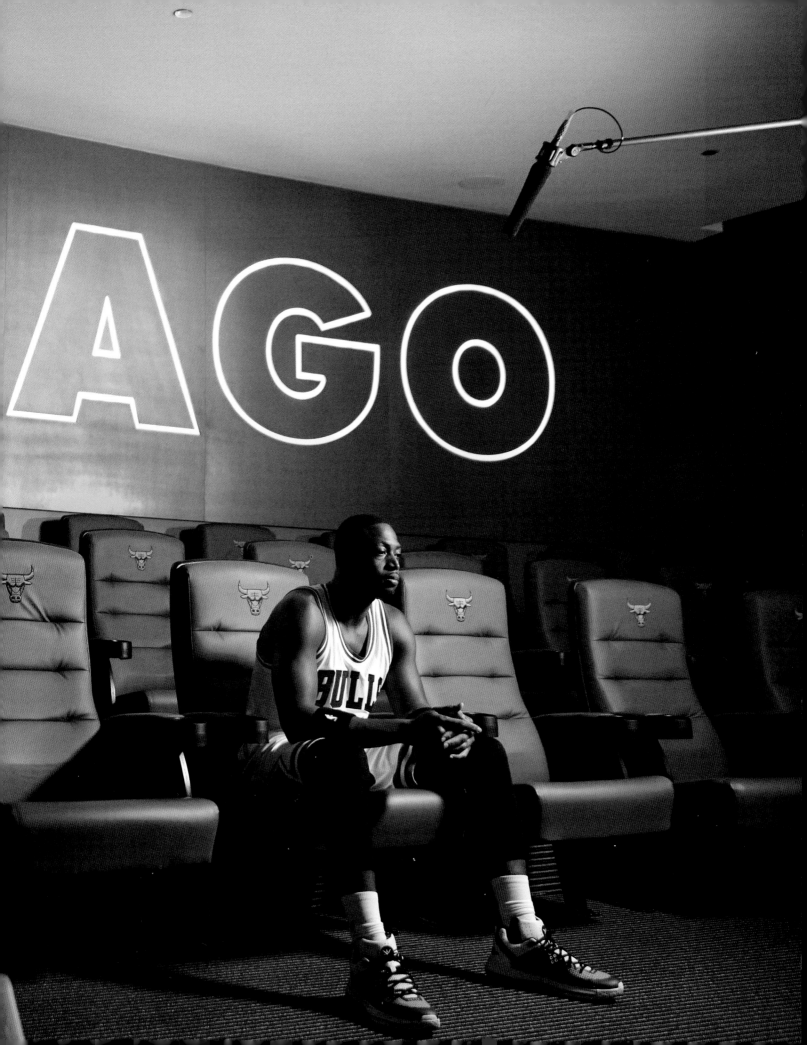

This is me realizing that winters in Chicago haven't gotten any warmer since I was a kid.

As an old head in the league, it's my job to pass on the knowledge that I've learned over my years as a pro.

I knew Jimmy at Marquette. And I'll keep it a buck with you, I didn't think he was a very good player in college. When Jimmy got drafted 30th in the first round, I remember thinking, "First round—good for Jimmy!"

But in the league, he became a guy you had to get ready for. Defensively, Jimmy is a dog.

When he got to the NBA, the Bulls and Heat were already rivals. And I felt it from Jimmy—even off the court! He wouldn't speak to me, or even look at me. When I got to Chicago, though, Jimmy was the first one to embrace me with open arms. I went in and took him under my wing. Even though it was his team, Jimmy was just a student from day one. He soaked up everything he could get from me. And we became brothers.

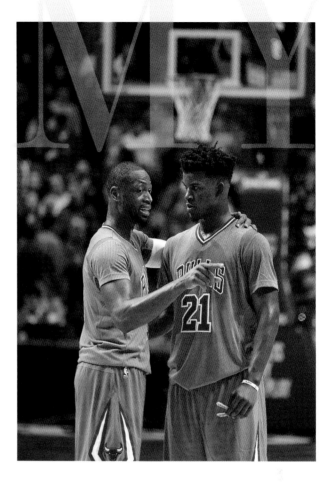

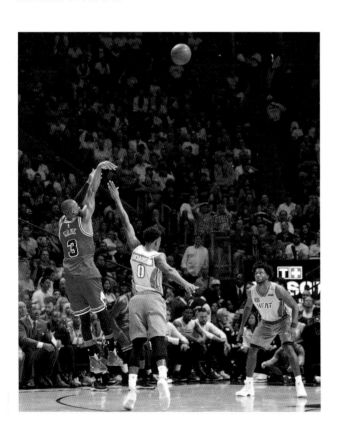

Aye, Jimmy, how does that jersey that you said you would never wear feel?

I know a little about that myself. I never thought I would put on a Cleveland jersey, but I did.

American Airlines Arena. The crazy thing to think of is that this was the only time I ever played at the arena on the visiting team. The moment was surreal walking into the visiting locker room and having to get ready. But once the whistle goes off it's back to business.

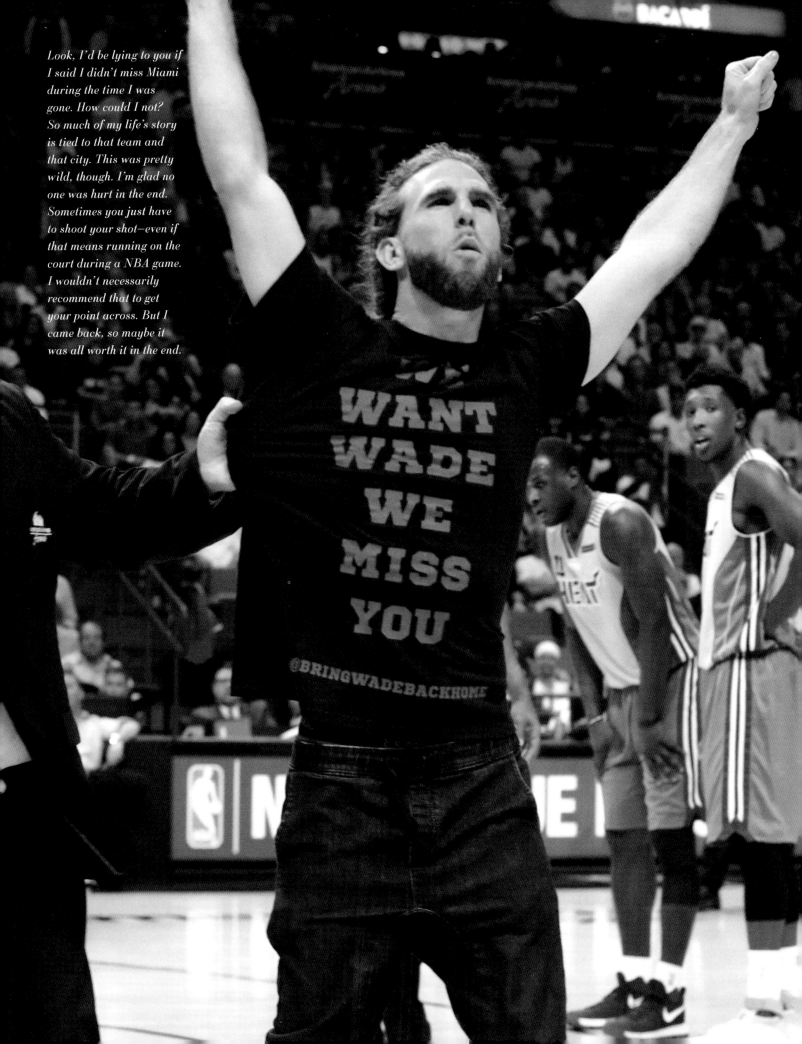

Look, I'd be lying to you if I said I didn't miss Miami during the time I was gone. How could I not? So much of my life's story is tied to that team and that city. This was pretty wild, though. I'm glad no one was hurt in the end. Sometimes you just have to shoot your shot—even if that means running on the court during a NBA game. I wouldn't necessarily recommend that to get your point across. But I came back, so maybe it was all worth it in the end.

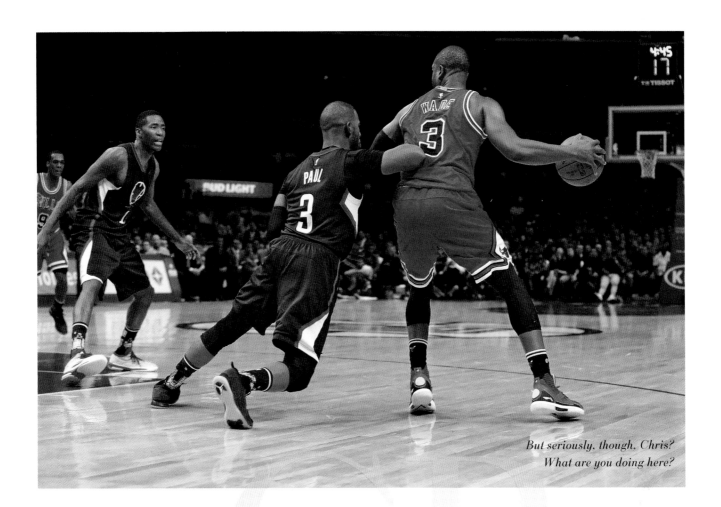

But seriously, though, Chris?
What are you doing here?

C'mon now, Chris. REALLY?

Chris Paul is one of the fiercest competitors I've ever played against. That sounds like standard athlete talk, but I promise you it's not. He'll do anything to win, and that's not just in a game. That's in practice, shooting drills, playing cards—whatever. C.P. and I bonded through our faith and sense of family. He's definitely that little brother who hates to be the little brother.

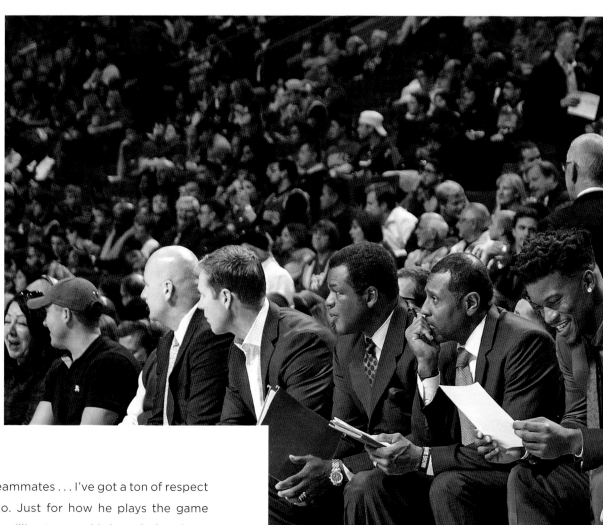

From rivals to teammates . . . I've got a ton of respect for Rajon Rondo. Just for how he plays the game and how he's so willing to pass his knowledge down to younger players.

There was one time after a loss against the Hawks in January. We blew a double-digit lead and I'm sitting in the locker room mad as fire. We were a talented team, but there were a lot of young dudes on the team and I felt like we didn't take losing seriously enough. I lashed out in the media, and it's something I regret. I apologized to my teammates. It was one of those moments where emotions boiled over. I've laughed and joked plenty of times after losses, but I wasn't thirty-five either. I felt that pressure then and I really wanted to do something special for the Bulls and the city of Chicago. It was just one of those times when emotions got the best of me.

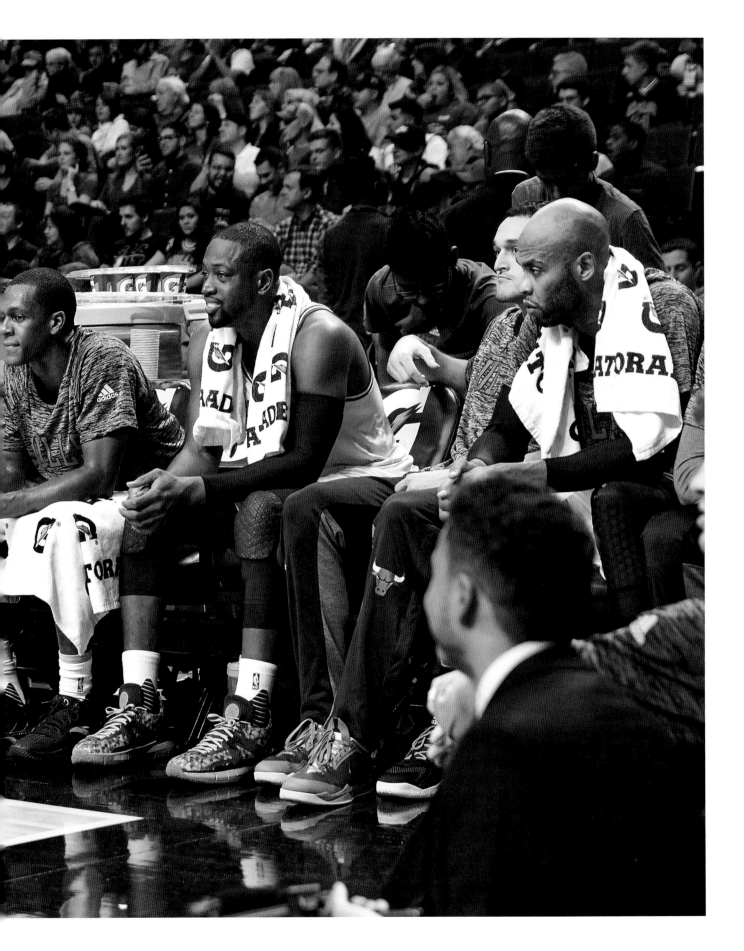

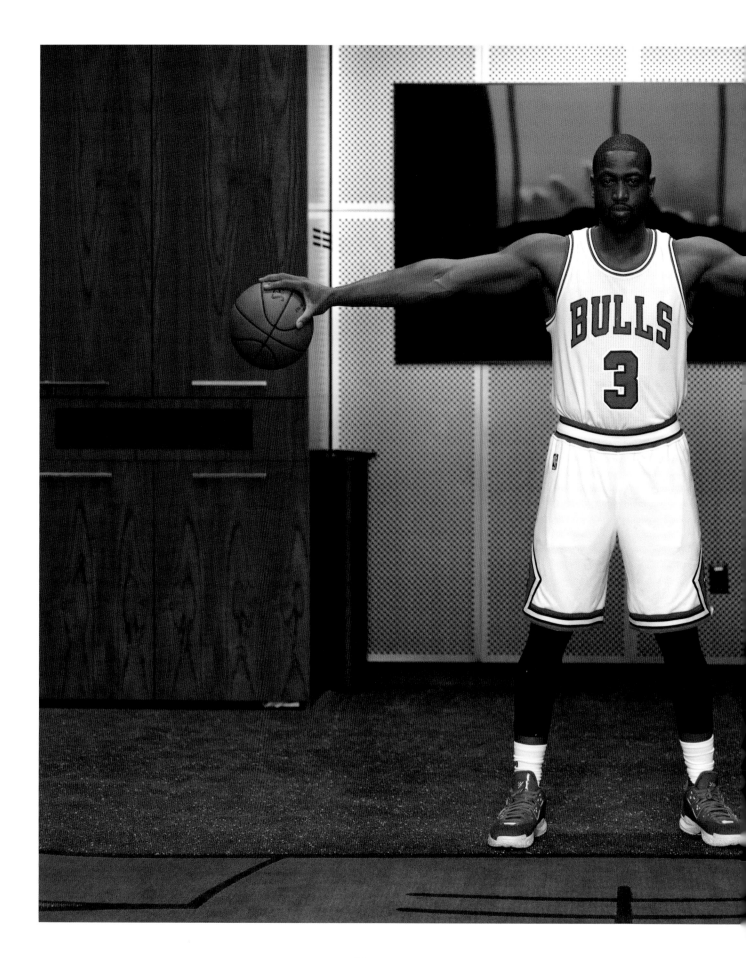

I'm a kid from Chicago who watched Jordan, Pippen, Rodman, and the Bulls on WGN. Look at this picture. A Chicago kid got to play under those United Center lights wearing this jersey. I don't have any regrets about Chicago. None. It's dope to say I played at home for at least one season. Even beyond the ups and downs, highs and lows of that season, I thought about all the memories of just dreaming of wearing that red-and-white Bulls uniform.

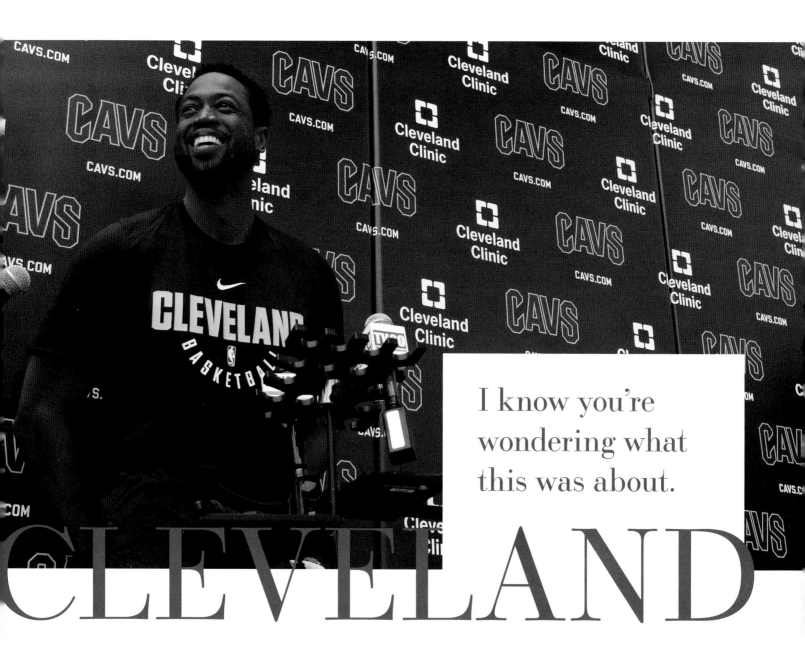

I know you're
wondering what
this was about.

CLEVELAND

The very brief Cleveland stint. I was happy to be hooping with LeBron again. The fans were great and the energy in Quicken Loans was crazy every night. But the elephant in the room was one everyone knew—including you reading this. I was never going to be wearing a Cavs journey for long. It didn't look right, and to be honest with you, it didn't feel right either. But I do appreciate Cleveland for bringing me clarity on how I knew I wanted to end my career.

Whatever happened that led me to leave Miami in the first place was in the past.

Right before the trade deadline in 2018, I got traded from the Cavs back to the Heat. After a season and a half away from Miami, I was back. And back in the familiar chaos that is the playoffs.

There was a lot of stuff going on in my life at this point. Hank had passed away in January, and I was still coping with that. When you lose someone who has helped you make so many important decisions, someone who's seen you grow up, everything feels different. Including basketball.

That second run with the Heat was exactly what I needed—but more importantly, what my family needed.

I WAS BACK

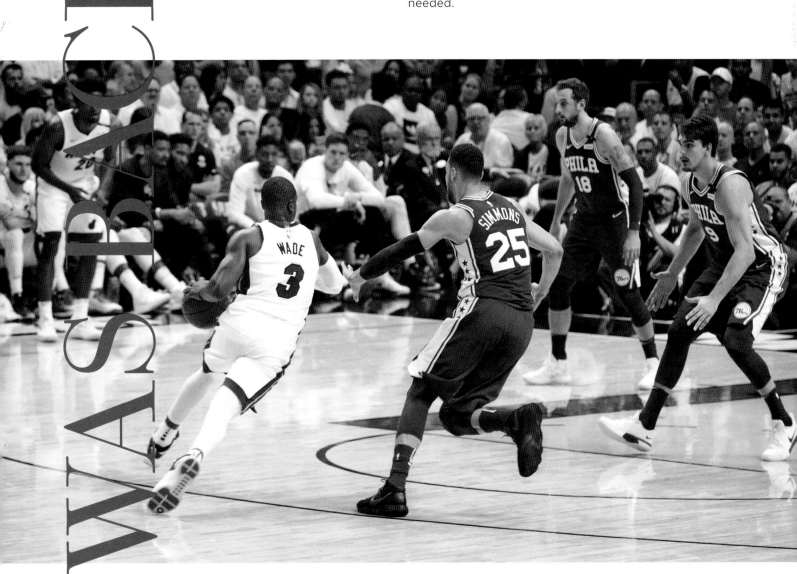

When I look at this picture, all I can see is I'm just happy to be back home. I felt rejuvenated.
I found that peace again.

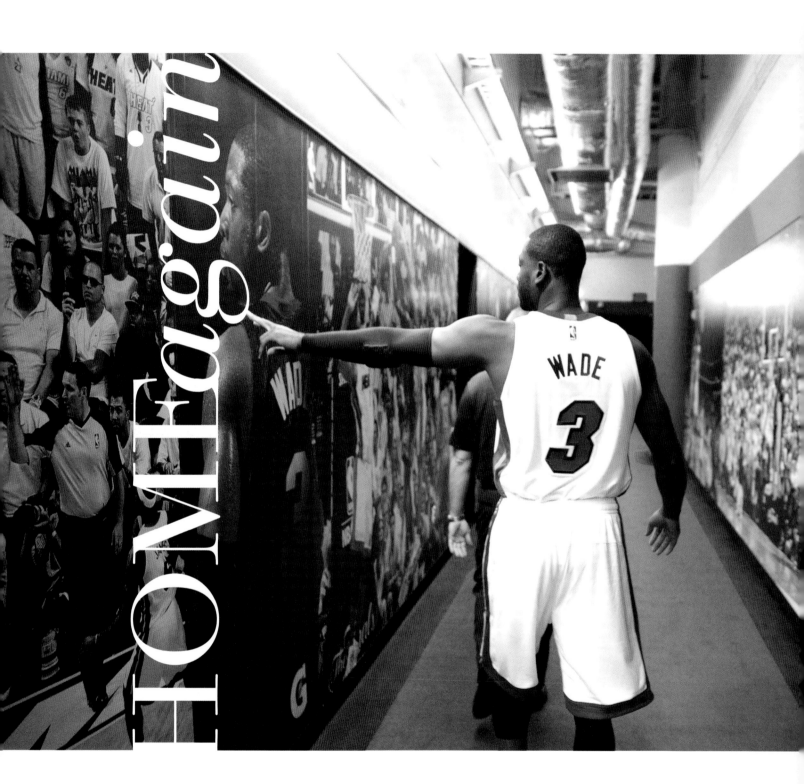

HOME again

MY GAME

Before we hit the locker room for halftime, I'm going to give you a little insight into some of my favorite parts of my game. Now that I'm retired, I can reveal some of my secrets—so get those pencils out.

Giving credit where it's due has never been an issue for me. But at some point I started hearing "that's the Dwyane Wade move." Over sixteen seasons, I lost count how many head fakes I did that allowed me to get to the free throw line. Of all the stats that are kept in basketball these days, how is that not one of them?

Regardless, that was a huge part of my game. It was a perfect storm in a lot of ways. Make a drive to the basket, stop on a dime, give an opponent that head fake, and next thing I know I'm at the line. It was beneficial in a lot of ways. It got my opponent in foul trouble, which means I was getting in their head.

It got me to the free throw line—and who doesn't like free money? It was also a cool way to catch a breather without having to come out of the game. But as much as I made a living off that, I can't take credit for it because I learned it from Sam Cassell.

Sam was hooping for the Milwaukee Bucks around the time I was at Marquette. My jump shot wasn't as lethal as my quickness, so I decided to try something out. I saw Sam do the move countless times with success. I began implementing that in my game—and defenders began biting on the fake. I saw the look of disappointment on their face in the air knowing they just got baited into a foul. I carried that with me into the league and ended up making an entire career out of it. So, while I appreciate people calling it a D-Wade move, I have to salute an OG who came before me.

EURO STEP

There's a sense of power when you've got an opponent backpedaling and they're wondering what the hell is about to happen. At that point, my only responsibility was to pick the poison I wanted to use. The Euro step was one of my favorite tricks.

When I came into the league, Manu Ginobili was seen as the guy when it came to that move. Honestly, it was well deserved, because Manu was sick with it. Allen Iverson was, too. I incorporated the move into my arsenal just because of the freedom it brought me in the open court.

My personal favorite?
Hitting Kevin Garnett
with it during the
2011 playoffs.

DEFENSE

I always took defense as a challenge. That's because I love defense. For the record, I still believe I should've won Defensive Player of the Year in 2008–09. I loved getting in my defensive stance and looking an opponent in the eye. Scoring was always fun, but stopping a person from scoring came with its own sense of pride.

You're not getting this bucket right now and it's nothing you can do to change what's about to happen. Half of the time, I was reminiscing back to the days when my dad was teaching me how to play the game. I couldn't allow my opponent to score. And if they did, I damn sure wasn't going to make it easy on them.

MID-RANGE

I was never really known for my three-point game, but my mid-range game was money. When I entered the league, the mid-range game was the bread and butter. Because I had so many other parts of my offensive game that I felt defenses had to always be on guard for, being able to knock down jumpers on a consistent basis helped take me from an offensive threat to offensive nightmare.

Off the glass, from the elbow, baseline—I could get it from anywhere on the court. I worked hard at that, too. That came from hours, months, and years in gyms with no one watching.

GOING BY YOU

Back when they called me "Flash," it was nothing for me to get to the basket. I could do it almost at will. I knew it. The defender knew it. And the crowd knew it.

As time went by, I was no longer that young dude whose athleticism was the big joker. I had to rely on a mental approach to the game. There's little giveaways that a defender will show that helped me get by them. The split-second lookaway. How they positioned their feet. Anticipating a screen that may or may not ever come. The moment they stopped focusing on me I was already gone.

CHALLENGING SHOT BLOCKERS

Fearless. That's the main quality I had to have if I was going to make a living going to the basket. Shot blockers live on intimidation, and swatting a guy's shot into the third row. I played against some really great ones, too, like Dwight Howard, Rudy Gobert, Serge Ibaka.

Basketball is a game of split-second decisions, and when you're going up against a shot blocker it's even more so. But the good thing is I had a bag of options. First, I'd look for the angle because if I could get that then more often than not I could get

the bucket. If the angle didn't work, then I'd take the more physical route—using my body to eliminate their shot-blocking ability. And then sometimes a head fake would do the trick.

The game is the game because, while I got the better of shot blockers a lot of times, they also got me as well. But at the end of the day, I knew they'd be there waiting on me, and they knew I'd be right back. There's this unspoken respect that forms along the way.

BLOCKING SHOTS

I consider myself a humble guy, because I am. For the most part. But not when it comes to this. As it relates to blocking shots as a guard, I'm the GOAT. The best to ever do it. The king of the hill. Whatever lingo you want to use, in my sixteen-year career combined in the regular season and playoffs, I tallied more blocks than any guard who has ever played the game.

And why am I so proud of that, you ask? Two reasons. First, the same way I spoke of the tactics of challenging shot blockers—I used that same mentality when challenging shots on my own. I got the reputation around the league of a guy who would block shots whether it be in a one-on-one situation, chasing down on a fast break, or playing help defense. That type of stuff stays in a defender's head. They had to know where I was on the court at all times. Secondly, I passed Michael Jordan to get to No. 1 on that list.

———————

How many people can ever say that?

ALLEY-OOPS

Arguably the most famous photo of my career is the one of me and LeBron in Milwaukee. You know what I'm talking about. The one where I have my arms extended and LeBron's behind me dunking. That wasn't a lob, but it became symbolic of a part of my game I'm still proud of to this day.

Combining the regular season and playoffs, I tallied 6,571 assists in my career. It feels like at least a fourth of them came off lobs. There aren't many parts of the game that can command the emotion of not only the crowd but also the players on the court than an alley-oop. To have that unspoken communication with a team to see a play before it happens is dope. But here's the thing about lobs—they're nowhere as easy as they look. It's not that the pass has to be perfect, but as the person throwing the alley it's on me to put the ball in the right place.

———————

It's a very thin line between a SportsCenter Top 10 highlight and Shaqtin' A Fool.

HALFTIME

Maintaining focus on the task at hand is oftentimes the difference between winning and losing. I know. I've been in Boston in must-win games when the crowd is directly on your back praying on my downfall. And I've been in Game 7's versus San Antonio and their multiple Hall of Famers. It doesn't matter that I'm retired now. I still carry that attitude when I'm working on projects. What's a life with all work and no play, though? Because I'm so competitive and because I'm always thinking "What's next?" it's important that I pull myself away and realize how blessed I am. It's about taking a step back and taking in life for what it really is.

LIFE

IS ALL ABOUT

BALANCE

Memories are life's currency. I'm grateful for the places I've been and the people I've met along the way. Why not take a break to showcase a small bit of the moments in life that even had me saying, "Wow, I can't believe this shit is really happening right now."

Life is all about the experiences we create and the memories we make that we can take with us.

Basketball has opened countless doors for me. It's taken me places that, as a kid growing up in Chicago, I couldn't have imagined. I've shaken hands with presidents, won a gold medal in China, and been name-dropped in songs. Throughout this chapter, you'll get a glimpse of some of my friendships with some never-before-seen photos with some people you just might recognize. The talent range is diverse, too. There's comedians and ball players, fashion icons and talk show hosts, rappers and legendary TV personalities. Enough talking, though. Let's get started with a man who truly needs no introduction.

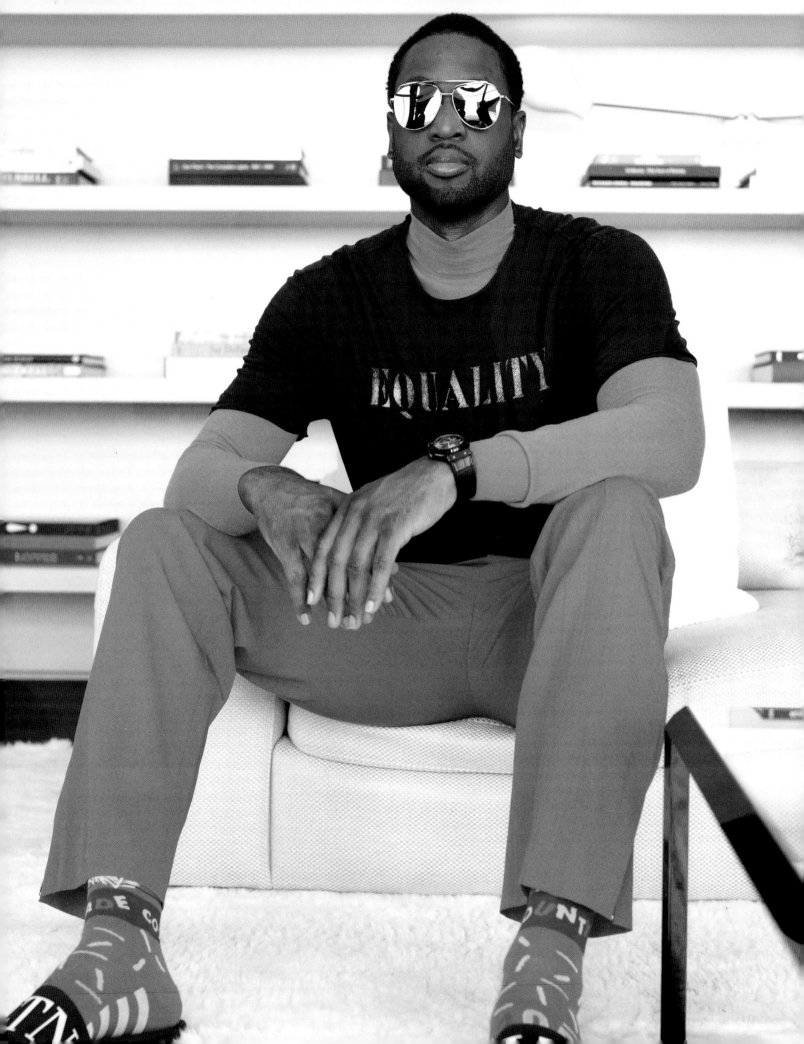

FASH

When it comes to fashion, I'm not afraid to take chances.

My whole logic is, as long as I like the look, why not?

The far left picture is from 2016 All-Star Weekend in Toronto, and if you know anything about that city in February, you know you need about five of those fur coats on. I was channeling my inner Frank Lucas from *American Gangster* with that coat. Thankfully, my professional career ended a lot better after wearing that fur coat. When I'm not doing that, I love the casual look of the second pic. You couldn't tell me I wasn't fly. I mean, you could, but you'd be wrong!

FASHION WEEK
was a movie.

I ran into so many people there. Usher's been my guy for a long time, and to make a basketball analogy, 8701 into Confessions is one helluva alley-oop combo. Anyway, it's always dope linking with Usher because we find ourselves chopping it up on a ton of topics from fatherhood to business, basketball, and damn near everything else under the sun.

That's myself, Kanye, and Virgil Abloh. Yes, the same Virgil Abloh who's a fashion institution now, the man behind your favorite Off-White sneakers and the artistic director of Louis Vuitton's menswear. But in 2011, I didn't know him too well. I thought he was Kanye's assistant!

OK, story time. We're at Fashion Week, and to be quite honest, I needed the trip to clear my mind. This was during the lockout, and after our loss to the Dallas Mavericks in the 2011 Finals.

One of the first people I ended up running into was Kanye. What you don't see in that first picture is him holding a Mavericks hat! He saw me walk up and he was like, "Oh, shit!" and he's trying to hide the hat. We laughed and I gave him a hard time, but that's when the second picture happened.

Kanye gave me Virgil's number, saying if I needed him for anything to just contact Virgil. I was like, "Yo, I need a barber!" Virgil made it happen. Later, my photographer Bob—the one behind a great majority of the pictures you see here including these—ran into Virgil on an elevator. Virgil was like, "Come up to the room. We're listening to the new album."

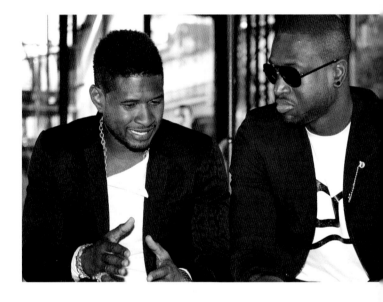

We're staying in the same building, but I'm like, "Man, I'm not going up to the room!" Keep in mind, we're in Paris, and they were playing the music loud as hell. I knew if I went we'd be there all night and jet-lagged doesn't have a pause button. Meanwhile, Bob's like, "Man, why not?! That's Kanye!" Mind you, neither of us knew the album they were playing was *Watch the Throne*. Now if they would've told me, "Yo, we got your name in one of these songs. You might wanna come down," then I definitely would've changed my mind. Less than a month later, *Watch the Throne* dropped and the rest was history.

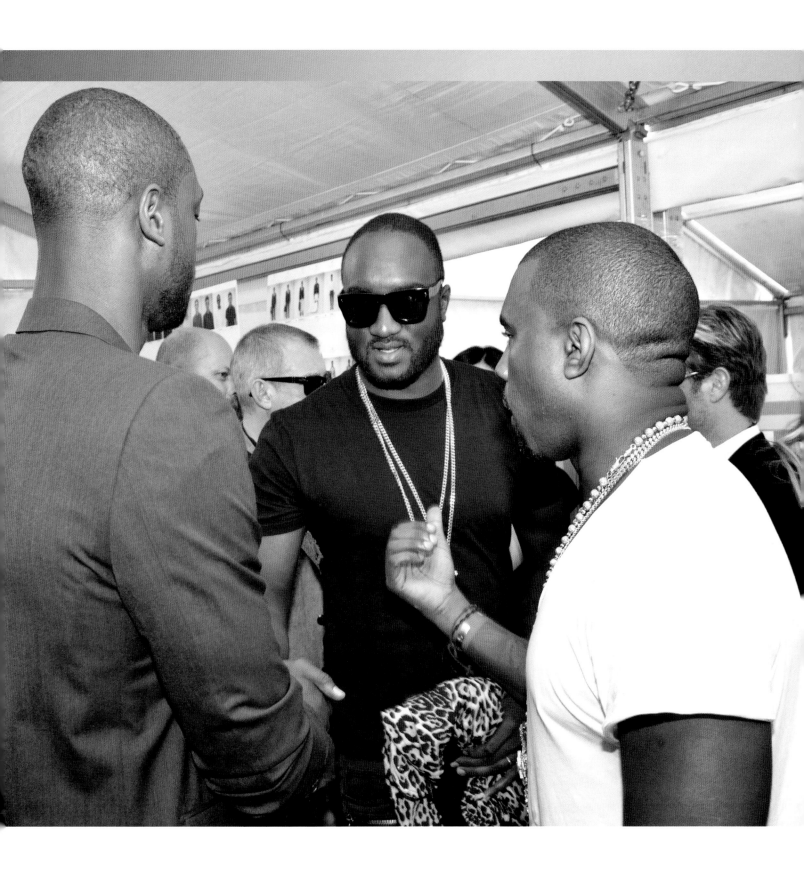

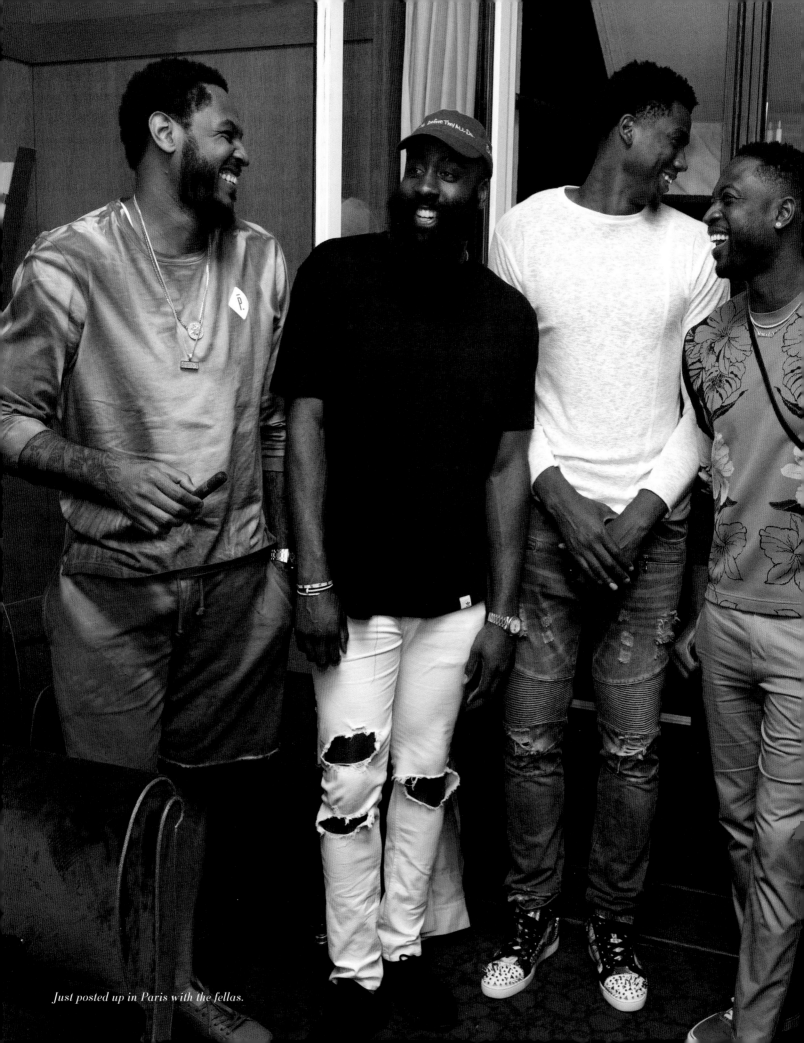

Just posted up in Paris with the fellas.

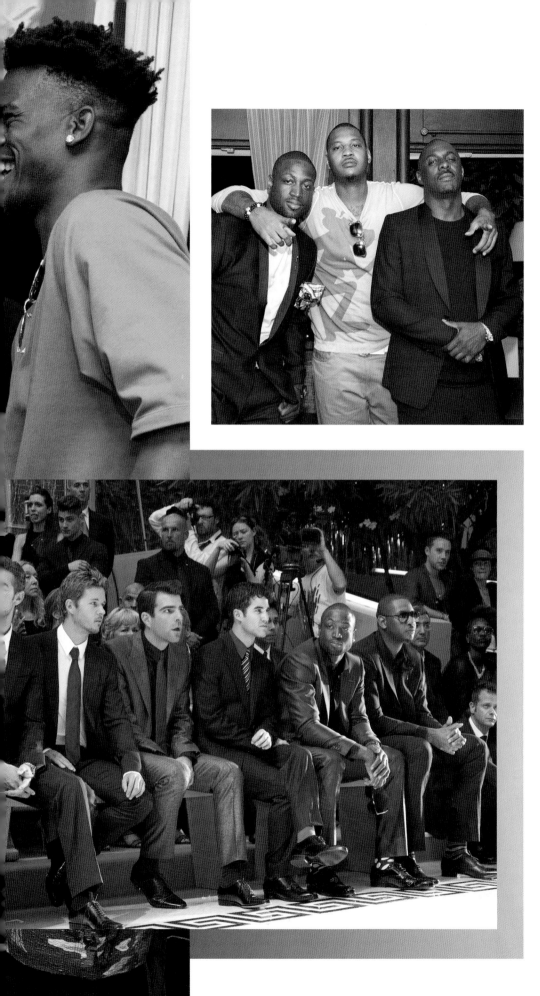

'Melo and me with the real-life Black James Bond during Fashion Week in Milan.

In the summer of 2011, 'Melo and I went to Milan for Fashion Week. We saw Idris one day at the Giorgio Armani show. Myself, 'Melo, and the team had a dinner planned for later that night. 'Melo told Idris to pull up on us at the spot where we'd be eating. We just had a dope-ass night from there.

My thirtieth birthday was a movie! How they flipped it on was fire. It all started out with a surprise birthday brunch where all of my family came to town to surprise me. One of my fave songs was "Open Up My Heart" by Yolanda Adams, and guess what? She was there to surprise me too with that song. Best of all was Willie Mae Morris. That's my grandmother. She had never been on a plane before that! I couldn't have asked for a better birthday. We all still talk about that night eight years later.

The next night was a birthday dinner for thirty of my closest friends and family, followed by an epic celebration at the Setai Hotel on South Beach. We ate great, popped bottles, partied all night—basically exactly how you'd want to celebrate a birthday of that magnitude. I walked away with a bottle of Dom Perignon from 1982 and a 2012 McLaren. Rick Ross, Common, and T.I. all performed. Kelly Rowland sang me "Happy Birthday"!

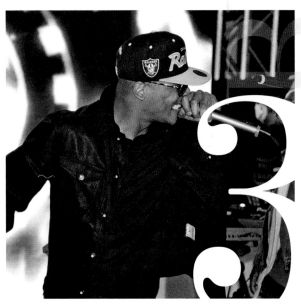

CELEBRATIONS

30

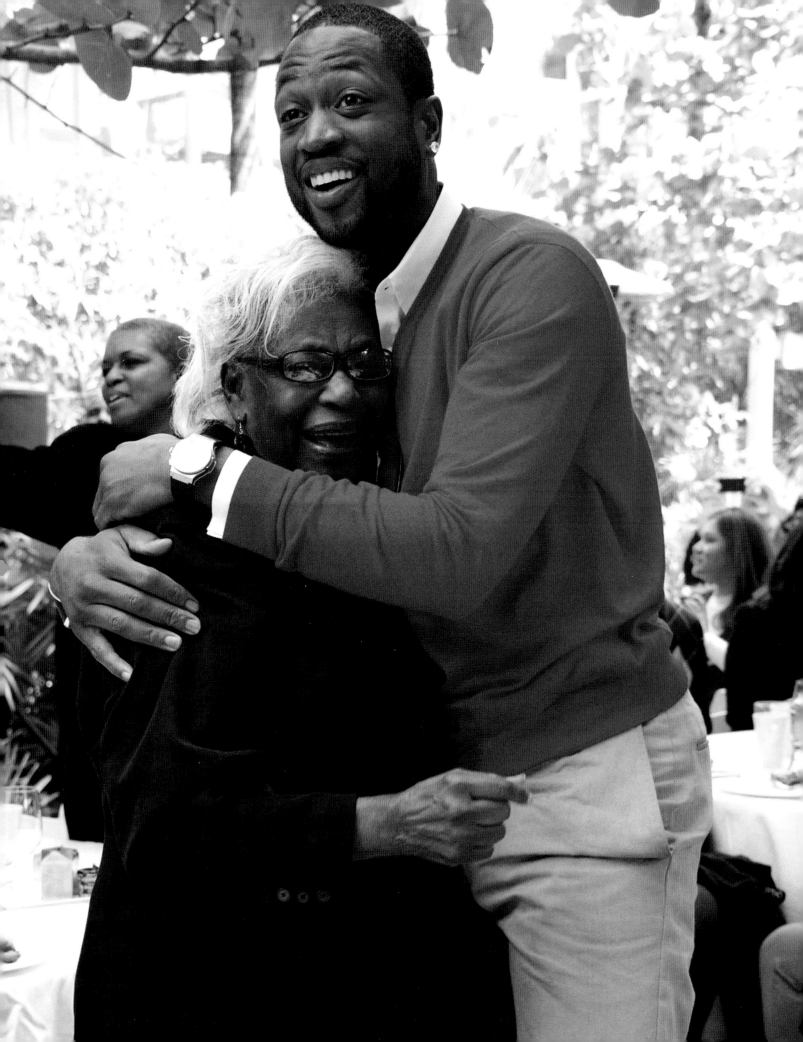

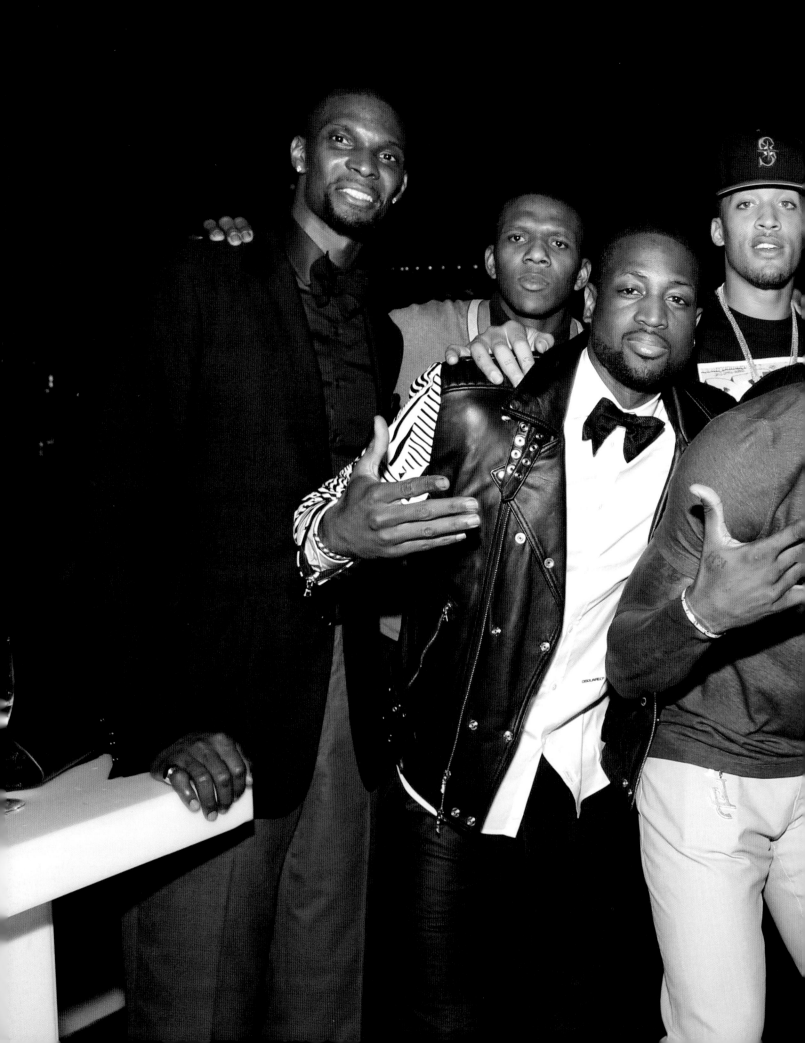

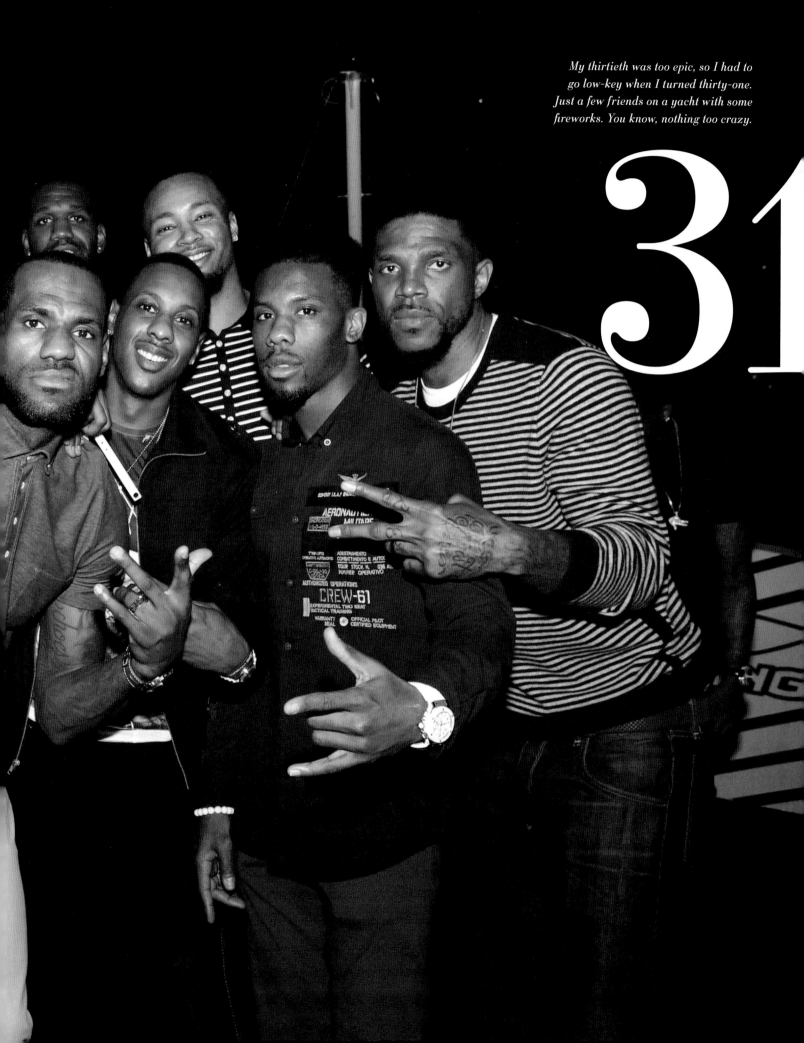

My thirtieth was too epic, so I had to go low-key when I turned thirty-one. Just a few friends on a yacht with some fireworks. You know, nothing too crazy.

31

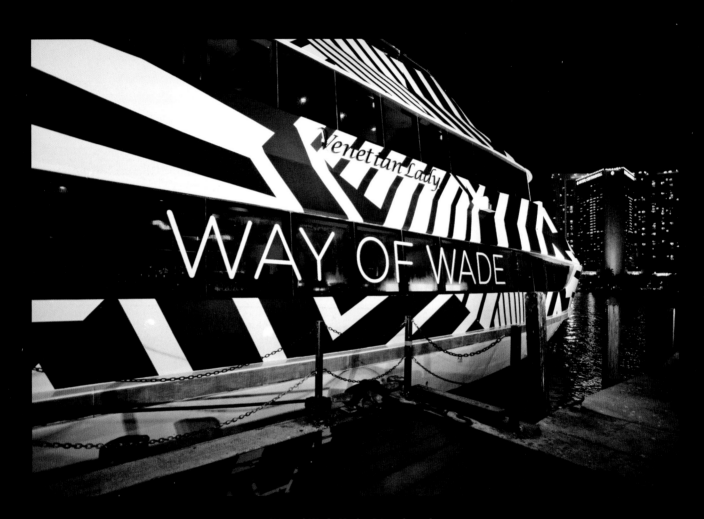

Way of Wade Yacht. It's only right.

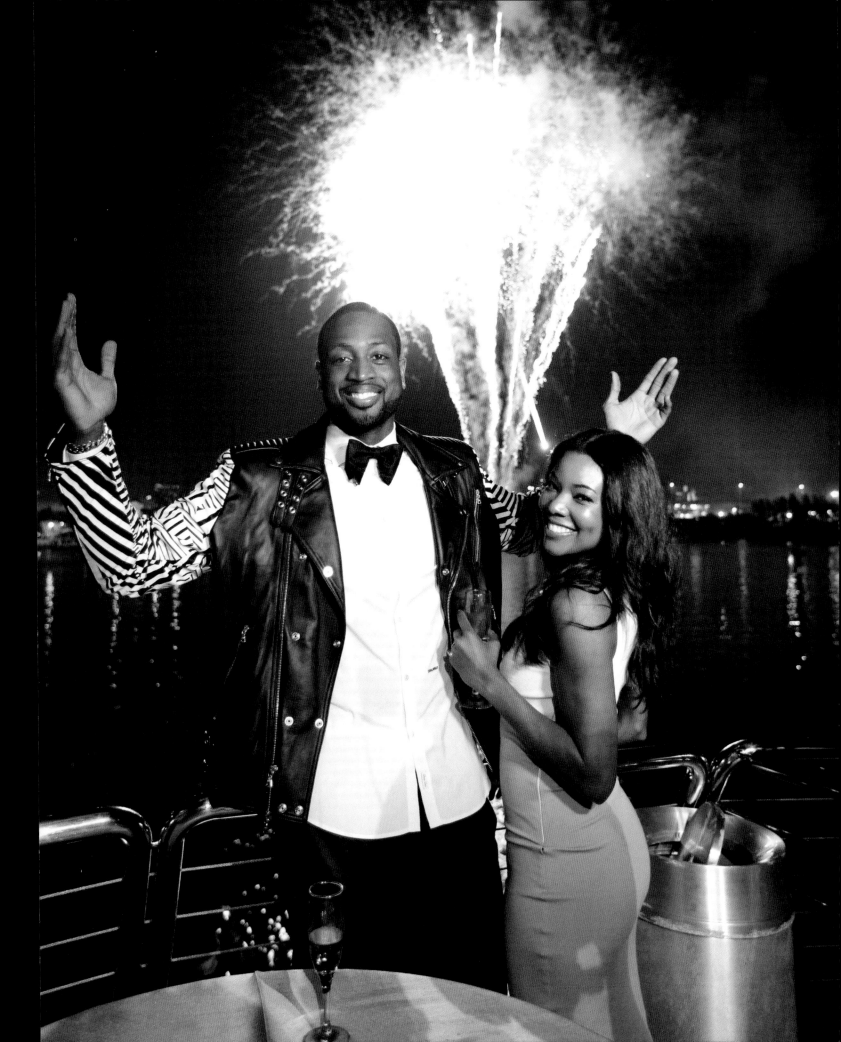

CHICAGO

I love my city with all my heart. I swear I do. But I didn't want to celebrate my thirty-fifth birthday in Chicago. Keep in mind, my birthday is January 17, so you can guess what the weather felt like in Chicago then. Plus, do you understand how crazy I sound asking my friends to leave Miami in the dead of winter to come to Chicago? I thought that birthday was going to be a dud.

But leave it to my team to make the impossible look easy. Just like my thirtieth birthday and every celebration, they showered your boy with love. This year was no different. We couldn't just have a party either. That's not how we move. There had to be a theme. That year's was Bad and Bougie. Harold's Chicken wing buckets and all.

God bless the women God blessed my life with. Here I am surrounded by my sisters Keisha, Tragil, and Deanna, my mom, and Gab. Shout-out to my brother-in-law, too. But these women have protected me, believed in me, loved me, and made me feel like I could accomplish anything I ever set my mind to throughout my life. There's no amount of money that can ever repay genuine love. I'm the wealthiest man in the world in that regard.

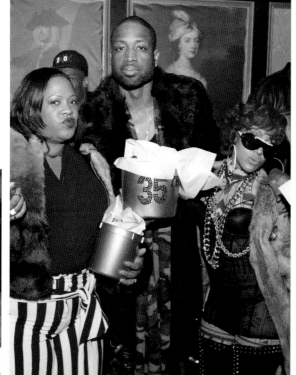

The Chi-Town OG, Twista and Do or Die, came through with a surprise performance. They were the soundtrack to my Chicago years growing up. How many of y'all know about "Po Pimp"?

There's no better feeling than being surrounded by family.
My brothers Demetrius and Donny.

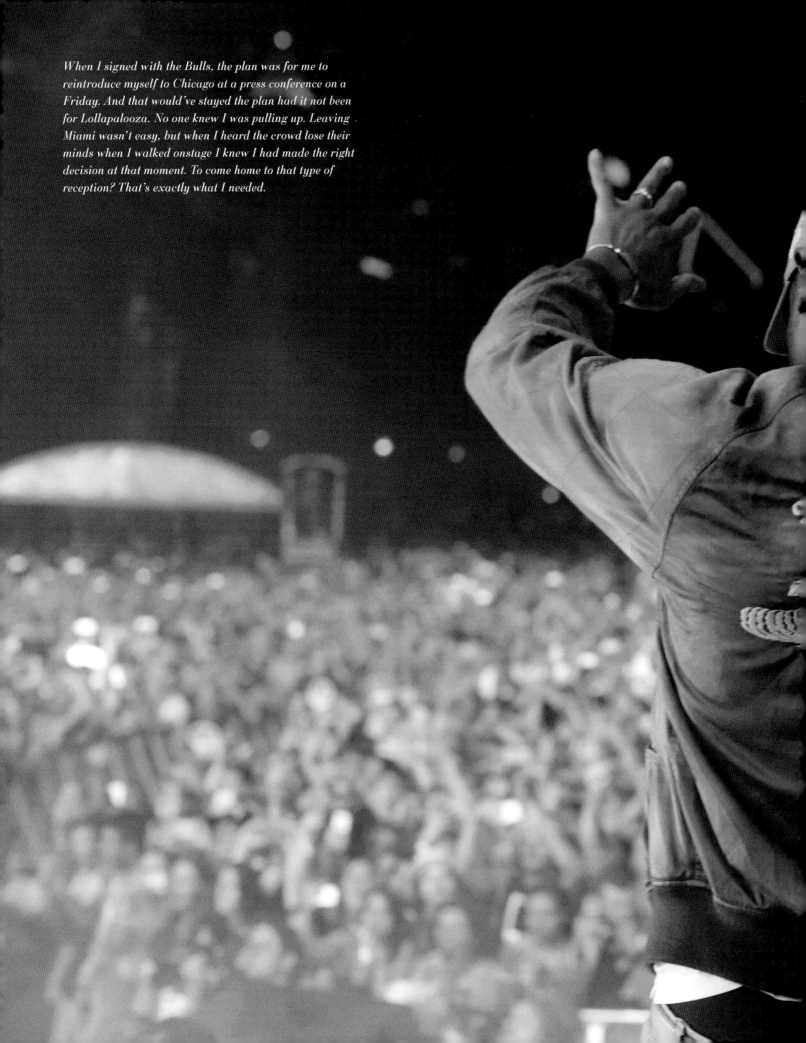

When I signed with the Bulls, the plan was for me to reintroduce myself to Chicago at a press conference on a Friday. And that would've stayed the plan had it not been for Lollapalooza. No one knew I was pulling up. Leaving Miami wasn't easy, but when I heard the crowd lose their minds when I walked onstage I knew I had made the right decision at that moment. To come home to that type of reception? That's exactly what I needed.

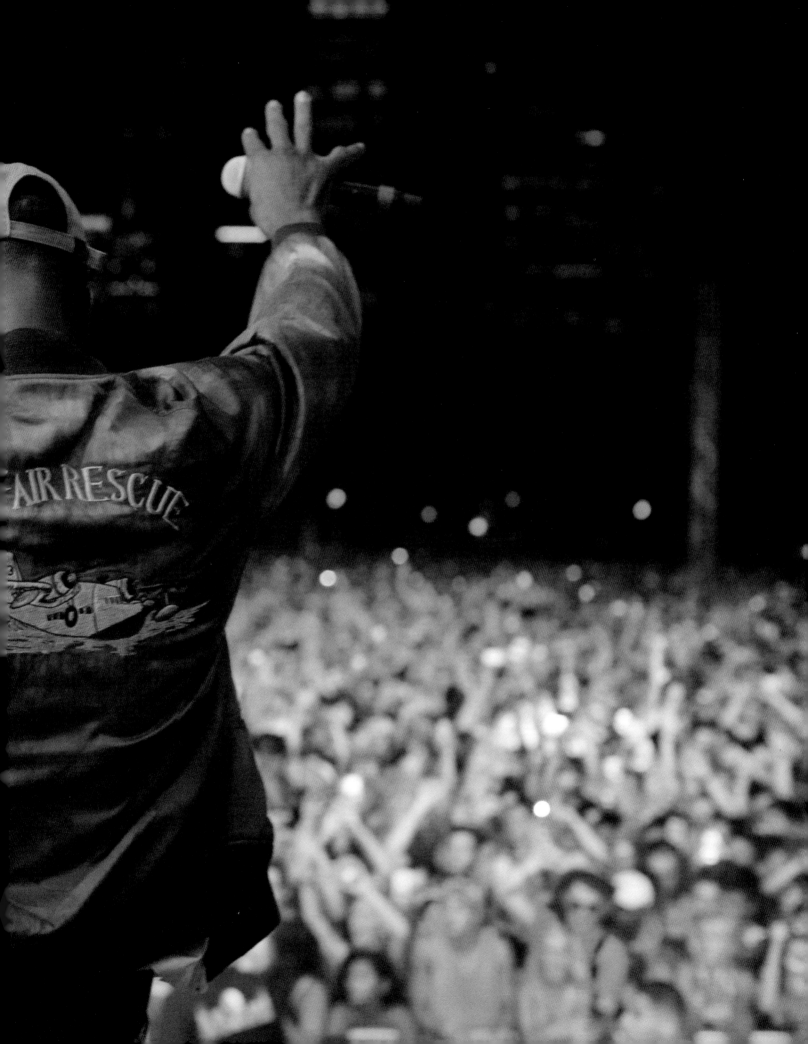

I used the word "blessing" a lot because I am
BLESSED

And to be able to say I spent time with the late Stuart Scott is a blessing. Here we are, almost a decade ago, on a panel discussing the business of sports.

Stu made sports better. Period. He made the experience more enjoyable and gave every sport, not just basketball, a voice that was absolutely needed. There weren't many people in his line of work who looked like him at the time. As a player, you wanted Stu to call one of your highlights. It was a status symbol, like being name-dropped in a Jay-Z song. Something that said, "I made it."

When we won the title in 2012, Stu was there on the podium with us to document the moment. It doesn't get any better than that. Stu's voice, charisma, and delivery had always been part of the soundtrack of my life. Now he was there at the mountaintop with me.

Today, being retired and beginning to immerse myself more and more in that world, I've gained an even deeper admiration for Stu. This isn't something he just woke up every morning and did. He made it look effortless because he put in the effort. This was his craft. He put in years of hard work and dedication that the world would never see, only to be ready when the lights cut on and the cameras were rolling. That's not any different from what we as athletes did. And he was always as cool as the other side of the pillow.

MEDIA

I GUESS I'M ONE OF THEM NOW.

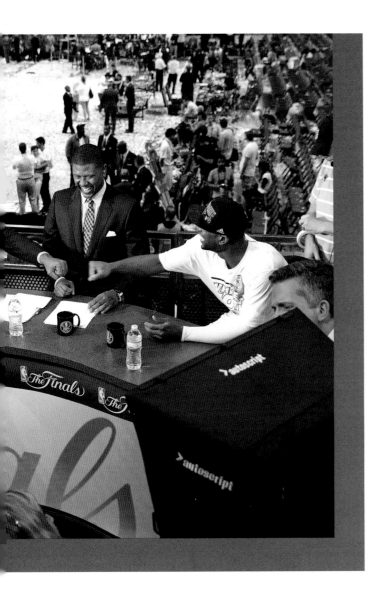

But already, it felt over the years like they had become my coworkers. That's wild. I didn't always agree with what they had to say, but I came to respect most of them, because their job is hard.

Take Rachel Nichols, for example. She's always getting the big interviews in the big moments because there's a big-time respect factor. We, as players, know she's going to ask the questions that matter, but more importantly, she's going to treat each story with the nuance and care it deserves. She's a true professional in every sense of the word.

Here, I'm pounding up Magic, a true icon. But also I have to give props to my guy and fellow Chicago native Michael Wilbon on receiving the Curt Gowdy Media Award this year from the Hall of Fame for his work in print journalism. Here's to hoping I can join him and Magic in Springfield in a few years.

RESS

I try to tell everyone
how much they mean
to me while they're
still here, because
I know one day they
won't be.

Dr. Jack Ramsay was a basketball savant amongst basketball savants. Hearing him talk hoops was a true thing of beauty because basketball to Jack was a religion.

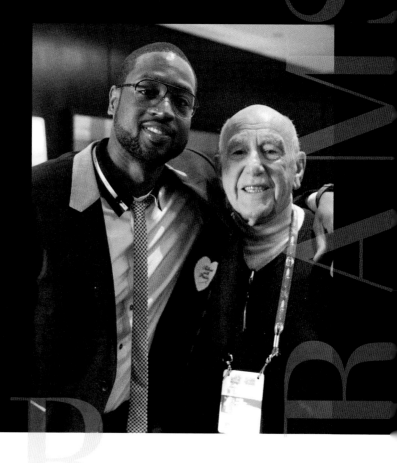

Then there's Craig Sager. People credit the NBA with being such a vibrant league because of the players, and that's true. But the NBA is a family, and Craig was that uncle you always get a kick out of seeing. If we as players always wanted Stuart Scott to call our highlights, we wanted to be interviewed by Craig right after a big win. He was a walking fashion statement, but he was also just a great spirit to be around.

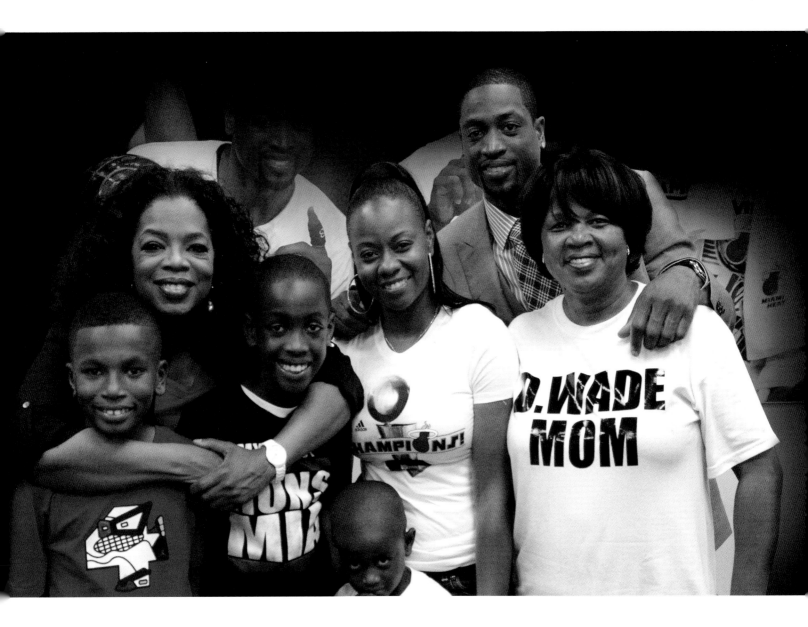

Growing up on 59th and Prairie and later Robbins, Illinois, Oprah was as much a part of daily life as Michael Jordan was. She's synonymous with the city. And while I never made it on her show, it was still a pretty dope moment to have my entire family meet her. Just look at my mom and sister's smiles. This is some real Chicago stuff right here.

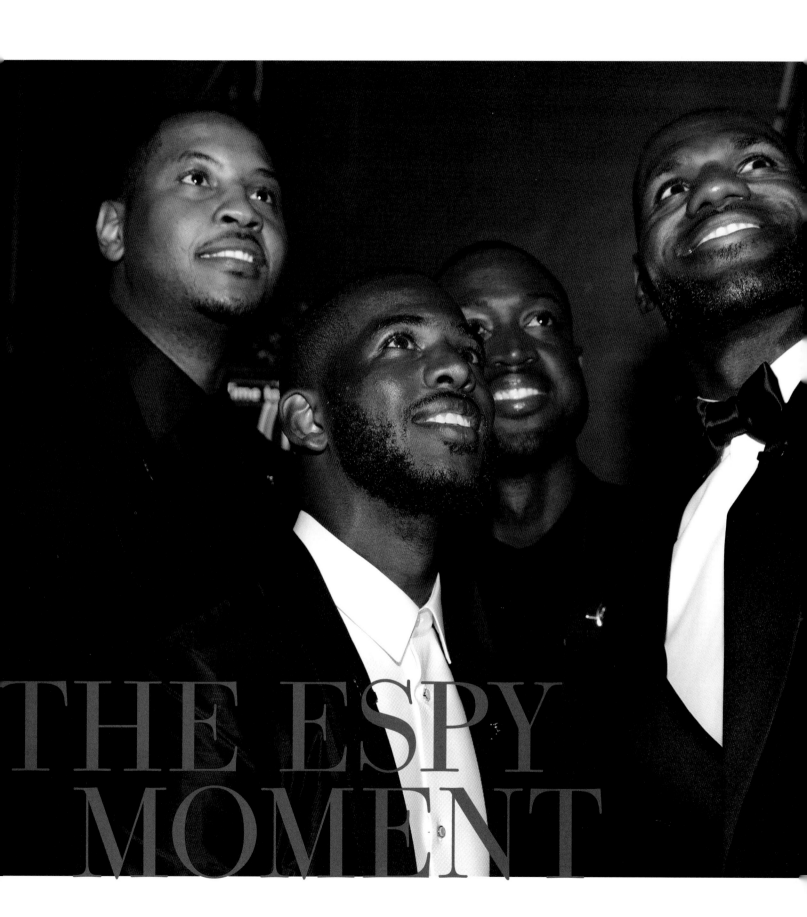

THE ESPY
MOMENT

Basketball brought us together. Loyalty keeps us together. Backstage at the ESPYs after giving a speech to our fellow athletes while the world watched.

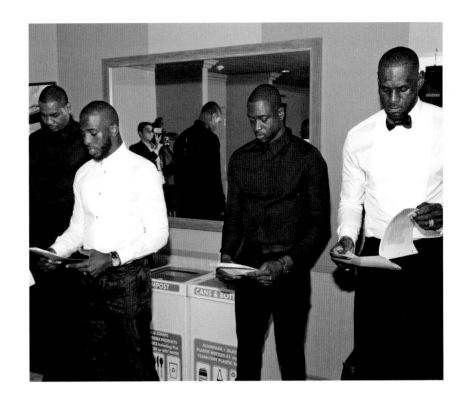

This was right before 'Melo, C.P., myself, and 'Bron went onstage at the ESPYs in 2016. So much was happening in America at the time, including Alton Sterling's and Philando Castile's deaths a week before the show.

It wasn't like police brutality, especially in Black and brown communities, was anything new. But people outside the Black community were finally starting to acknowledge it. Oscar Grant, Trayvon Martin, Mike Brown, Tamir Rice, Tanisha Anderson, Sandra Bland, Eric Garner, Freddie Gray, and Walter Scott. And Ahmaud Arbery, Breonna Taylor, and George Floyd from 2020. Life is bigger than basketball, and if these same people can support us for playing a game, it's part of our responsibility to speak up for them. It was always about being on the right side of history for us. We knew what we had to do.

The riots in Baltimore and Ferguson and the #SayHerName campaign impacted us on a profound level. This was right after the deaths of Alton Sterling and Philando Castile, too. We remembered how we felt when the Trayvon verdict was delivered because it could've easily been one of our kids. No amount of All-Star Games, championships, or gold medals could ever make us forget that anger and that feeling of helplessness.

It's no point in having a platform if we weren't going to use it for the right reasons.

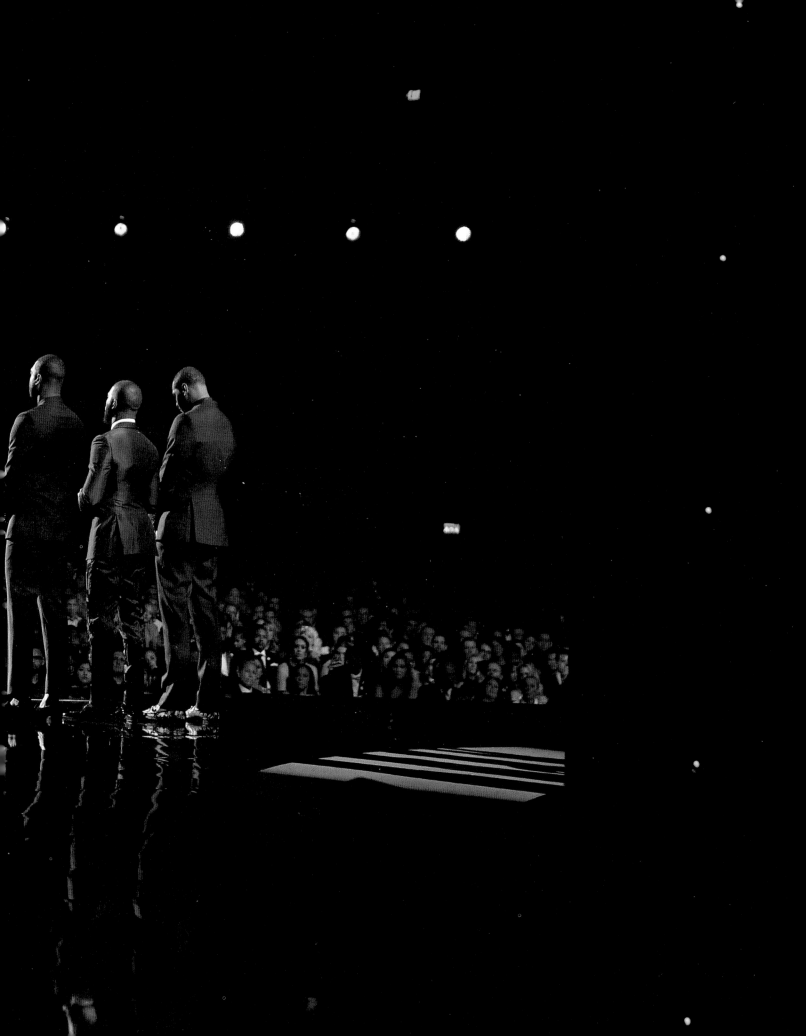

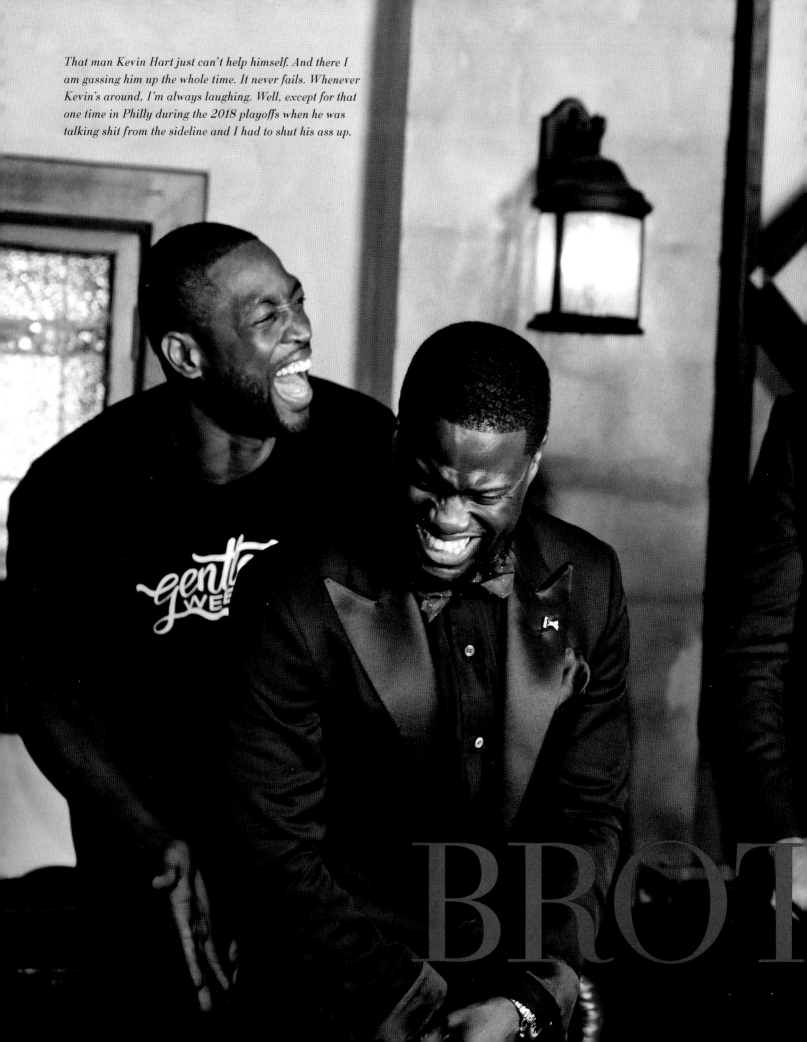

That man Kevin Hart just can't help himself. And there I am gassing him up the whole time. It never fails. Whenever Kevin's around, I'm always laughing. Well, except for that one time in Philly during the 2018 playoffs when he was talking shit from the sideline and I had to shut his ass up.

BROT

HERHOOD

Cleveland Cavaliers versus Houston Rockets, November 2017. C.P.'s purple jacket. LeBron's hat. It's a lot going on here. That's the thing about all of us. 'Melo isn't pictured here, but he, 'Bron, and I entered the NBA in 2003. Chris was drafted two years later. We all grew up in the league together. The one thing I'm most proud of is that we've always been there for each other. During our proudest moments and lowest times, we always had each other.

LAUGHTER IS
POWERFUL

And we always find a way to get a laugh in around each other. We just love being around each other. Straight like that.

But on a related note, you do realize there are over 116,000 combined points in this picture, right?

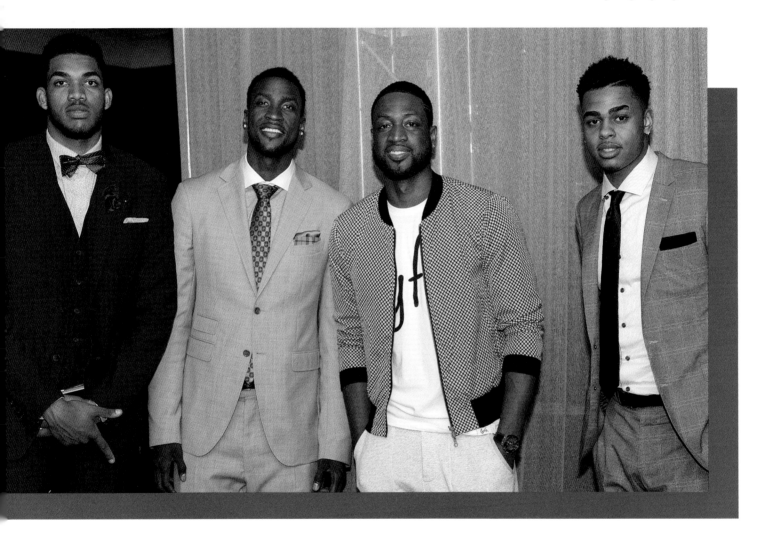

That brotherhood extends through the entire league. We're competitors. And we want to win every time we step on the court. Above everything, though, we know how blessed we are to be in the position to play a game for a living, impact millions, and do our part in changing the world in the process.

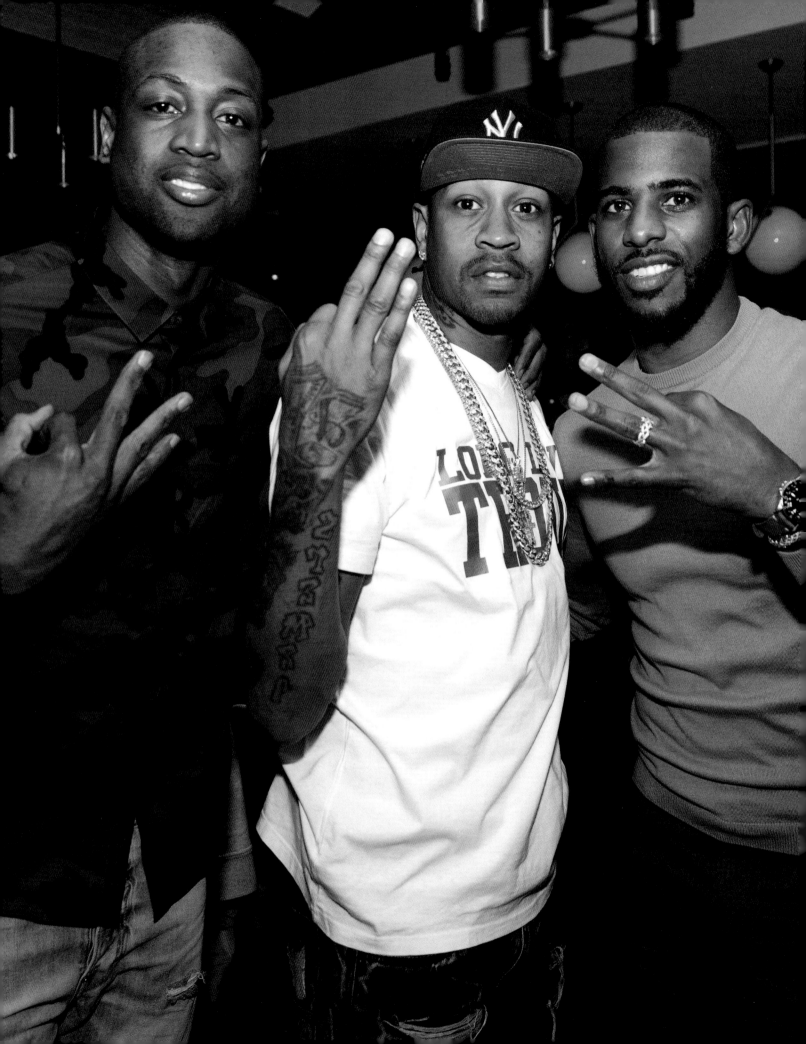

OK, there's a slim chance I might be biased, but I'm always going to tell you 2003 was the best draft class. But there's something really special about that class of 1996, too. A lot of real ones came into the league that year. I'm talking Marcus Camby, Shareef Abdur-Rahim, Stephon Marbury, Ray Allen, Steve Nash, Antoine Walker, Jermaine O'Neal, Peja Stojaković.

And you already know how I feel about Kobe. But I have to give just as much love and respect to my guy Allen Iverson.

We all love being around "The Answer." Bubba Chuck is like a real-life superhero.

One who went through really public highs, and some really public lows. One who's still here to tell his story. And one who changed the game that changed my life.

random
MOMENTS

Jamie Foxx is the most talented entertainer of my lifetime—but more importantly one of my favorite people. And, without question, the unanimous MVP of my Fantasy Camps that I hosted in Miami. This was for men over thirty-five who thought they had game. That was already going to be hilarious. But adding someone like Jamie to the mix? It's amazing I never passed out from laughter!

This wasn't my first time meeting Mike. But every now and then when you're around him, you find yourself thinking, "Bro, that's Michael Jordan!" Every kid around my age growing up idolized Mike, but it was different for us Chicago kids. We all ate the Wheaties and drank the Gatorade—some of us probably at the same time—because if that's what it took to be like Mike then dammit that's just what had to be done.

Growing up in Chicago, we all watched Mike on WGN at night, and then

the next morning you went to the playground and tried to pull off whatever new move he'd pulled the night before.

There's a funny story
behind this photo.

I was super excited because I was going to check out Yankee Stadium for the first time. To make the day even better, we had an early tip-off against the Knicks. We ended up beating them, and I balled out that afternoon with 28 points and nine rebounds. The game was over with more than enough time for me to make moves to the Bronx to check out the Yankees game. Tim Tebow had recently been traded to the New York Jets. We both got booed that night. Long live New York sports fans!

Competitors respect competitors, and winners recognize winners. Here's Formula One legend Lewis Hamilton and myself at New York Fashion Week in 2015. A year later, Chris Bosh, myself, and our wives took a European vacation. We even had a hashtag to document the experience, #boshwadesummer16. One of the most exciting things we did was catch Lewis winning the Monaco Grand Prix.

What's wild is how young both Steph and Cam look in these pictures. This is before both became future league MVPs.

Steph, 'Bron, and myself are three guys who really changed what basketball looks like, both in terms of how the game is played and what they now call "player empowerment." I don't think anyone knew at the time that right after our era in Miami would arise the juggernaut in the Bay with the Golden State Warriors, led by Stephen Curry. This is Steph before Steph became Steph. I remember 'Bron and I were joking with him about why he had to cook our point guard Mario Chalmers the way he did that night. I'd be lying to you if I said that I haven't thought about the "what if" possibility, though. What if the prime Miami Heat went up against those prime Warriors squads? That would've been one for the books.

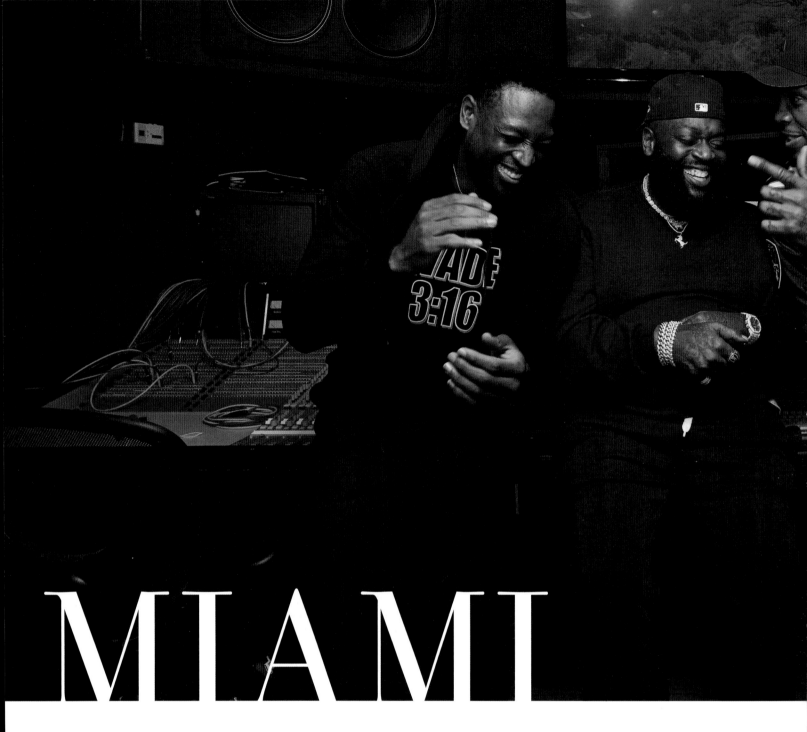

MIAMI
NIGH

Miami embraced me. South Beach, downtown—any 'hood in Miami, I embraced that love. My last season in the league was about doing things I've never done before. One of those things happened to be jumping in the studio with Rick Ross to record an ode to the city. Ross says there was no pressure in the studio session for "Season Ticket Holder." And there wasn't. I went straight in the booth and laid my verse. It's not that I was nervous, but being in the studio with one of the greatest rappers was a big moment for me.

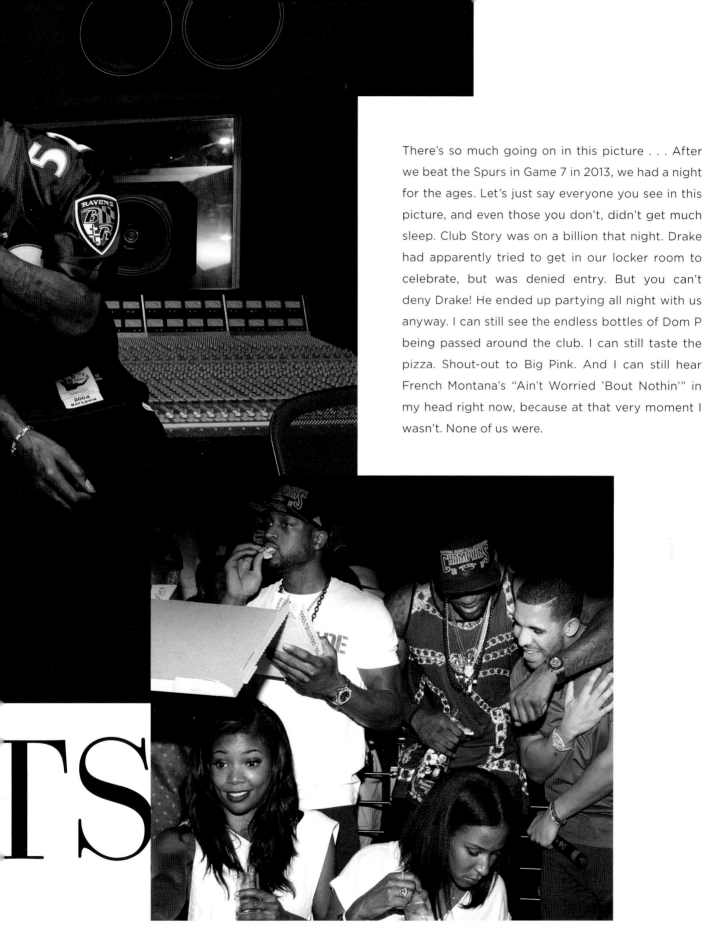

There's so much going on in this picture . . . After we beat the Spurs in Game 7 in 2013, we had a night for the ages. Let's just say everyone you see in this picture, and even those you don't, didn't get much sleep. Club Story was on a billion that night. Drake had apparently tried to get in our locker room to celebrate, but was denied entry. But you can't deny Drake! He ended up partying all night with us anyway. I can still see the endless bottles of Dom P being passed around the club. I can still taste the pizza. Shout-out to Big Pink. And I can still hear French Montana's "Ain't Worried 'Bout Nothin'" in my head right now, because at that very moment I wasn't. None of us were.

Post-2013 championship game party. South Beach. Club Story.
You haven't lived until you've eaten a whole pizza in VIP in the club.

The fact that I know whenever the culture of Miami is discussed my name will always be part of the conversation is deep to me. I didn't just play there. I lived there. I interacted with the community there. They helped pick me up on nights when I didn't have anything in the tank. In return, I gave the city everything I had until the very end.

THE 305

The 305 always shows me love, and it was no different in this picture. We were in the middle of the 'hood during Critical Mass, a monthly bike ride in Miami. I always loved participating in those because it just gave me a very real way to get out and touch the city.

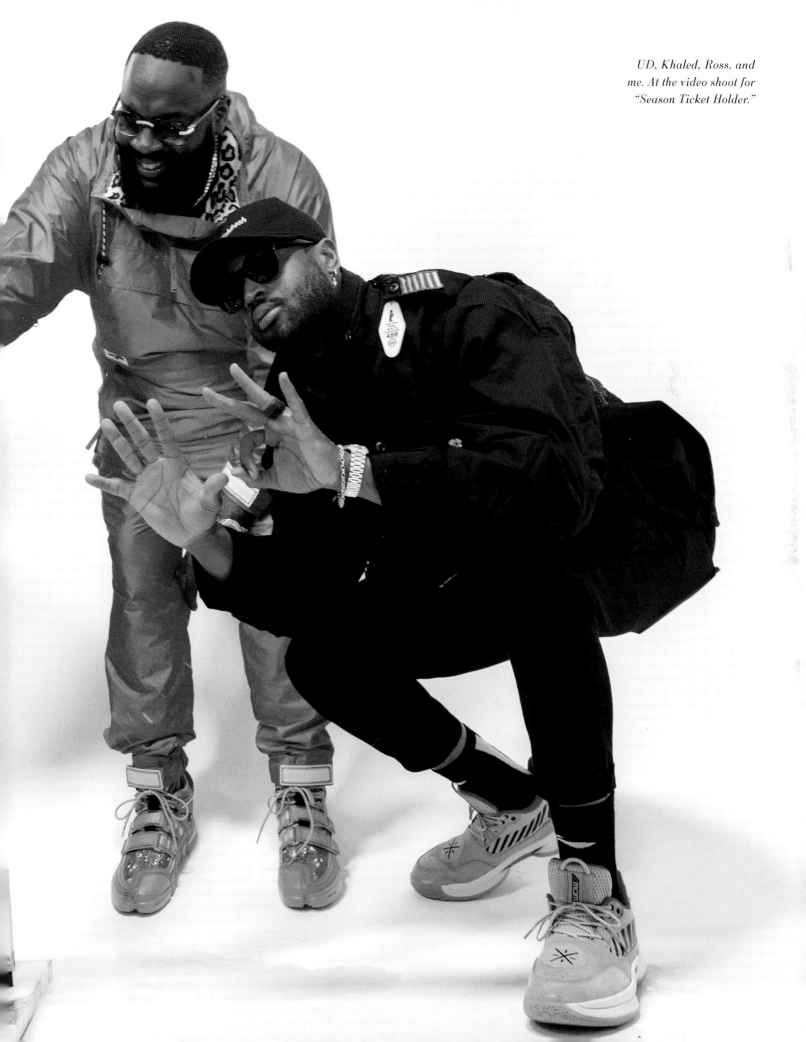

UD. Khaled. Ross. and me. At the video shoot for "Season Ticket Holder."

Coming into the league, Kobe Bryant was the benchmark. He was the competitor we all aspired to be. Even in retirement he was someone I looked up to, with how he moved to the next chapter of his life with so much grace and ease. He looked so happy pursuing the next stage of his professional life, but also so peaceful just being Kobe the family man. Life without Kobe doesn't feel real. I'm not sure it ever will. I don't know how it can.

KOBE

Finding the right words for a person who meant so much to so many is one of the hardest things I'll ever have to do.

On the court, I knew No. 8 and later No. 24 was going to bring it every night I stepped on the hardwood with him. There was no off switch with that dude— and that's one of the highest compliments I can ever give. I remember All-Star 2016 in Toronto like it was yesterday. We all wanted to honor him

for his last All-Star Weekend. I can still see Kobe walking into the room. His laugh still echoes in my head. I remember Kobe taking time during pregame shootaround to work with Zaire. I remember how awestruck Zaire was just to be on the same court with him. I remember telling Zaire, "You better go get your Kobe moment!"

It hurts that all my Kobe moments are now in the past. I wanted more. Just referring to him in the past tense makes me sick. We were supposed to be the old guys sitting courtside like Bill Russell is now. Attending All-Star Weekend together watching the new generation blaze their path.

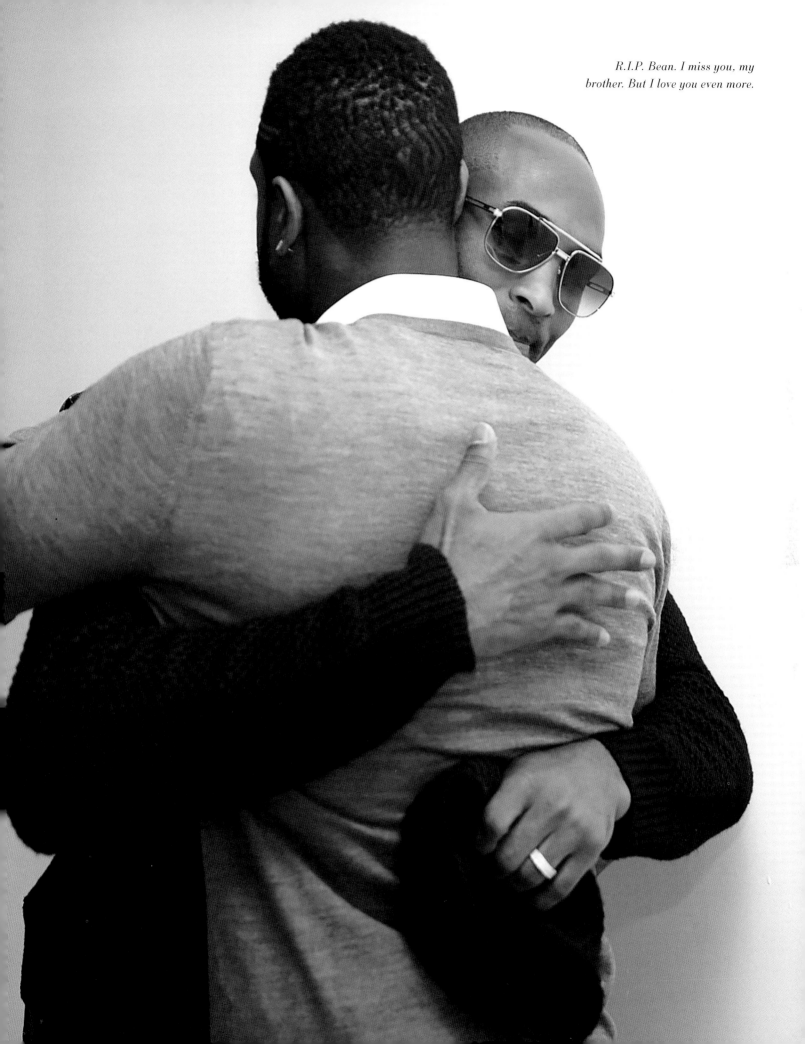

R.I.P. Bean. I miss you, my brother. But I love you even more.

THIRD
QUARTER

NOW

IS WHEN YOU MAKE A

STATEMENT

How I came out after halftime always set the tone for the rest of the game. Whatever happened in the 24 minutes prior, stayed there. I had to give a different look. I had to go harder. If I stopped on a dime and took jumpers in the first half, best believe I'm attacking the basket in the second. The whole plan is to never allow anyone to dictate what I wanted to do on the court.

I keep that same energy in everything I do, too. If I've said it before, I've said it a million times. I love basketball with all of my heart. What it's given to me is a piece of my soul. But I've also worked extremely hard to never let it completely define who I am. Happiness, for me, never came from just one source. I've gotten the chance to meet so many people, from so many walks of life, and impact them in ways that didn't always matter if I led the league in scoring or if we finished atop the Eastern Conference. I'm proud of being Dwyane Wade, the three-time champion or Olympic gold medalist. But I'm not just that. I never will be.

I'm also Dwyane Wade, the man who has busted his ass over the past several decades to be the best father, husband, businessman, and community leader I could possibly be. Who we are isn't just what our job title says. Who we are, rather, is what we strive to be each and every day when we wake up. And that process doesn't stop when the games do.

Let me say this again: You only go as far as the people around you.

Hank always made sure my business was handled. He put the right people in my life to make sure I'd always succeed from a business standpoint even without him. Lisa Joseph Metelus is one of those people.

Lisa has cared for my family and me like we were her very own, and that's because at this point we are. Having someone so passionate and not afraid to challenge others for answers to the questions we needed answered was what I needed. I was a very shy young man and in business there's no space for being timid or unsure. That world will eat you alive if you're not careful. Having Lisa be the bad guy early on was what I needed, but I also learned a lot by watching her approach to my business.

Hank and Lisa saw greatness in me even when I couldn't. This was their trophy just as much as it was mine.

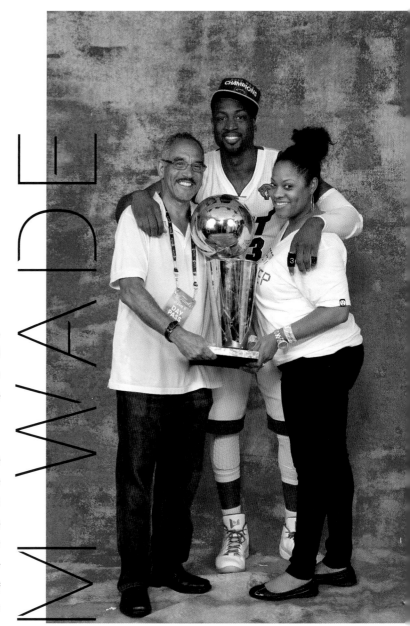

TEAM WADE

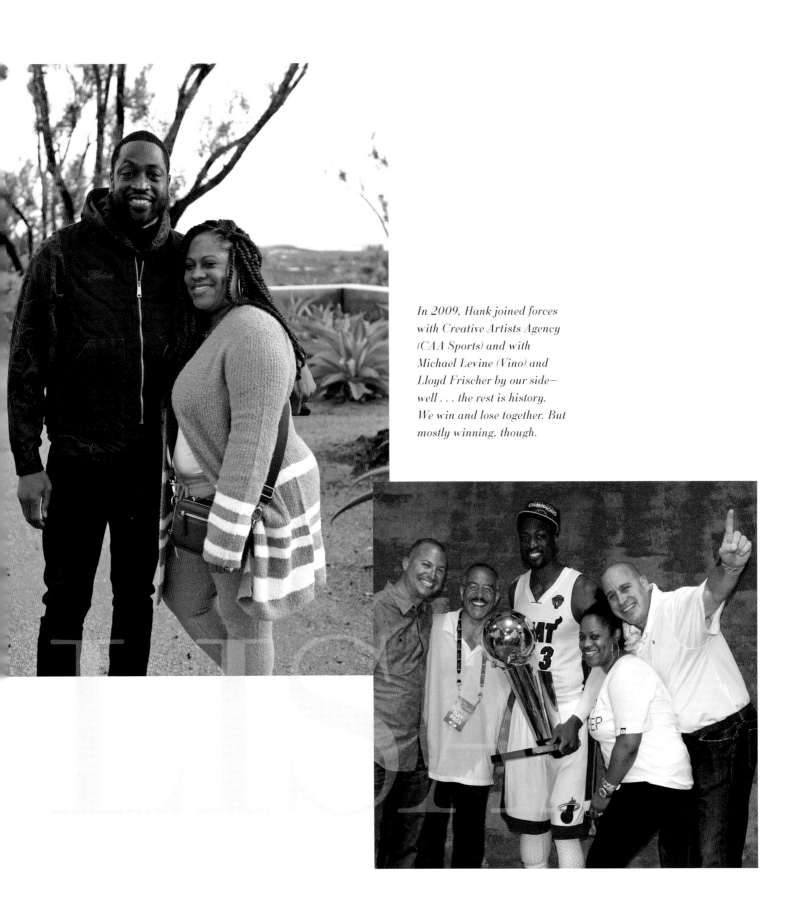

In 2009, Hank joined forces
with Creative Artists Agency
(CAA Sports) and with
Michael Levine (Vino) and
Lloyd Frischer by our side—
well . . . the rest is history.
We win and lose together. But
mostly winning, though.

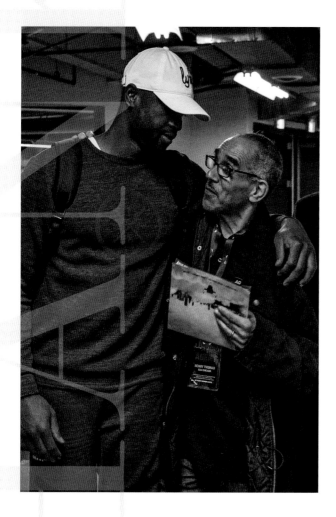

There aren't many bigger prayers that were answered in my life than Henry Thomas. Losing Hank in 2018 shook me to my core, but I know he wants me to keep growing. To never let one chapter of my life define me and always keep living a life of evolution. He stressed that so much. Hank had kids my age, so he understood that despite me being a high draft pick, making all this money, and becoming a star in the league, I still needed someone by my side who actually cared about who Dwyane Wade was. Not just D. Wade or Flash. Thank you, Hank.

Hank's vision was to make sure that when my career was done, I had created a
LEGACY

Being young in the NBA is a heavy blessing to carry. We work our entire lives to get to this point. We consume basketball 24/7, but then you get to the league and basketball is only part of the education. It's a delicate balance to learn this new life you earned, the money that's coming in, and all the outside forces that feel entitled. And this was even before social media.

It's a lot easier to flame out in the NBA than it is to succeed. I go back to what I said when I came into the league as a rookie. If you don't have the right people around you, that makes growing into your full potential that much more difficult. And in some cases impossible. I'm one of the lucky ones.

He had this deep understanding of life: how to approach situations, how to treat people. He helped me understand that mistakes happen; it was how I learned from them that mattered.

Hank was around to celebrate some of my proudest moments both on and off the court. I'm still not over not being able to share some things with him: Kaavia's birth, Zaya joining the choir, and the men Zaire and Dahveon are becoming—because Hank taught me so much about fatherhood. Without Hank, part of me is gone.

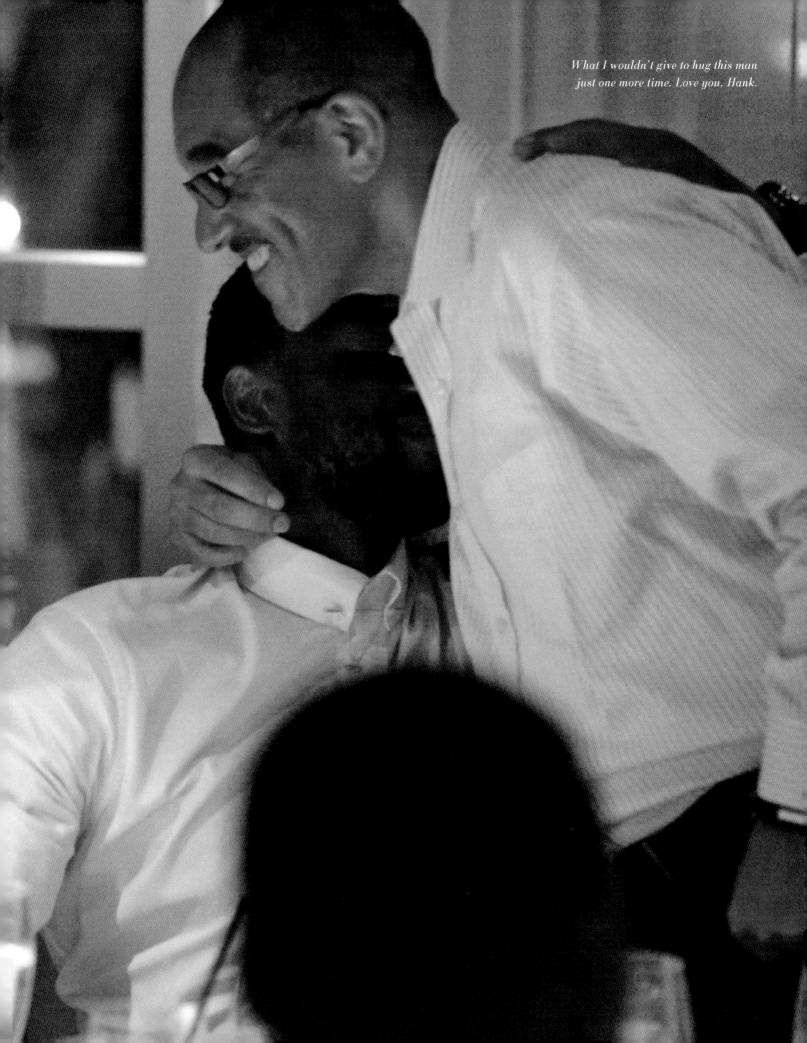

What I wouldn't give to hug this man just one more time. Love you, Hank.

Strategizing at the CAA New York offices. I would always tell Hank that I needed a team around me. I didn't always know why, but I knew I wanted one. As an athlete who plays a team sport, you know individual success is never more important than team success. I knew that to be successful in business I needed the right mix of people around me. And that's Team Wade.

Team Wade stays planning a good time! We love a good event—and this one was from RunWade Chicago . . .
our annual fashion fundraiser. Celebrating 'cause it's all over and was a huge success.

Over the course of our lives, we meet so many people. Most come and then go. But every now and then, we meet people and we can tell at that moment they're different. We don't know if it's a good or bad thing initially, but we just know they're different. That's how it was for me with Calyann Barnett that first day I met her in New York. In the mid-2000s, the late David Stern implemented a dress code in the NBA. It wasn't fair at all, but there was a perception of NBA players following the Malice at the Palace. We took that dress code as a challenge, so by embracing that I began looking for a stylist. I had someone dressing me at the time I met Calyann, and to be honest, it didn't start off with her right away. She was persistent as hell trying to get me to work with her mentor.

She helped me become one of the trailblazers (no pun intended) in the new era of the NBA when it comes to fashion. She had me out here taking chances on trends, sitting at fashion shows in Paris and New York and designing sock lines. She quite literally changed what it looks like for an athlete to be in fashion in my eyes. She changed the way I see things.

I've enjoyed having someone I know who can creatively understand my mind, and somebody who pushes the boundaries a little bit. She gets us out of our comfort zone. Being comfortable isn't conducive to growth.

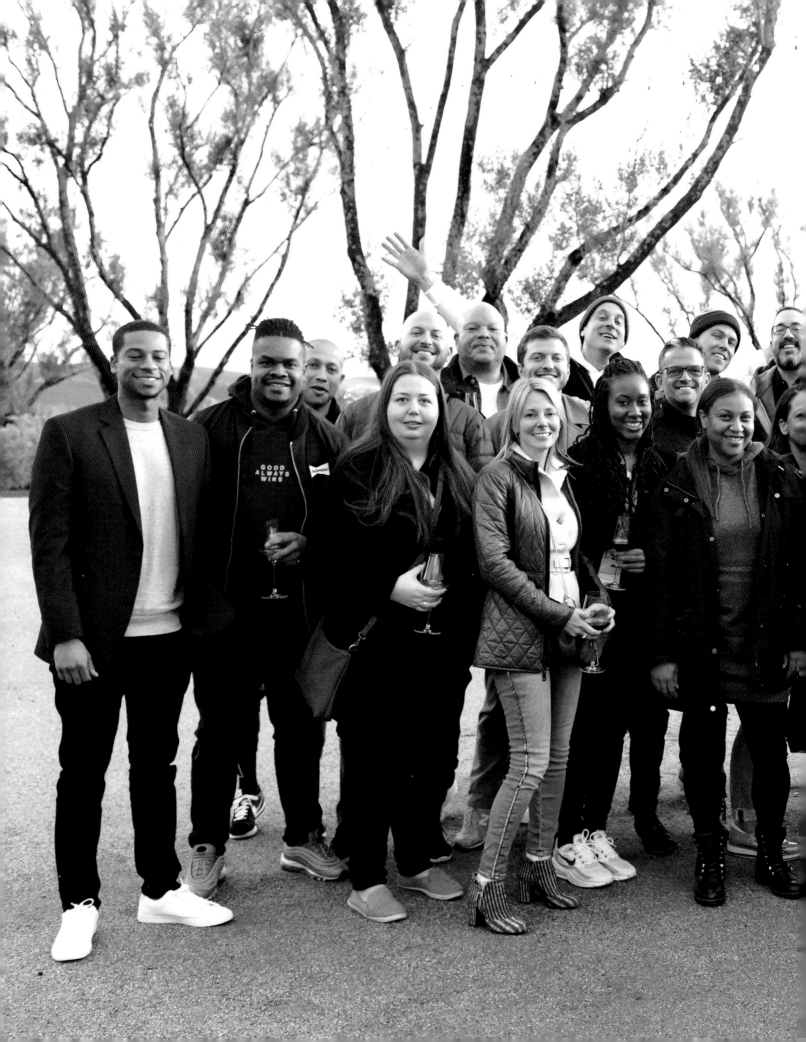

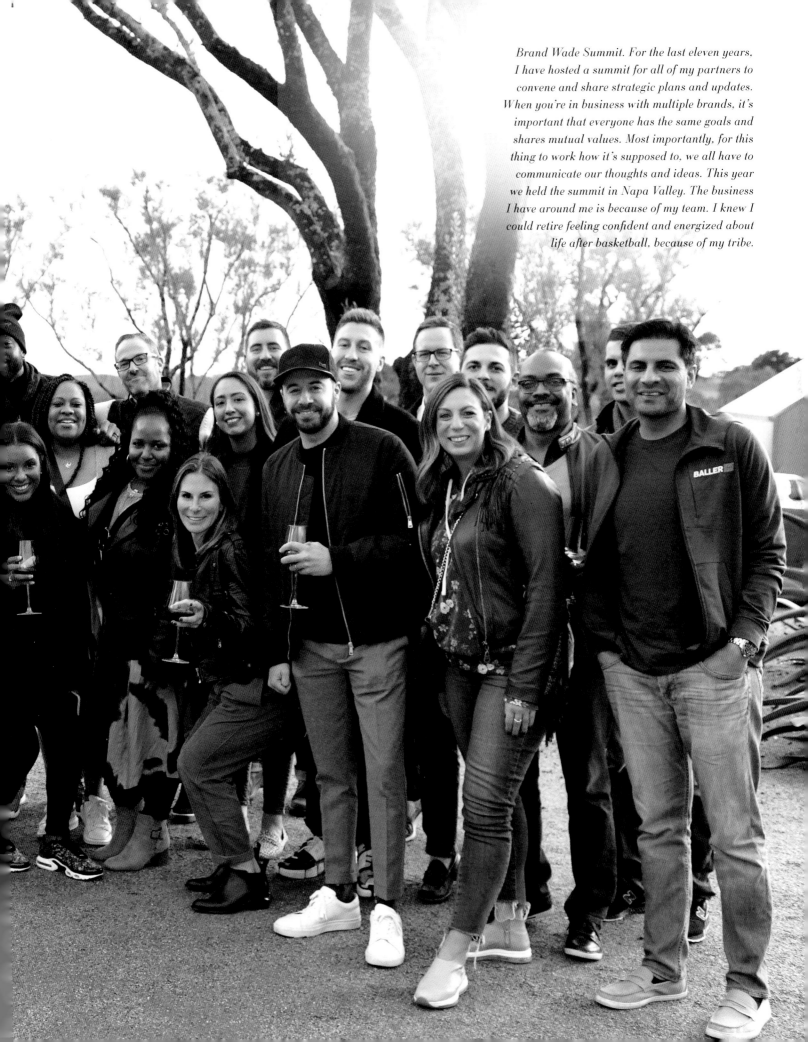

Brand Wade Summit. For the last eleven years, I have hosted a summit for all of my partners to convene and share strategic plans and updates. When you're in business with multiple brands, it's important that everyone has the same goals and shares mutual values. Most importantly, for this thing to work how it's supposed to, we all have to communicate our thoughts and ideas. This year we held the summit in Napa Valley. The business I have around me is because of my team. I knew I could retire feeling confident and energized about life after basketball, because of my tribe.

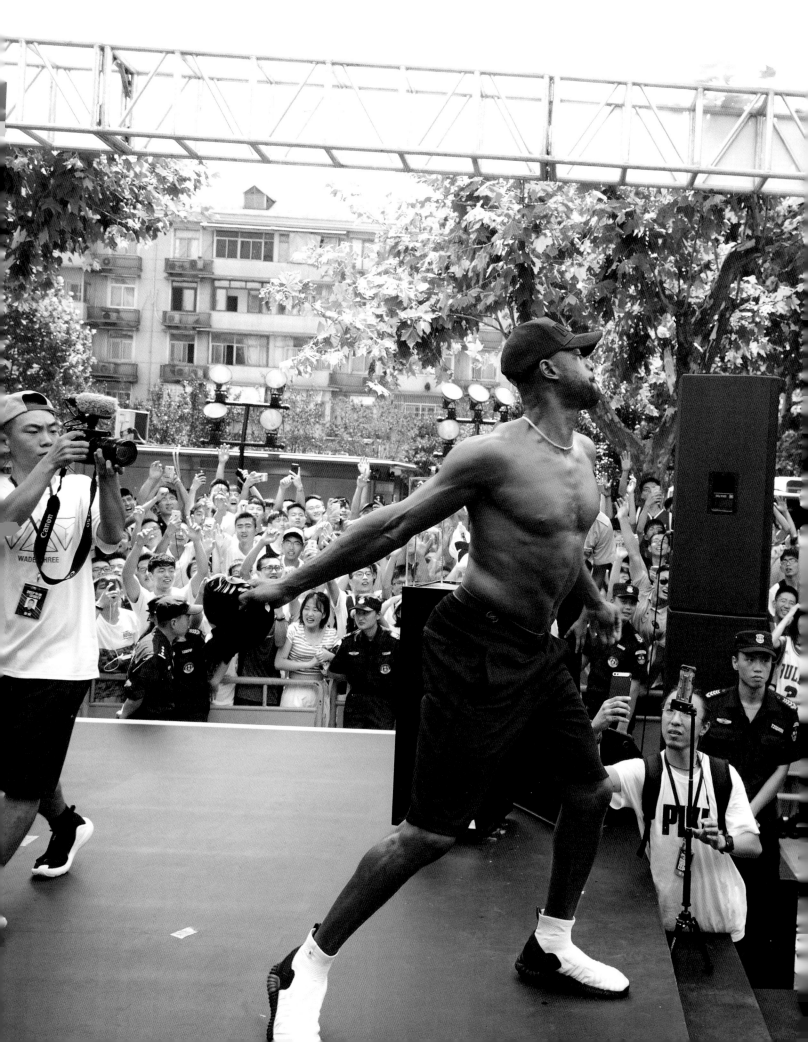

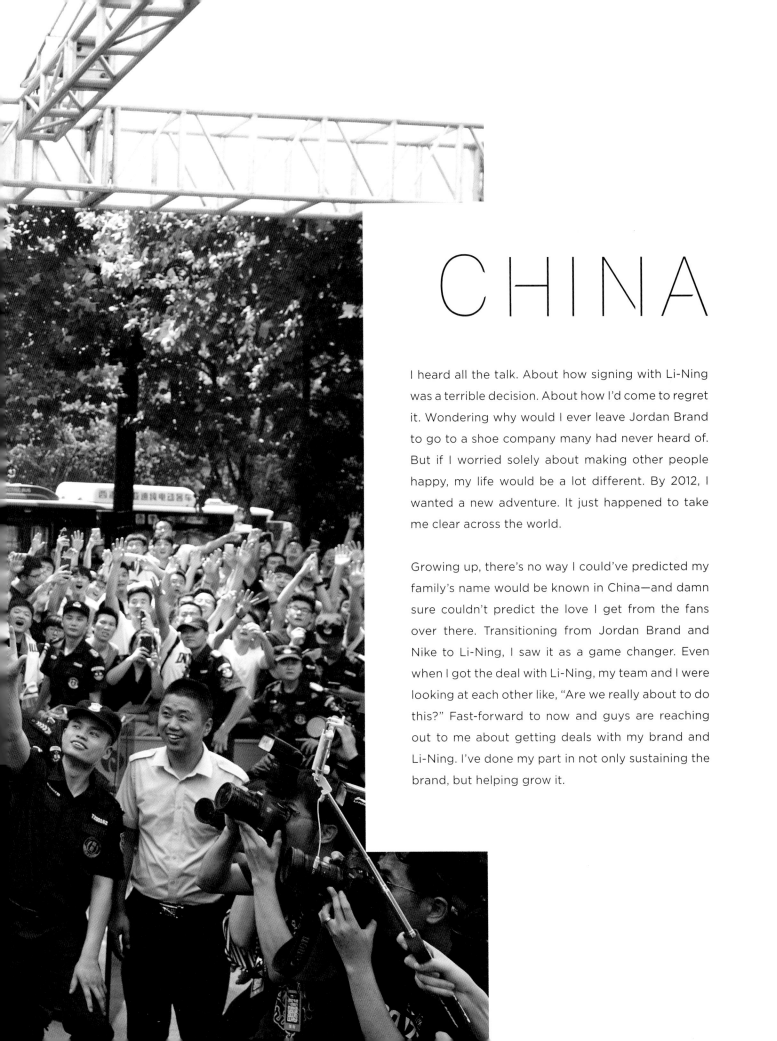

CHINA

I heard all the talk. About how signing with Li-Ning was a terrible decision. About how I'd come to regret it. Wondering why would I ever leave Jordan Brand to go to a shoe company many had never heard of. But if I worried solely about making other people happy, my life would be a lot different. By 2012, I wanted a new adventure. It just happened to take me clear across the world.

Growing up, there's no way I could've predicted my family's name would be known in China—and damn sure couldn't predict the love I get from the fans over there. Transitioning from Jordan Brand and Nike to Li-Ning, I saw it as a game changer. Even when I got the deal with Li-Ning, my team and I were looking at each other like, "Are we really about to do this?" Fast-forward to now and guys are reaching out to me about getting deals with my brand and Li-Ning. I've done my part in not only sustaining the brand, but helping grow it.

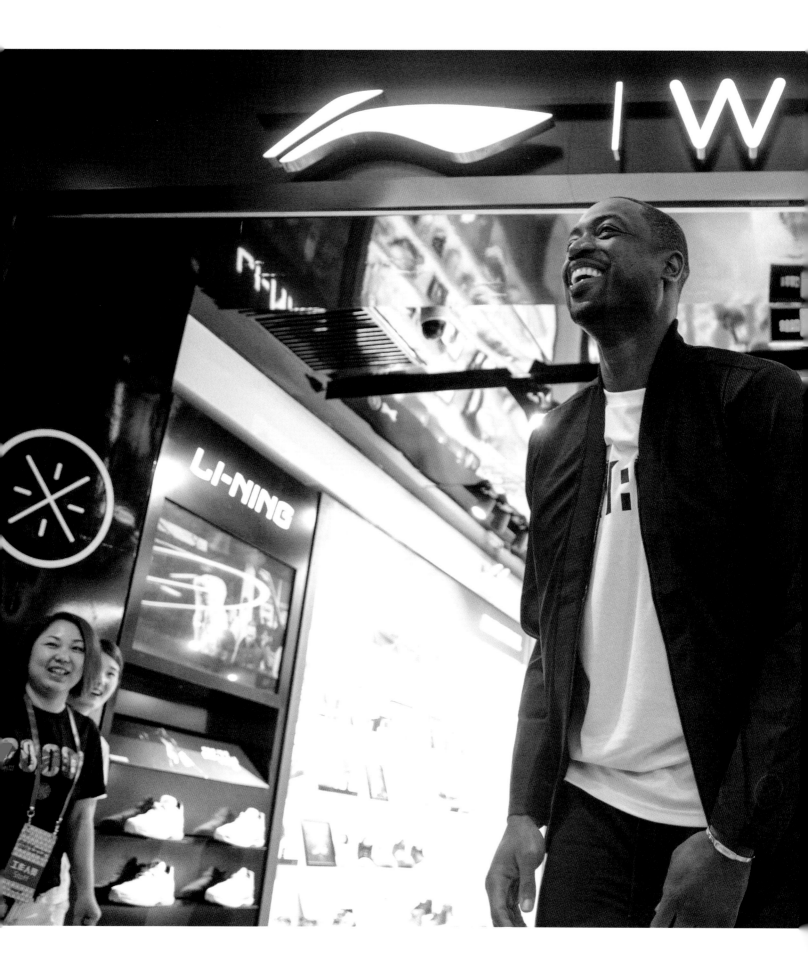

Because when you grow up on 59th and Prairie and travel to the other side of the world and see an entire store dedicated to yourself, what other reaction is there? There are over ten WADE stores in China.

This was a young man from Chicago. He had never been on a plane before, and we flew him out with us to China to be a part of my business meetings. It was part of a program we have in the Wade Family Foundation called "Spotlight On." We not only praise the youth for the work that they're doing in school and their community, but we try to put them in a position to have hands-on experiences in the field of their dreams. Tsubuka wanted to be a shoe designer. He not only sat in on our design session— he had a voice in the process.

That's me in Napa. I look like I'm having a good time, right? Well, I am, but how I got into the world of wine is a little more than just enjoying the taste. I'd say until my thirties I never socially drank alcohol. Growing up, I saw firsthand how alcoholism impacted my family. I stayed away from it altogether. I wasn't really educated on how to enjoy alcohol and have it not be something that can control your life. I only saw the negative effects.

But that's what life experiences are for. The more I began to be exposed to different things, the wider my knowledge on it became. I have to give credit to 'Melo for putting me on to a lot of different wines. He really opened my eyes to not just the taste of wines from all over the world, but the business of it as well.

WADE CELLARS

A few years ago, I was approached by the Pahlmeyer family—one of the most prominent in the Napa region—about partnering with them in the wine business. My whole thought process was, if you enjoy something, and there's an opportunity to do so, why not own it as well? Fast-forward to today and now I have D Wade Cellars with the Pahlmeyer family, and we have four varieties on the market. Being a Black-owned wine business is something that isn't lost on me. I'm proud of that. But you know what else I'm proud of? That I allowed myself not to be controlled by the trauma that I thought alcohol would have on me my entire life. God bless growth and positive life experiences.

Whenever someone says healthy lifestyles are made in the kitchen, believe them.

I was a professional athlete, and by the grace of God I was able to make it to the league with the diet I had. I wanted my lemonade as sweet as humanly possible. I wanted fried, well, everything. Fried chicken, smothered pork chops, the whole nine. That's when Richard Inghram had to have a heart-to-heart with me. It's actually smooth as hell the way he did it. Richard became my personal chef in 2005. He'd still cook my favorite foods, but he'd mention adding vegetables. He would even throw in blasphemy about portion size, which I was originally not trying to hear at all. Anyone who knows me knows I'm picky as hell when it comes to my food. But over time, I started to see the benefit in what he was preaching. How you treat your body in the kitchen is just as important, if not more, than what you train it to do in the gym. Without Richard, it's no telling how my career pans out.

But it's deeper than just food with Richard and me. Since I was drafted, I always had two father figures: my dad and Hank. When Hank died, it became my dad and Rich. He took care of me from a food perspective, but really in just life in general. For Father's Day, I call him and my dad. Richard is one of my best friends, who's also a father figure, but he's also my chef.

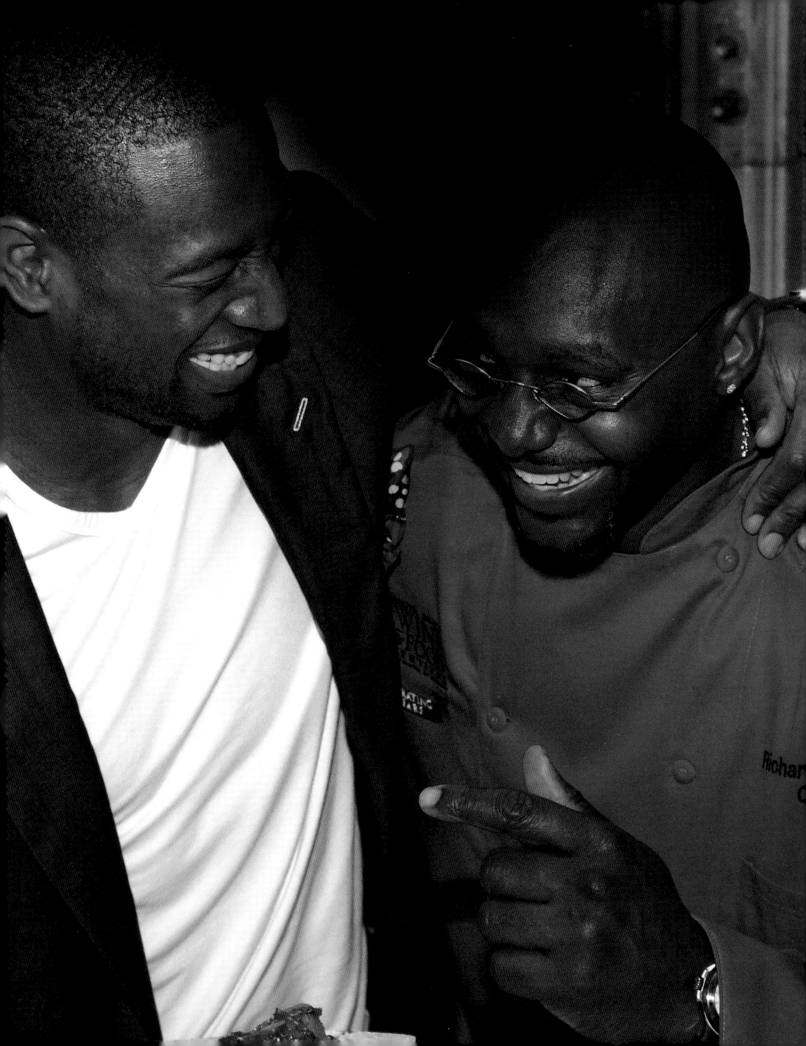

I love socks. No, seriously, I love socks.

SOCKS
SOCKS
SOCKS

They've always made me feel good. Linking up with Stance in 2013 was just a natural thing to do. I was the first NBA player to launch his own collection. And I'll tell you that one of the proudest moments I had in the league was when the league made Stance its official sock ahead of the 2015–16 season.

The relationship with Stance led to PKWY. Stance and myself cofounded the company. That means it's more than just a check. PKWY is ownership. Our products are in Targets nationwide. That evolution from being a face of a brand like Gatorade to having equity in other worlds like fashion and the wine industry is something that makes me extremely proud. In everything I do, the purpose is to always level up.

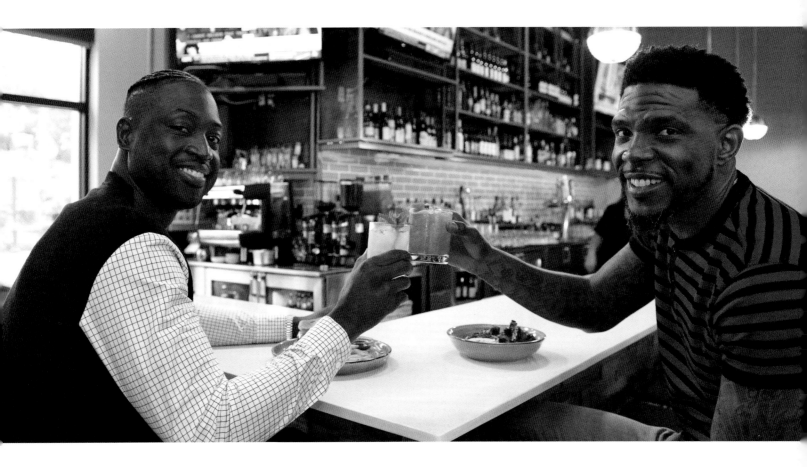

I never dreaded life after basketball. Because I was already preparing for it while I was still playing basketball. Of course, I love the game, but I always knew I couldn't depend on it being my sole source of happiness. Just because I retired doesn't mean I'm going to sit in a rocking chair all day and reminisce on the old days. This is the next chapter of my life, and the reason why it's such a fun challenge is because I prepared for this moment—my team helped me prepare for this moment.

In 2018, Udonis and I partnered up with 800° Woodfired Kitchen. This was a special moment for us both because we came into the league together, won multiple championships together—and now we're business partners in the city we played in. It doesn't get any better than that. My whole thought process there was similar to why I got into the wine industry. I love freshly prepared food, and the opportunity to be able to spread that love to communities across the world was too much to pass up.

Surprised the students at my alma mater Harold L. Richards High School with a special screening of my documentary. Another full-circle moment for me.

I launched my own production company, 59th & Prairie Entertainment. One of our first projects was the movie *Shot in the Dark*, where I was an executive producer alongside Chance the Rapper. The documentary was about a high school basketball team from Chicago whose star player is shot the night before their championship game. But these are photos from a VIP screening we did in Chicago this past All-Star Weekend for my documentary Life Unexpected. This was a special moment for me because it was a culmination of a decade's worth of work between Bob and myself. We understood from jump street that producing our own content and directing our narrative was the best way to tell our story in the most authentic way possible. That's the foundation of what 59th & Prairie Entertainment is built on. I'm not just a businessman, an ambassador, and key player in the food and wine industries—I'm a storyteller, too.

Back at Harvard teaching my case study that Anita Elberse published in 2016.

Here's a fun fact about me that some may not know. Back in 2015, I enrolled in Professor Anita Elberse's "Business of Entertainment, Media, and Sports" program at Harvard Business School. I even stayed in a dorm room. I didn't even do that at Marquette! Honestly, the experience was a little nerve-racking at first, because I hadn't been in a classroom as a student since 2003. But Professor Elberse's swag made the experience truly unbelievable. So much so that she invited me back several times to be a guest speaker. Learning from her helped me open my eyes even more to how to interact with my team and the questions I should be asking. Because at that point I was already preparing for life after basketball.

If we're not trying to empower the next generation then whatever we set out to do is pointless.

I've always believed that any time I can give to speak to generations younger than me then I do it. If you're going to be part of the community, the community has to see you. That was always my mindset. The game was given to me, and it's my job to make sure that cycle continues.

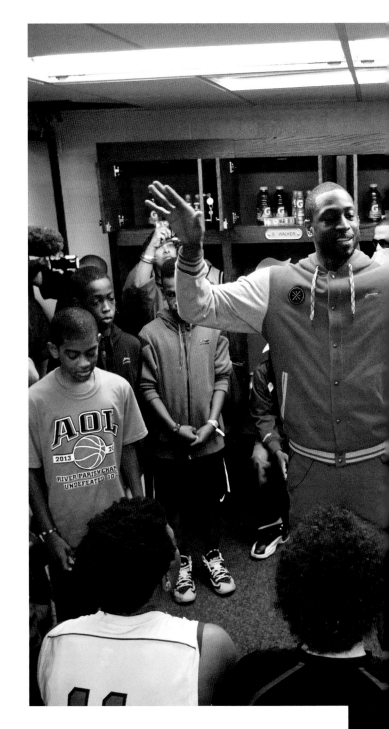

COMMUNITY

In Miami, I tapped in with the Feed the Children campaign in honor of Martin Luther King Jr. Day. As a kid, there were certain nights I didn't eat. I don't harbor resentment for that, but if I can make sure another kid doesn't know that struggle then I'm willing to do whatever I can.

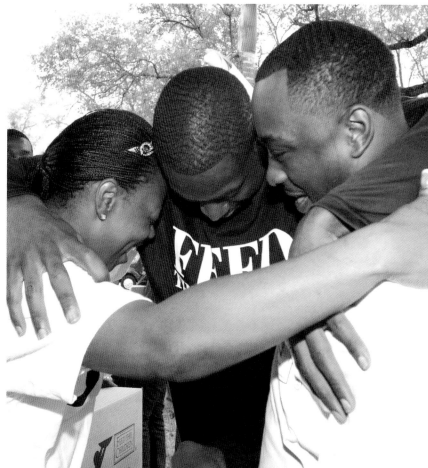

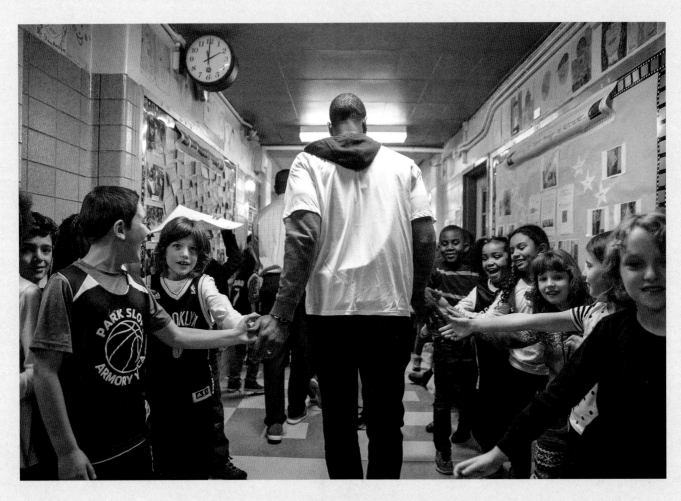

The thing I always remember when working with kids is that at one point, a long time ago, I was one of them.
One interaction can change the rest of their life.

Traveling the world is a blessing, but charity starts at home.

There's that saying our parents hammered home in our heads when we were kids around the holidays: "To give is better than to receive." The older you get, the more you realize how true it is.

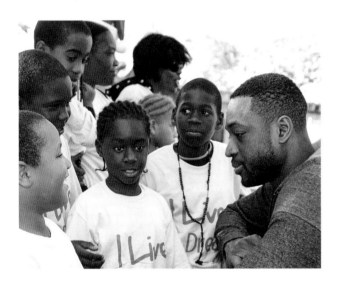

There's a lot of depth in this photo that doesn't necessarily jump off the page at first glance. In 2011, the National Fatherhood Initiative honored me. This wasn't too long after I received full custody of Zaire and Zaya. Basketball accolades are incredible, but being a great father was always the ultimate goal that would bring the ultimate joy. During All-Star Weekend 2012 in Orlando, I led the discussion as part of the White House's Fatherhood & Mentoring initiative. Understanding the purpose I was there for, this photo hits home even more knowing that forty-eight hours after this photo was taken, Trayvon Martin would lose his life. And the lives of myself, and so many other guys in the NBA, would be dedicated to a far greater purpose moving forward.

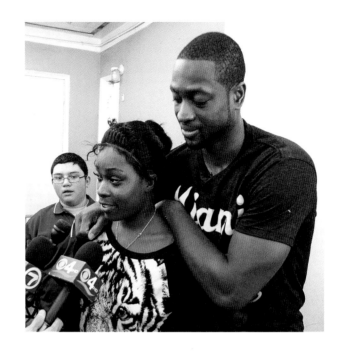

This is Dawn Smith. I didn't just play in South Florida. I lived in South Florida. And I'll always call South Florida home. When I heard that Dawn's nephew accidently burned their house down and they had lost everything, I couldn't just sit back, read the story, and go on about my day. Right before Christmas, we were able to give her keys to a brand-new house.

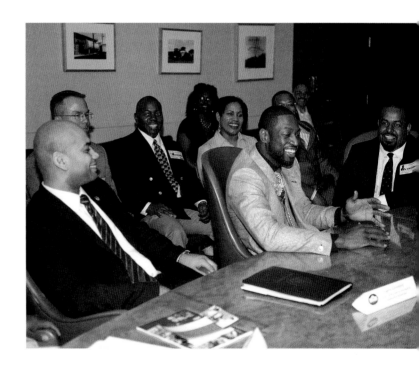

Here's how quickly my life changed. On February 8, 2018, I was traded from Cleveland back to Miami. On Valentine's Day, fourteen students and three staff members lost their lives in a massacre at Marjory Stoneman Douglas High School in Parkland, Florida. I was in Los Angeles for All-Star Weekend, but my mind was in Florida the entire time. Later that month, I had one of my best games of the season. We beat the Philadelphia 76ers 102–101, and I had 27 points including the game winner. But that was far from the most important element of that game. I wore shoes that night honoring Joaquin Oliver. He was one of the seventeen victims.

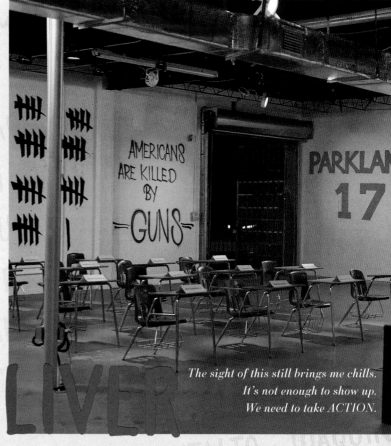

The sight of this still brings me chills. It's not enough to show up. We need to take ACTION.

PARKLAND 17
JOAQUIN OLIVER

I heard about Joaquin being buried in my jersey over the radio. No one from the family reached out to us. This was something they did. The fact that, in that family's most heartbreaking moment they thought of burying their son in my jersey, drove me to tears. This was never about me, but I had to do something. South Florida had embraced me as one its own, and I felt it was my responsibility to be there for a community in need. I had to visit the school. I wanted to give the kids something to be happy about because they deserved that moment. This wasn't about alerting the press. This was about connecting with people. I'm going to be really honest with you for a second. I've heard loud crowds before, but the reaction that school had when I walked in the building—I've got goosebumps

just thinking about it. They were looking for anything to be happy about, anything to remind them of what joy felt like. I spent some time with teachers and the principal. I also met with some of the leaders from the school, the juniors and seniors. They were the ones behind the March for Our Lives demonstration in Washington, D.C. They told me the best way to help was to use my platform. I was hesitant to do an interview with CNN, but I knew it was never about me and the kids reminded me of the power of my voice. I spoke about gun violence and why this country desperately needs to change its laws around gun control. My team and myself also sponsored a bunch of kids to go to the rally. We partnered with young people in Chicago and Miami and paid for transportation to D.C.

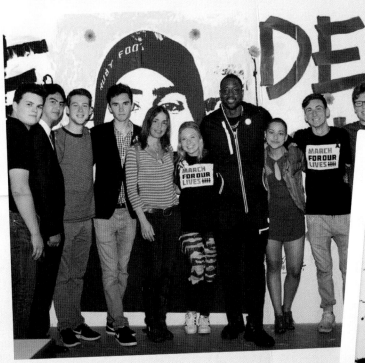

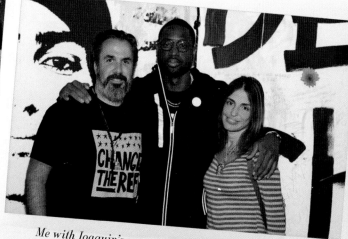

Me with Joaquin's parents. They started an organization
called Change the Ref in honor of Joaquin.

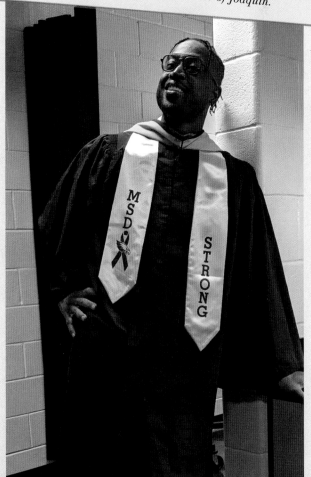

Calyann Barnett and I had an idea to honor the victims through an exhibition where we took over a warehouse in Wynwood—a part of Miami known for its art scene. There we had a mural designed with seventeen desks and a teacher's desk. Each desk had the name of the kids and staff who were killed and their bios. The community showed up in droves. It was only supposed to be one day, but ended up being multiple weekends and re-created in New York and California. Thanks to a symbolic yellow phone booth we had on site, we gave attendees a chance to call their senators and representatives to petition for gun law change.

In 2019, I surprised the students again. This time at their graduation. For the rest of my life, I'll always have a connection with Marjory Stoneman Douglas High School in Parkland, Florida.

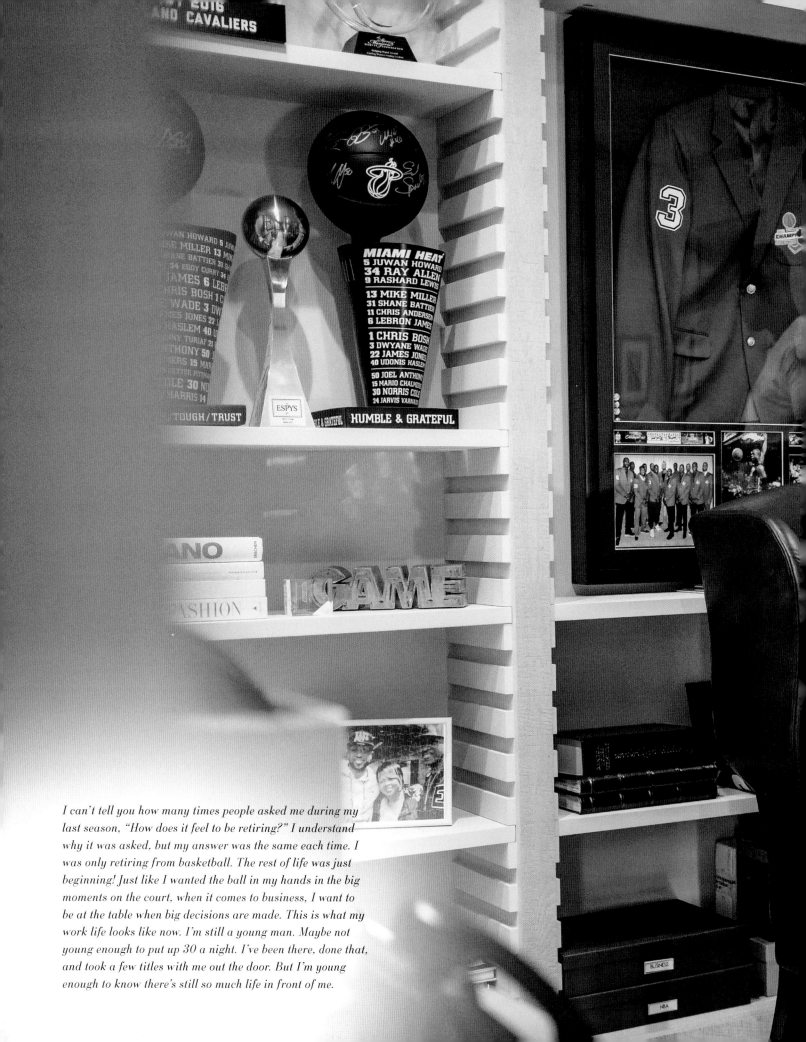

I can't tell you how many times people asked me during my last season, "How does it feel to be retiring?" I understand why it was asked, but my answer was the same each time. I was only retiring from basketball. The rest of life was just beginning! Just like I wanted the ball in my hands in the big moments on the court, when it comes to business, I want to be at the table when big decisions are made. This is what my work life looks like now. I'm still a young man. Maybe not young enough to put up 30 a night. I've been there, done that, and took a few titles with me out the door. But I'm young enough to know there's still so much life in front of me.

FOURTH
QUARTER

It's winning time. It's time to show and prove why the responsibility to lead a team falls on my lap. Every decision is magnified. I've been in every situation you can ever fathom with the game on the line. I've hit game-winners. I've had game-winners hit on me. I've taken over games and I've seen others take over. Regardless, it's this quarter that has always shown what I'm willing to do to win a game.

There are so many people who depend on me to make the right decision at the right time. Have I always succeeded? No. The next perfect person I meet will be the first. But I always, always want that weight. Leading a team or leading my family, it's people out there who depend on me. Any real leader's biggest fear is letting those who trust in him down. Everything I've ever been through in life has been with a purpose. The journey hasn't always been easy, and there have been times when I've wondered to myself, "Am I doing this right?" or "Where am I going?"

Sometimes I've had to learn lessons on my own. Sometimes I've had to teach lessons. But I've learned with family, like with basketball, that having all the answers isn't nearly as important as having each other. Sometimes you just figure it out together.

This was my original Big Three. I was a single dad when Gab (a.k.a. "Nickie") and I first started dating. You never know how that's going to go. Some people are great with kids, while some aren't. Gab was, and still is, phenomenal. I knew if I were to bring someone into Zaire, Zaya, and Dahveon's lives that she had to be important—and I wanted them to love her just like I did. My kids love Gabrielle. But marrying me was a package deal. Marrying me meant you were taking on the kids, too. So, for the proposal, I had to get the whole squad involved. Just me getting down on one knee wouldn't have been enough. We had to hit Gab with an offer she couldn't refuse.

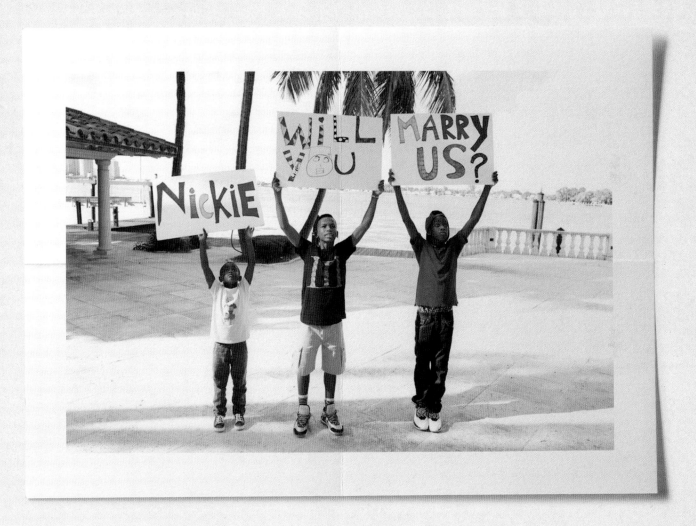

Thankfully, she said yes. To all of us. We haven't looked back since.

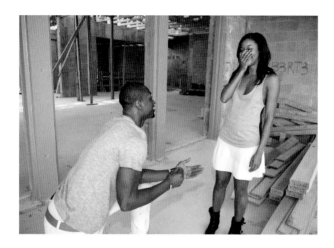

August 30, 2014. Without question, the most memorable date I've ever been on. The thing I really appreciate about how Gab and I went into our, well, union is that neither of us rushed the process. She knew I was down for her. I knew she was down for me. We were always secure in what we were building. And that's a forever thing. We tied the knot at the Chateau Artisan in Miami. The day was already going to be special if it were just me, Gab, and the kids. But so many of our closest friends and family members pulled up and made it the dream moment we had always envisioned. From Gab walking down the aisle to the theme of the wedding scene in the beginning of Coming to America with John Legend singing, to me walking down the aisle to Rich Homie Quan's "Walk Thru," to violinist Lee England Jr.'s performance—it was all perfect.

When I tell you, though, that Gab looked like an angel walking down the aisle, I put that on everything. I can be 120 years old, and I'll remember that moment like it happened five minutes ago. That's why I'm wiping my eye.

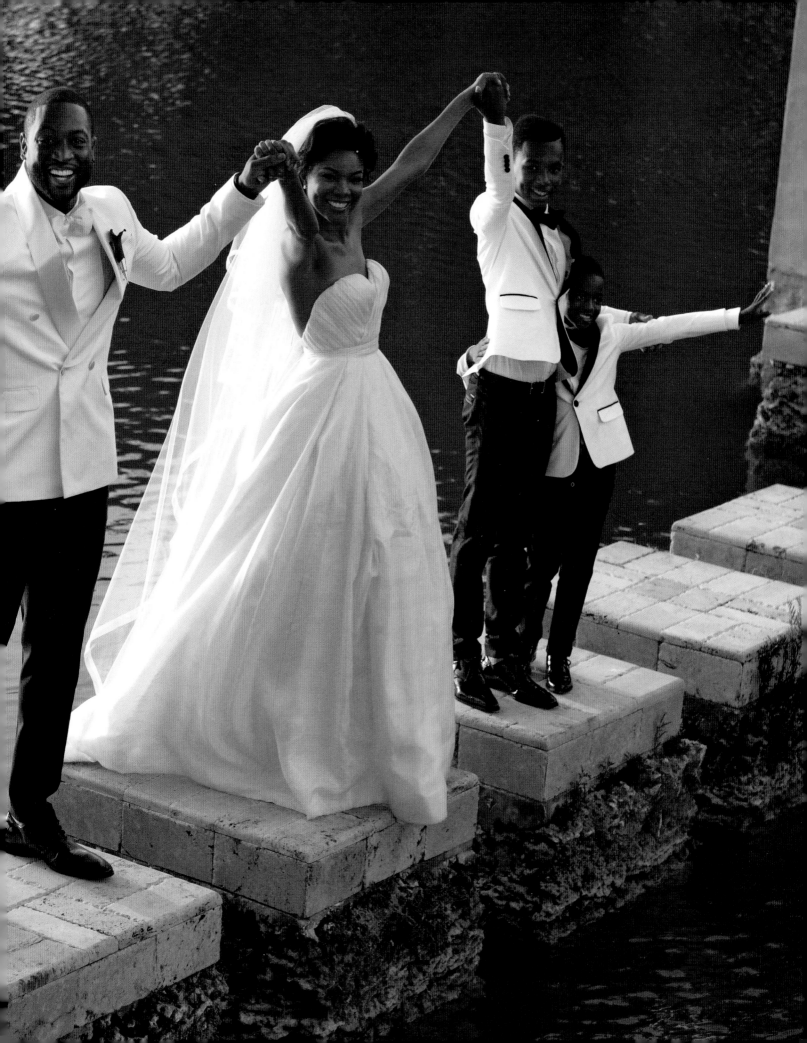

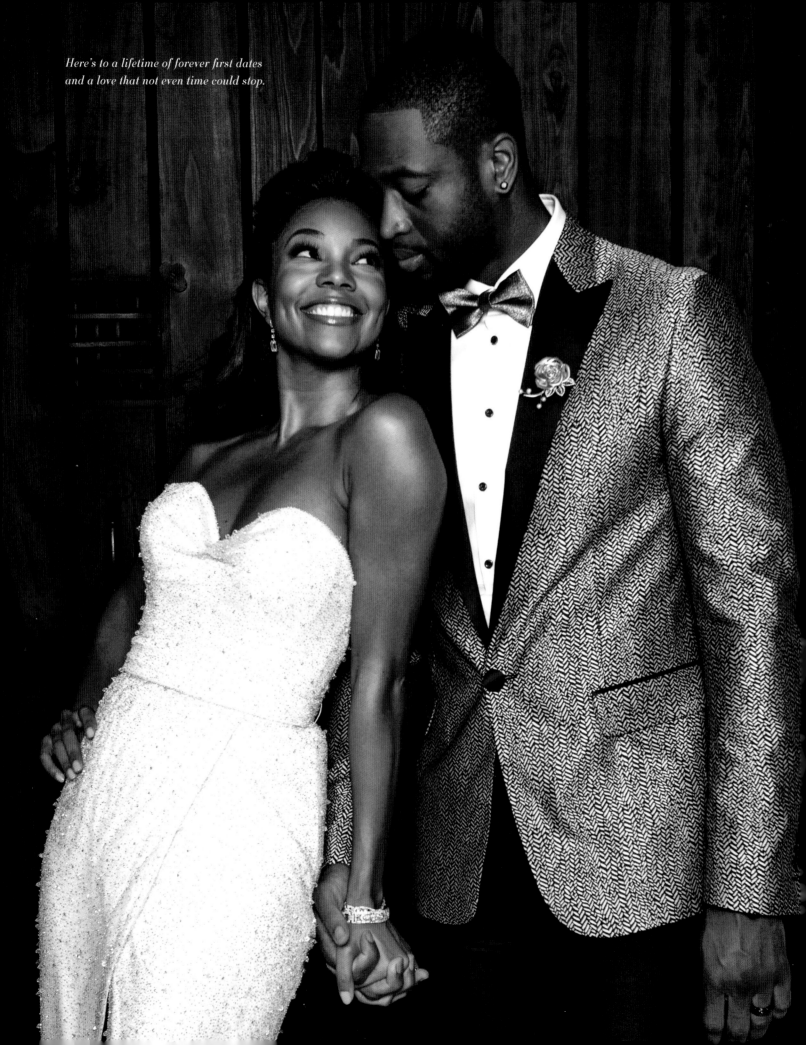

Here's to a lifetime of forever first dates and a love that not even time could stop.

If it looks like Gab and I are always having fun, it's because we are. There's no one in the world I'd rather collect passport stamps with than my wife. We've been all over the world and chances are you've seen some of our adventures on Instagram because we hashtag all of our trips. For most of 2020, we had to practice social distancing. It was the right thing to do, but please believe these two travelholics were losing their minds. The travel withdrawal is super real.

What's better than being able to jet-set with your best friend? Not a damn thing. Gab and I have both been blessed to travel the world, both for work and for pleasure. Not too bad for two kids from Chicago and Omaha, I'd say. Yet, whether I'm with her or she's with me for work or we just decide to catch a flight, it's always the best of both worlds.

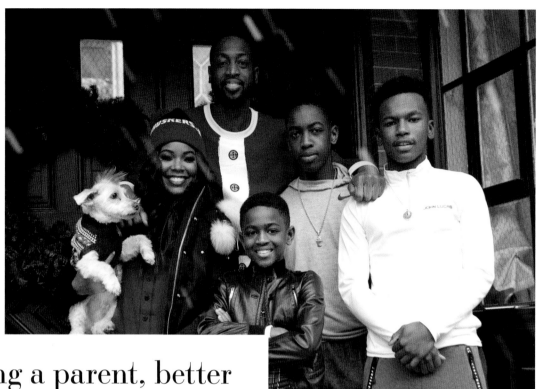

Being a parent, better yet being a Black parent, comes with a ton of emotions and experiences.

is what they take into the world. So, if you ask me what my greatest accomplishment is? Finals MVP is dope as hell. As was winning a gold medal. All that pales in comparison to being a Black parent. It's maddening, frustrating, and scary at times. But that could never be more than the love. I walk in love, not doubt.

With the world we live in, it's natural to be fearful at times. As parents, all Gab and I want to do is protect them as much as we can. It comes with uncomfortable conversations at times, but we'd be doing them a grave disservice by not keeping it 100 with them. Yet, if there is fear, that's only because of how deep the love is. That love that runs so deep that you'd give up everything to see them smile and to never see them hurt. I'm talking about that love you realize is unlike anything you've ever experienced as soon as they come into your life. I'm a proud Black man married to a beautiful and powerful Black woman and we're raising some incredible young Black adults and children. The game I give to them

After I was awarded custody of Zaire and Zaya, I spoke with my sister Deanna about her son, my nephew, Dahveon, coming to live with me and Gab in Miami. Every time I would get the kids for a weekend I would make sure Dahveon came along as well. Zaire and Da have been best friends since they were young and were only a few months apart. I knew of the struggles my sister was having with Dahveon in school and also growing up in Chicago. So I felt my environment and resources could give him a better chance to succeed. It's been the best thing for all of us, myself included. I can't imagine my journey without him around. Here we are getting Dada ready for his junior prom.

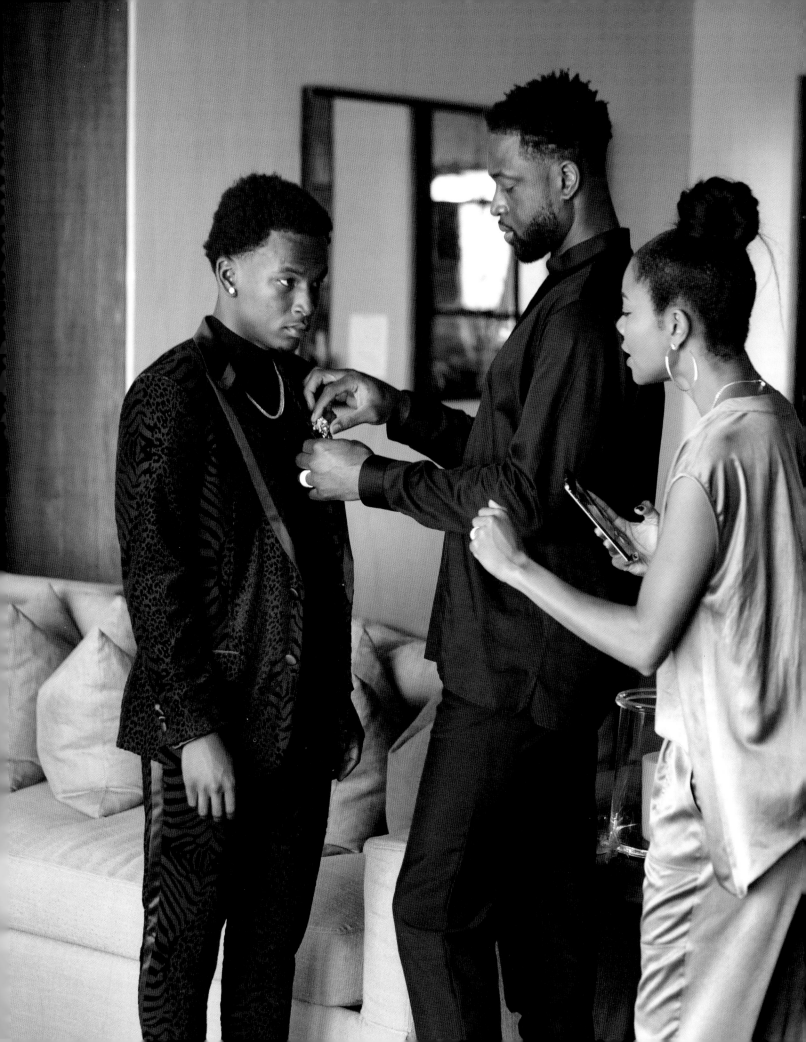

We always hear the terms "Black love" and "Black joy." There's no real definition of what they are. You just know it when you see it. The thing about life is good times never last forever, but neither do bad times. But to have people in your life for both, that's when the value of love, joy, and happiness really begin to define themselves. To see my wife smile, to see my kids grow up into people who'll make this world a little bit better than how they found it, and to see myself grow into a better version of me each day—it's those definitions that I lean on. I have to hold on to it tight, too. With so much uncertainty in the world, being able to come back to the people and the things that bring me the most peace is as vital as anything these days.

My first year at Marquette I didn't play, so Coach Crean sent me to Italy to play traveling basketball to gain some in-game experience. While I was over there, that's when my ex-wife, Siovaughan, told me she was pregnant with Zaire. I was scared as hell. I remember crying to Coach Crean. I'm talking ugly-face, snot-coming-out-of-my-nose crying. Here I am, in college, with no money, and I'm about to have a son. A kid having a kid. I thought my career was over. But Coach told me, "We're gonna get through this." From that moment, my new life began.

Zaire had no way of knowing this, but he changed my life before he even got here. I wasn't just living for myself. If I did nothing else of note, I knew I owed

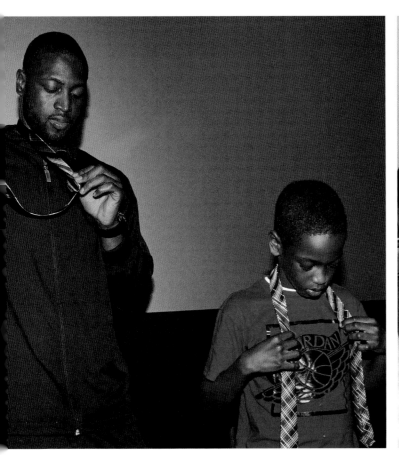

it to him to be the best father I could. What I got in return is a blessing I could've never imagined in my wildest dreams. He was there sitting on my lap the night I was drafted. When we won championships. Asking me questions at my final All-Star Weekend as a player. And there to swap jerseys with me for the last home game of my career. Zaire has always been a rock. Even when our situation wasn't as stable as it is now, he always held his head up and believed in me.

And now, Zaire's his own man. Am I proud to watch him be such an incredible basketball player? Of course. But I was proud of Z even before he picked up a basketball. That's just an added bonus. Z is

When your oldest son thinks you're just old and you can't give him buckets anymore.

part of the reason my heart beats. He's part of the reason you see me smiling so much. To my oldest child, I love you more than even you know. Thank you for helping me become the man I am today. Not perfect, but blessed beyond belief.

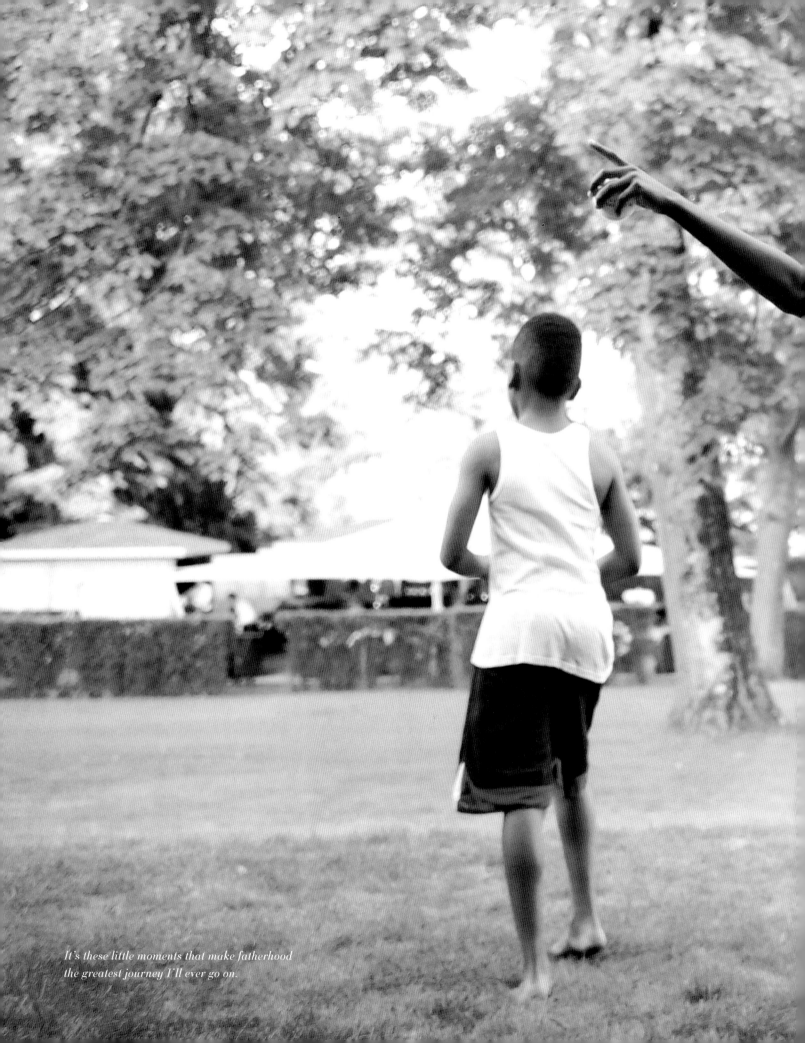

It's these little moments that make fatherhood
the greatest journey I'll ever go on.

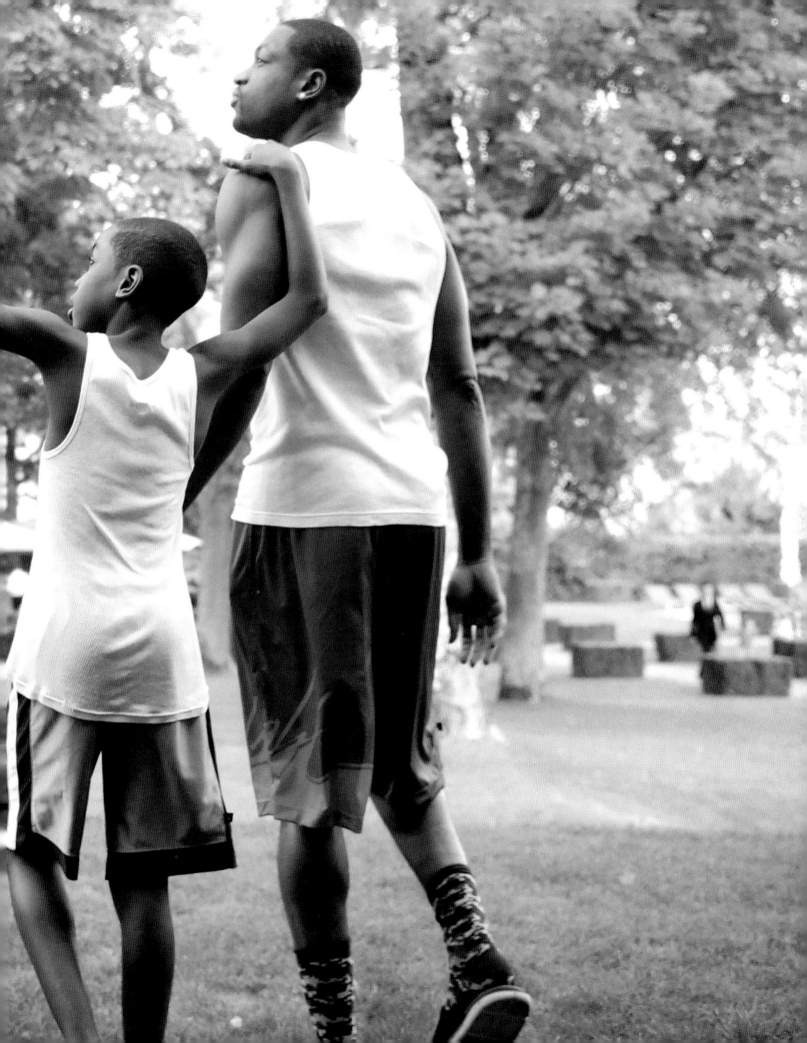

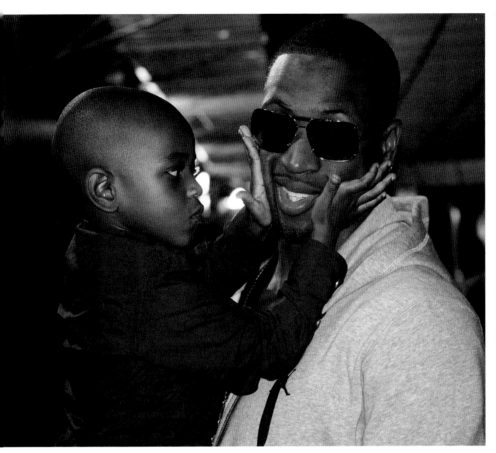
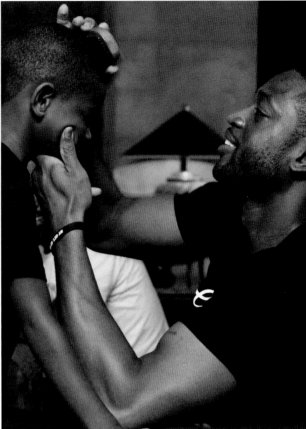

As a parent, I thought my main job was to teach my kids to be good people and lead them on that path. But along the way, I realized that I learn from them as much as I teach.

Zaya has been one of the greatest teachers of my life.

I love her for the young woman she's becoming and the father she's helped me evolve into.

It's these simple moments I carry with me every day. When I first spoke about Zaya's transition, I saw the reaction about how great and how heartwarming it was for me to accept my child's decision. I saw the criticism as well, but ignorance could never inspire me the way love does. But of course I was going to support Zaya through her journey. Turning my back on my child was never an option. We're in this thing called life together forever. Whatever she needs from me, she knows Dad will be there at the drop of a hat.

When Zaya was born, I made the same commitment to her as I did when Zaire was born. That I would, under every circumstance, love her unconditionally.

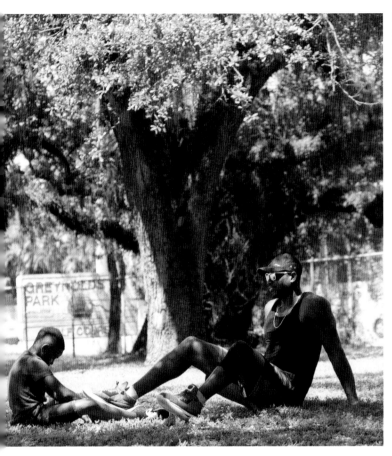

And that, under no circumstance, would I ever allow her to feel abandoned. Zaya is the bravest person I know. Keeping it buck, I didn't know much about Zaya's transition when she told the family. But even having the courage to tell us moved me deeply. I've been in pressure-packed situations on the court before, but what Zaya did blew all of that out the water.

I love the person Zaya is becoming. I love her creativity, and her grasp on the world at such a young age constantly blows me out the water. Every day I wake up I tell myself there's no way I can love her more than I did yesterday, but by the end of the day I've been proven wrong again.

This is how we family.

Here I am teaching my son Xavier the family business. Count that bucket, too. Xavier doesn't live with me, so we don't get to see each other every day like I do with my other kids. It makes things challenging at times, but it's my job to make sure he never has to carry that weight. It's up to me to make sure he knows he's being raised with love even if we don't live under the same roof. And it's up to me to let him know that while distance may physically separate us at times,

I'm always going to be the man he can depend on to love him and help lead him.

What I've come to learn over my life is that fatherhood isn't a monolithic image that looks the same in every household. Each relationship is different. All I'm concerned about with Xavier is him always knowing he's loved.

When my mom was going through some really rough parts of her life, my sister Tragil took me to live with our dad, Dwyane Wade Sr. That's where I met and fell in love with basketball. I can't thank him enough for giving me stability at a time in my life when I desperately needed it. Like so many other parents and kids, we've had our times where we didn't always see eye-to-eye. But when I look at how close we are now, maybe we had to go through those to get this close bond we have now. That's my guy for life. And I thank him for every lesson he ever taught me—on the court, but really away from it. I take those gems with me in every room I walk in.

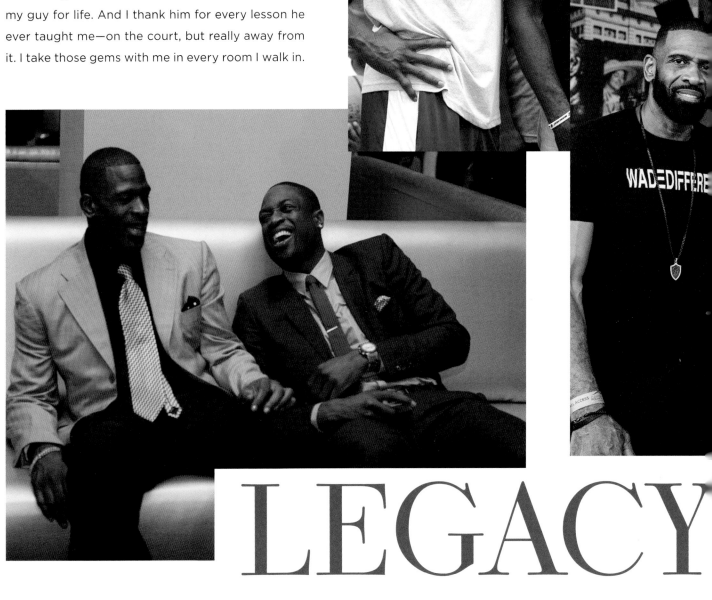

LEGACY

And when it came to basketball, I can't thank him enough for throwing me into the fire. He was always tough on me.

He was very critical of my game—but it drove me to want to be better.

Pops made me play against guys way older than me. It didn't seem fair at first. I got hit, elbowed, bruised, and battered doing that, but it made me tough. Over time, I grew to yearn for that type of competition. My dad had his own demons he had to fight earlier in life, but just like with my mom, I never judged. I couldn't. So, when I see pictures like these, they make me feel good. We both overcame a lot in life to be here today.

By now, you're probably tired of me saying how fatherhood is my most important job. But being able to share in this journey of raising my kids with my dad is such a joy. My dad's a cool-ass grandfather. He's a strong guy and a great role model for my kids. And he's someone they can always depend on for the truth. Whether he's passing down game to them, or telling them funny stories about me when I was their age, he's a nonstop fountain of memories, experiences, and laughs.

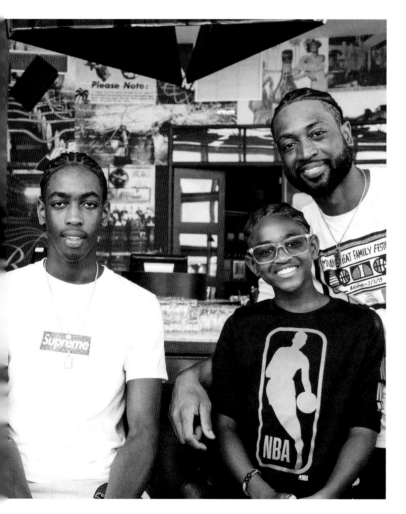

When I see this picture, one word comes to mind: legacy.

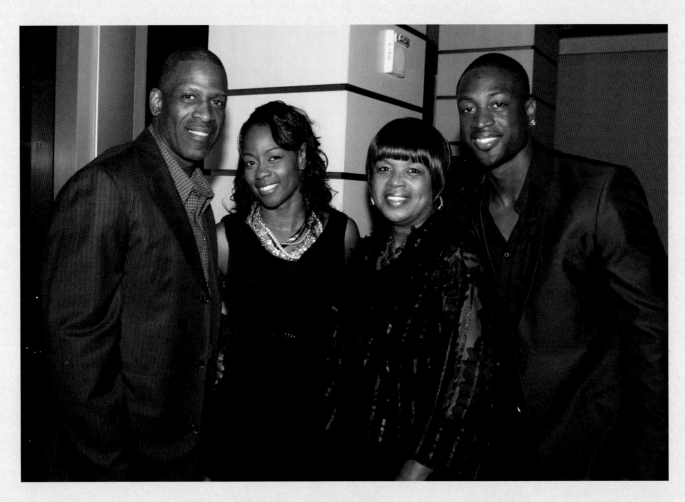

Family is my world. It's not always easy. Damn sure not always fun either.
We've been through a lot, but most importantly, we've stayed together.

From my kids, Gab, parents, sisters, my grandma, and more, all these people are responsible for the man I have grown into these days.

We saw each other at some of the lowest moments of our lives, and we all held each other up.

So to have them there when we won championships or being able to do nice things for them, I believe that's just God at work.

Earlier in my career, I starred in a commercial with the phrase "Fall down seven, get up eight." The commercial was supposed to be a testament to how I approached the game of basketball. But that line could just as easily be said about my mom. It's probably even more applicable to her.

Jolinda Wade's story is well known by now. She battled addiction. She spent time in jail. Watching my mom struggle was hard. I didn't know if she would come home some nights. And when you heard of people around the neighborhood passing away, all I could hope was that she wasn't next.

Through it all, I never judged my mom. I never gave up on her. All I did was love her. Her journey has been hers alone. I don't know how different my life would be had it played out differently. What I respect so much about her is her transparency. I'm proud of my mom for everything she has overcome. She's a role model of mine not because she made mistakes. She's a role model because she never allowed her mistakes to define her story. She's never run away from her flaws. She always accepted responsibility for her own actions, no matter how much they hurt. None of us are perfect in life. Trust me, I've learned that in more ways than one. But I applaud my mom so much for the strength in turning her life around because it's helped more people than she might ever realize. I love my mom with every part of my soul. Everything we've ever gone through in life—I wouldn't change a single part.

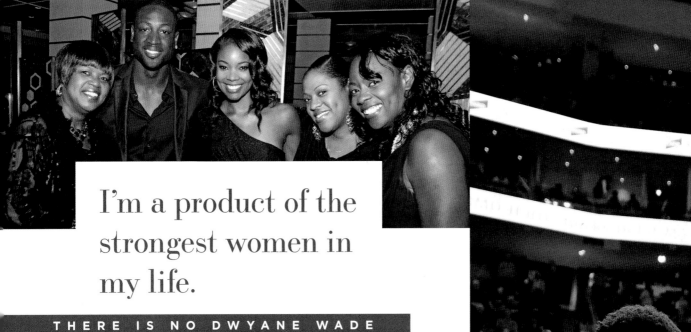

I'm a product of the strongest women in my life.

THERE IS NO DWYANE WADE WITHOUT THESE WOMEN.

All of them are family—two by blood, one by marriage, and one by a working relationship that turned into an inseparable bond.

I explained earlier why Marquette will always hold a special place in my heart. Now imagine going back to have your school dedicate an entire day to you. Then add having your family there to witness it all. The same family who kept you going while you were in college, even when you had a kid on the way and everyone was wondering how you were going to make this work. I'll never forget how important my sister Tragil was at that point in time in my life.

Then, on top of all that, you have your kids surprise you at the ceremony. I was going to be happy regardless because of the magnitude of the moment, but I did want my kids there. But I understood, especially when my family told me they had basketball commitments. I'm a guy who played 16 seasons in the NBA, and I missed out on more than a few family events I wish I could've gotten to over the years. But to have Zaire, Zaya, and Dahveon meet me at half-court—that was one of the coolest moments of my life.

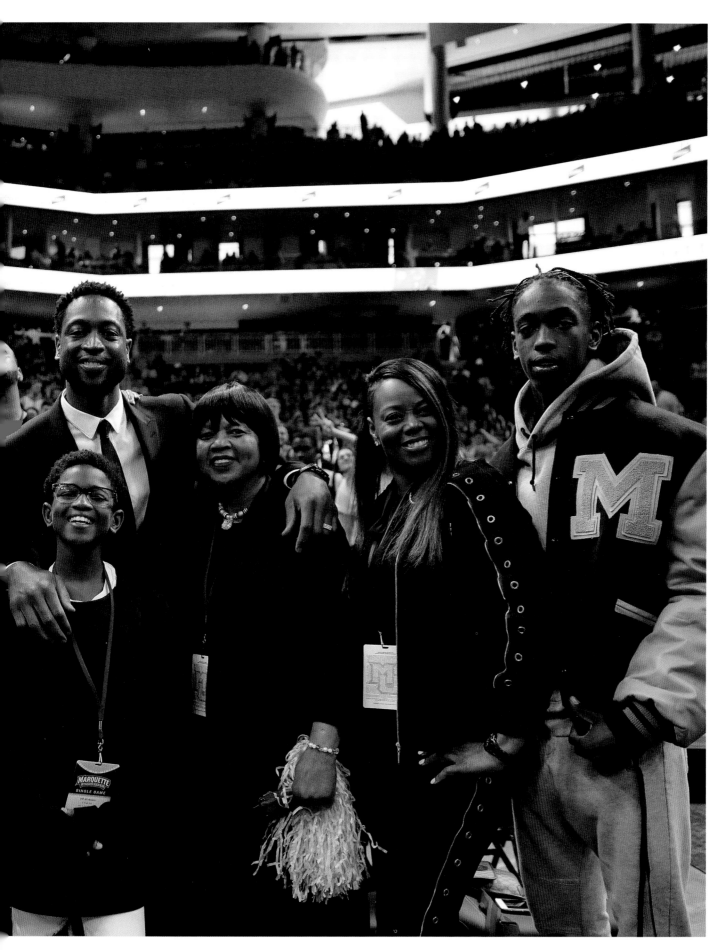

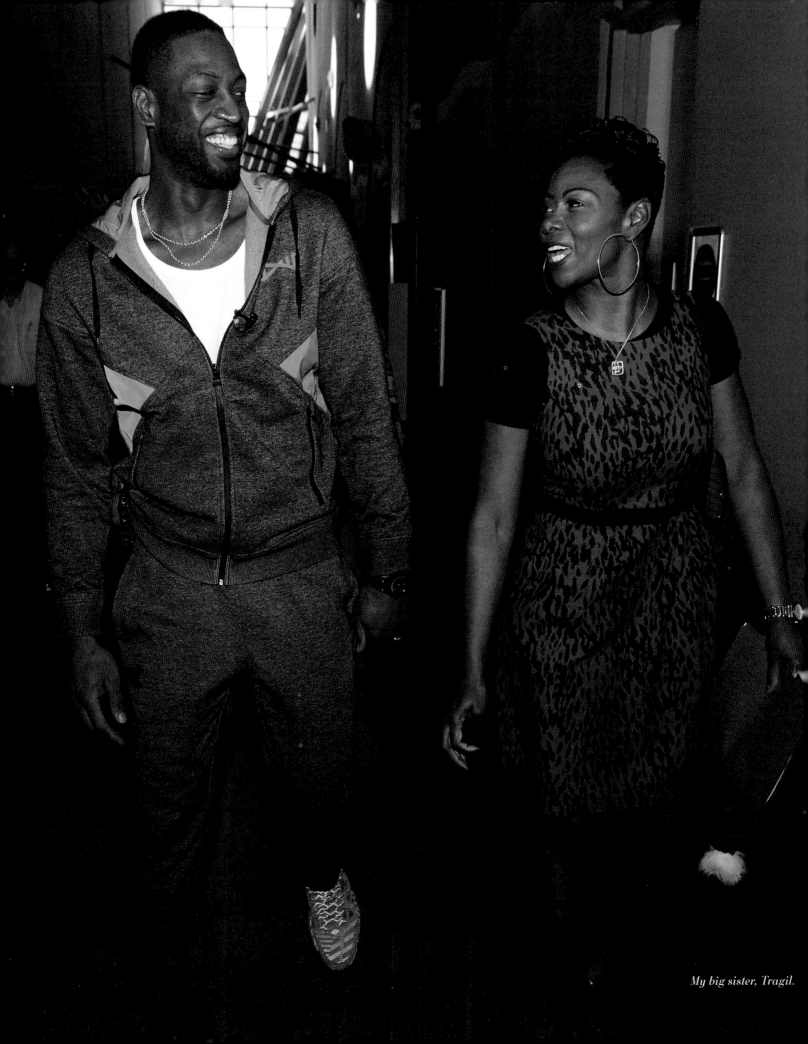

My big sister, Tragil.

If there was a definition for "real one" in the dictionary, my sister Tragil's face should be beside it.

She's a protector. She's a provider. She's a caregiver. She's a straight shooter. She's one of my earliest memories of what a strong Black woman looked like. People see me as D. Wade and see the accolades. But if anyone were to ask me, so much of my strength comes from Tragil. She took me out of a situation that wasn't conducive to my growth when I was younger to go live with my dad. That decision changed the course of my entire life. She was also a big reason why I ended up getting full custody of Zaire and Zaya. When I was stressed out, she was there with me for the entire process. She kept me focused and understanding that no matter how trying that process was, the ultimate goal was being with my kids. That's my big sister. She'll always have a piece of my heart because she never let me forget what it looked like.

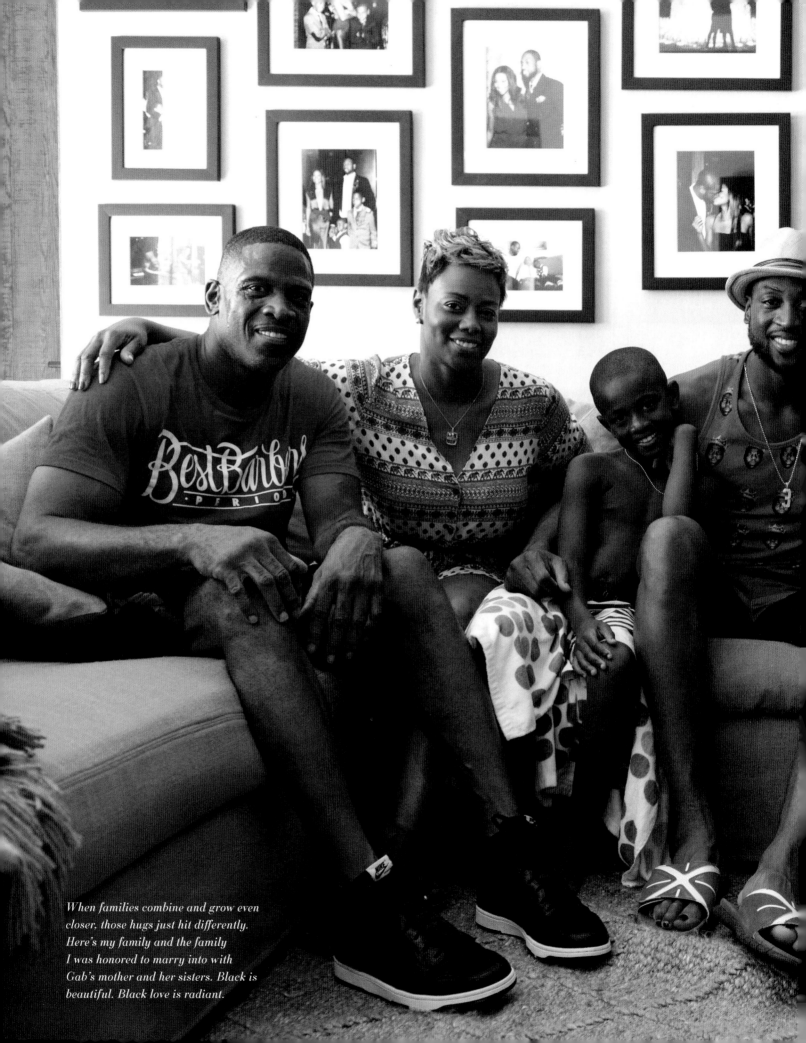

When families combine and grow even closer, those hugs just hit differently. Here's my family and the family I was honored to marry into with Gab's mother and her sisters. Black is beautiful. Black love is radiant.

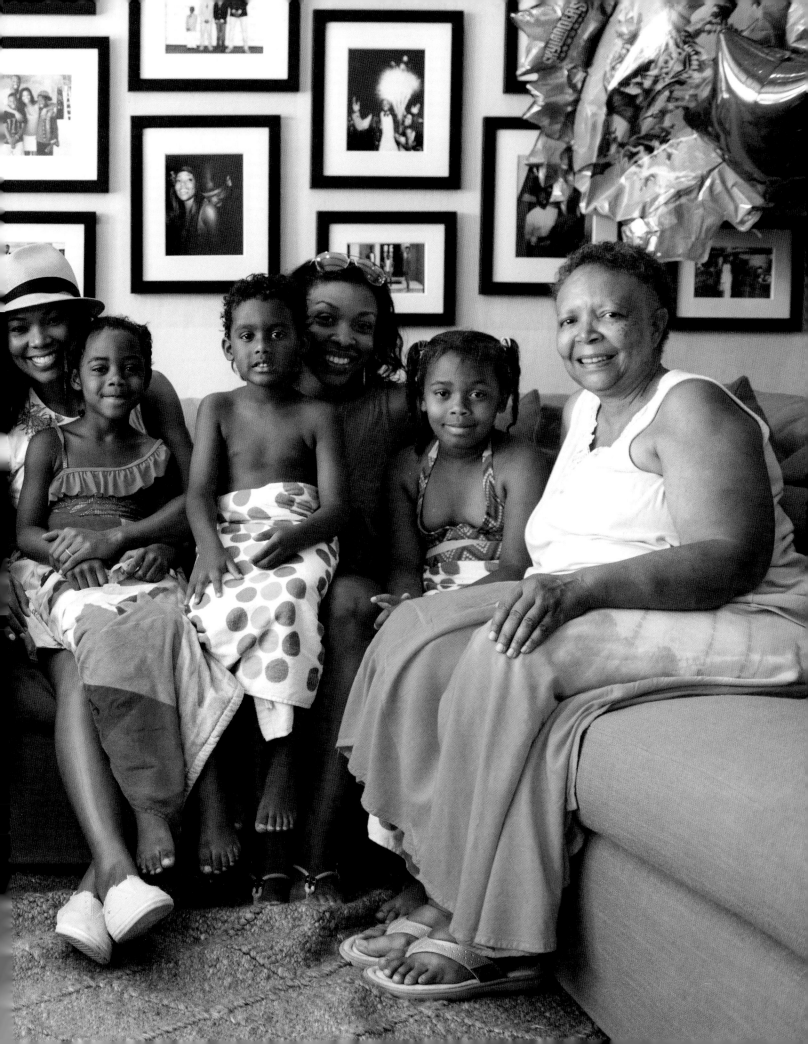

Gab and I have never hid our journey. We had been trying to have a baby for a long time. She suffered nine miscarriages, and it got to a point where I didn't want anything to happen to Gab. It was getting dangerous, and I'm not going to lie to you—I was scared. That's why we decided to go with a surrogate. I remember the hurtful comments about why Gab was in the bed with a gown holding our daughter and so forth. What I've learned is it's so much easier for people to judge than understand. If they did, then they'd understand why holding Kaavia was one of the most important moments of both of our lives. And why every day since she's come into our lives has been so incredible. Our daughter is a testament to perseverance and love. We'll never let ourselves forget that.

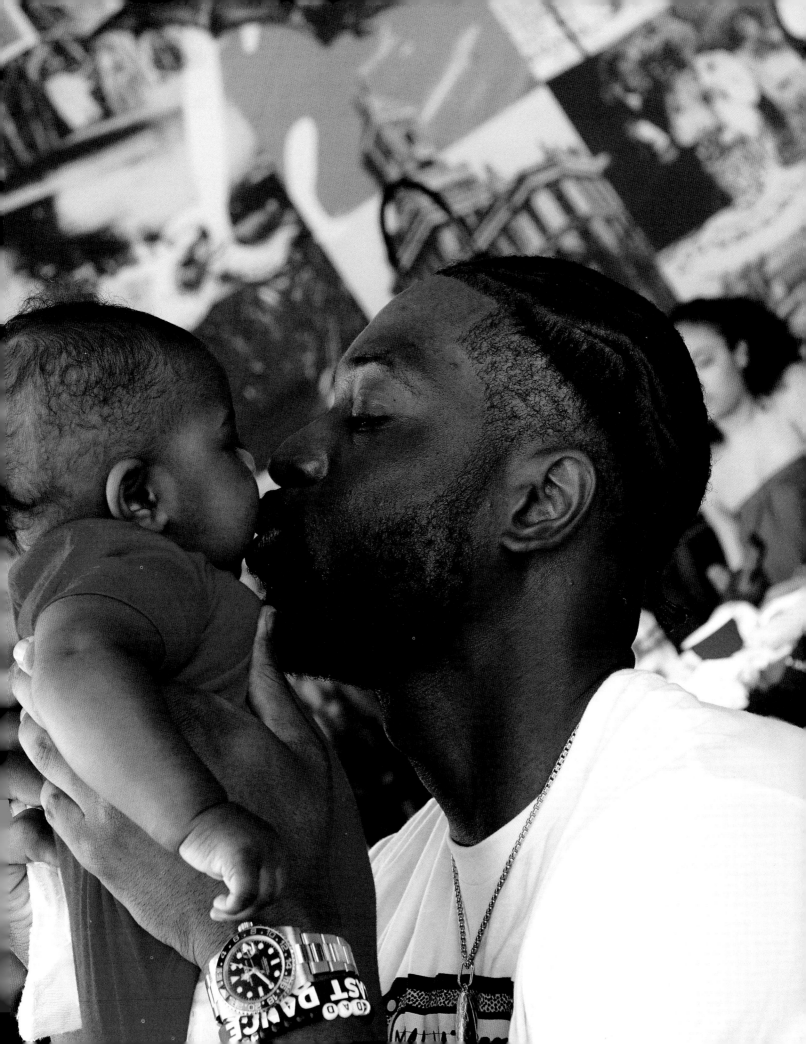

POSTGAME

Hank and I always talked about the importance of leaving a legacy. When I was younger, I didn't necessarily grasp what a legacy was. I was young and carefree, but being young and carefree always gives way to maturity and introspection. My basketball career is over. There's no coming back for me, but I know what those conversations with Hank mean now more than ever. What will I leave behind that has made the game, the people I've met, and the lives I'm responsible for better? That's what legacy is.

If we do this life thing right, who we are and what we stand for will always live in concert together. We remember words, but we immortalize actions. For 16 seasons in the NBA, all I ever wanted to do was treat the game with the respect it deserves. Honestly, even longer if I go back to those concrete battles in Chicago. All I ever wanted was to be respected for the way I played the game. I walked off the court that last night in Brooklyn knowing exactly that. I couldn't ask for anything more!

The jersey swaps were phenomenal. I loved every single one of them. But they take a distant second to this princess coming into my life. If you follow Gab or myself on social media, then you already know Kaavia. But what a lot of people don't know is that a big part of my reason for leaving the game was because of her. I had already missed so many crucial life moments. My family understood, and ultimately I did, too. And while I understand that it's part of the game I played, I couldn't do that again. She's my perfect exit interview.

During my last season, our daughter Kaavia was born. I ended up taking some time off because it was important for me to be there the first time she laid eyes on Gab and me. I've always done things my way, so this didn't feel like some landmark decision in my eyes. But it's been cool to see the conversation it helped spark around paternity leave in sports.

My last season was important to me, of course, but this was family. There are 82 games in an NBA season. But your daughter's only born once. I'll never forget seeing Kaavia for the first time. But to witness the joy on Gab's face? That's a feeling of happiness nothing in this world can ever replace. Having a surrogate carry Kaavia, Gab and I knew that the initial moments of us being around her would be vital. To speak to Kaavia, to laugh with her and just kiss her cheeks and tell her how much we love her, we knew that was a bond that had to happen immediately.

All of your kids teach you something about yourself. With Kaavia, she's given our family another lifeline. You find deeper purpose in your own life by the ones you are given the responsibility to protect. Oh, and for those wondering, Kaavia's side-eyes are already a family heirloom at this point. She will absolutely let you know when she's fed up. No one's immune either. Not me, Gab, Zaire, Zaya, Dahveon—anybody.

I didn't know how my last season would turn out, but I wanted it to be special. I watched Kobe's last season and the love the entire league (and country) poured out for him. I saw Mike's in Washington. They even gave Dr. J a rocking chair for his. Life is funny like that, because during my last dance I got a rocking chair, too. Donovan Mitchell gave it to me during my last stop in Utah—and the next night I needed it!

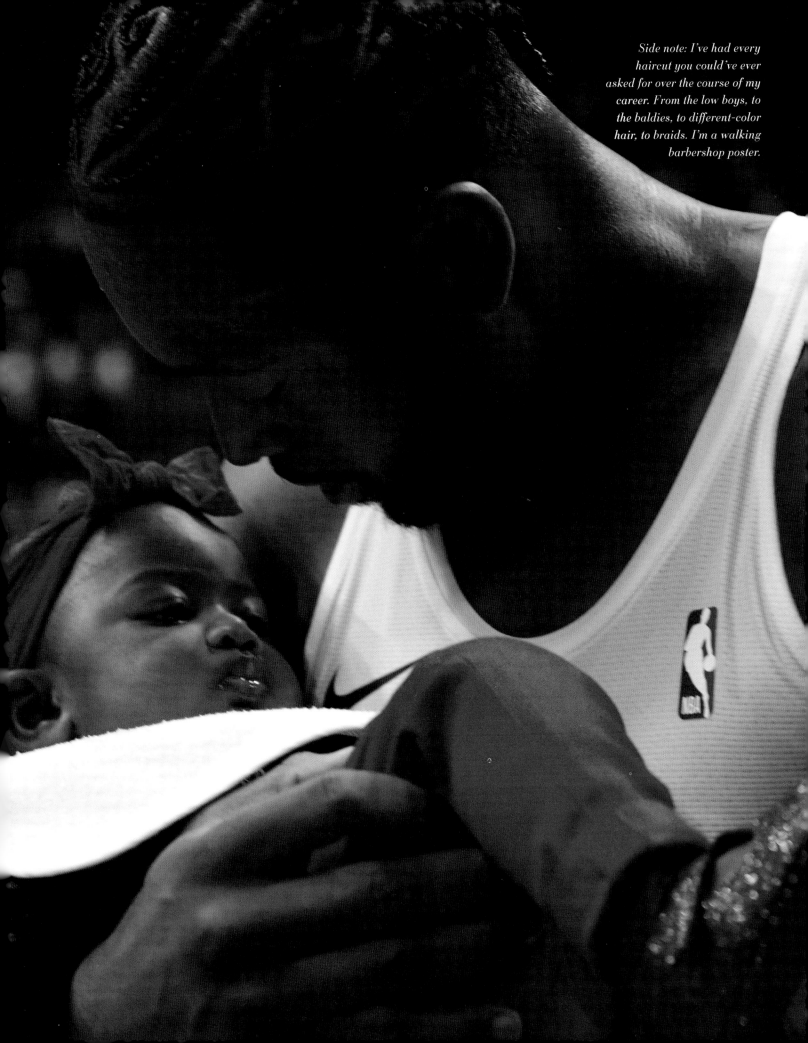

Side note: I've had every haircut you could've ever asked for over the course of my career. From the low boys, to the baldies, to different-color hair, to braids. I'm a walking barbershop poster.

Every game was special. I got standing ovations in places that have booed me for years. But hearing from your peers how much they appreciate you is a feeling money can't buy. They made me compete every night.

As the end of the season drew closer, I never got cold feet. I knew I was making the right decision. And I still do, which is why I can look at these pictures with the greatest sense of fulfillment.

Of course, I would've loved to win another title in my last season, but there's nothing I would change about that last season. Nothing at all.

I LIVED A FULL

BASKETBALL LIFE

Soccer and NFL players have been swapping jerseys for a while, and I always thought it was a dope gesture of respect.

The idea came to me the summer before my last season. During Kobe's last year, he signed shoes for a lot of guys. I thought I'd swap jerseys. I knew I was going to need a ton of jerseys if I was gonna pull this off right. When you've been in the league as long as I have, you make a few friends!

Money and celebrity come with their perks for damn sure. But respect doesn't come with a price tag. You can't buy that or talk your way into it. You earn it by the work you put in and how you treat people along the way. To know I left this league with the respect I had from my peers means the world to me.

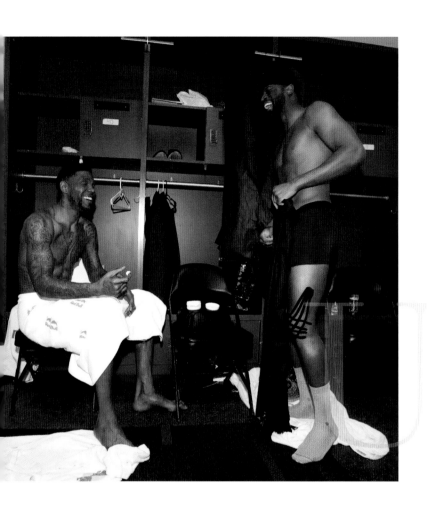

Certain people come into your life and not even blood could make you closer. Udonis Haslem—you better call him UD—is one of those people for me.

UD and I came into the league together. And aside from my year in Chicago and half season in Cleveland, we spent our entire careers together. In the last game of my career, I found UD wide open to give me a triple double in my final NBA game. The world first met me through the triple double I put on Kentucky, so going out the way I came in was special for me.

UD is as important to those three title teams as anyone. He's an enforcer, a big-game player, a guy you need in the locker room to keep everything in order. There was almost a point where he left Miami in 2010. He had a deal elsewhere that would've paid him more money. (Ironically, Dallas really wanted UD that offseason.) I couldn't have been mad at him if he took it, but I don't think either one of us wanted to accomplish anything without the other.

I look back on the days when we bought matching Bentleys and would hit the club wearing big 6X white tees, baggy jeans, and even bigger chains. I'd do anything for UD and I know he'd do the same for me. From one Dade County legend to another. That's my brother for life.

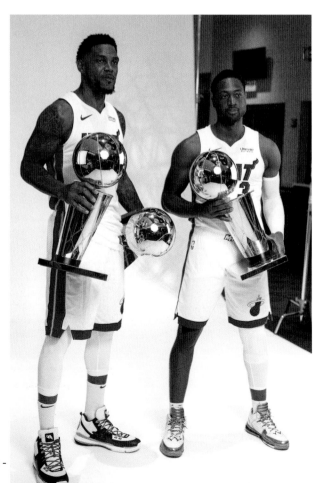

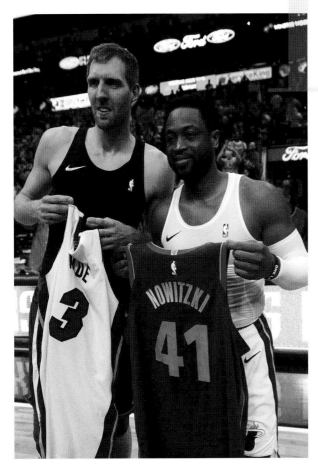

We played different positions, but I looked at Dirk as a rival. Swapping jerseys was a huge moment for me. We haven't shared many conversations since the 2006 Finals. Dirk was one of the hardest guys ever to game plan. Trust me, I know firsthand. I was on those teams that had to game plan against him. Honestly, though, he's just an all-around great guy. One of the game's greatest international ambassadors, too.

Dirk and I are connected forever. My squad got the best of his in 2006. He returned the favor in 2011. Our last All-Star Games were together, and we retired at the same time. Dirk's honestly just one of those guys who I'll always speak highly of.

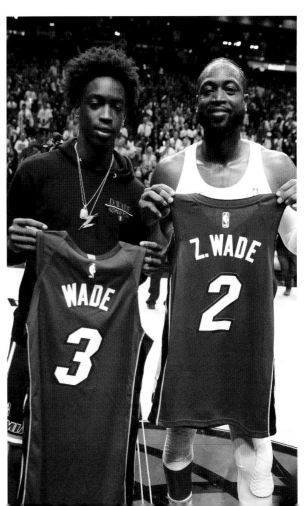

If you would've told me this was a possibility the night I was drafted in 2003. I'd have called you a liar. By far my favorite jersey swap.

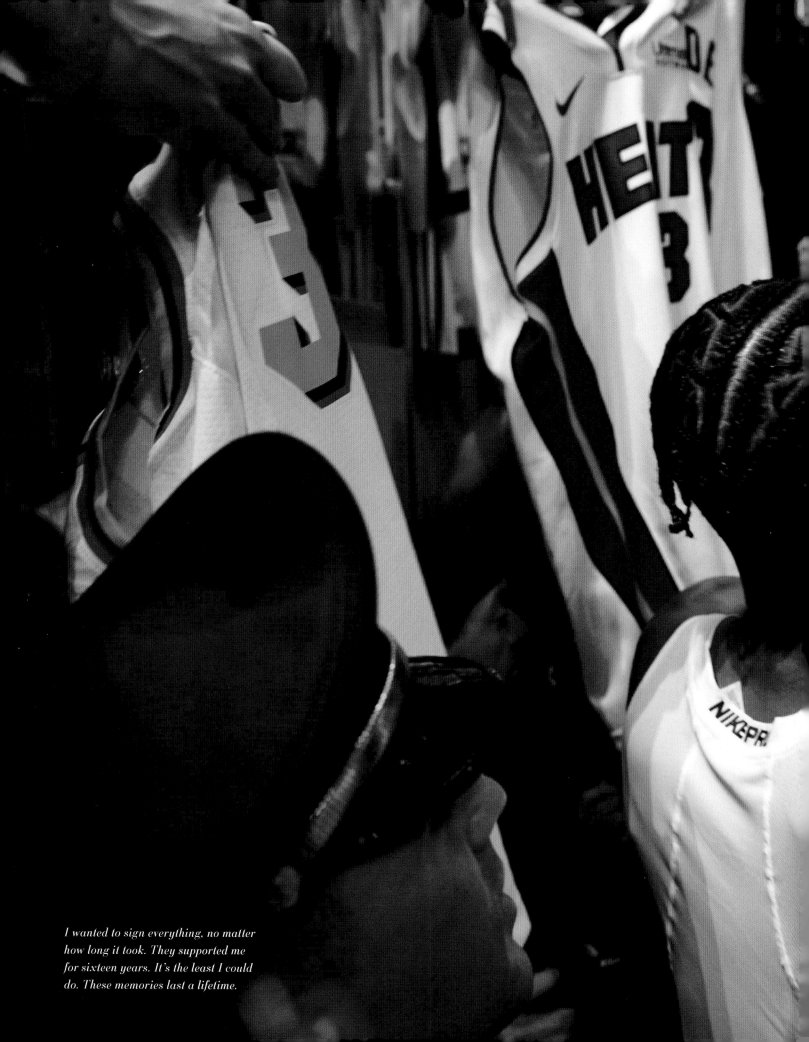

I wanted to sign everything, no matter how long it took. They supported me for sixteen years. It's the least I could do. These memories last a lifetime.

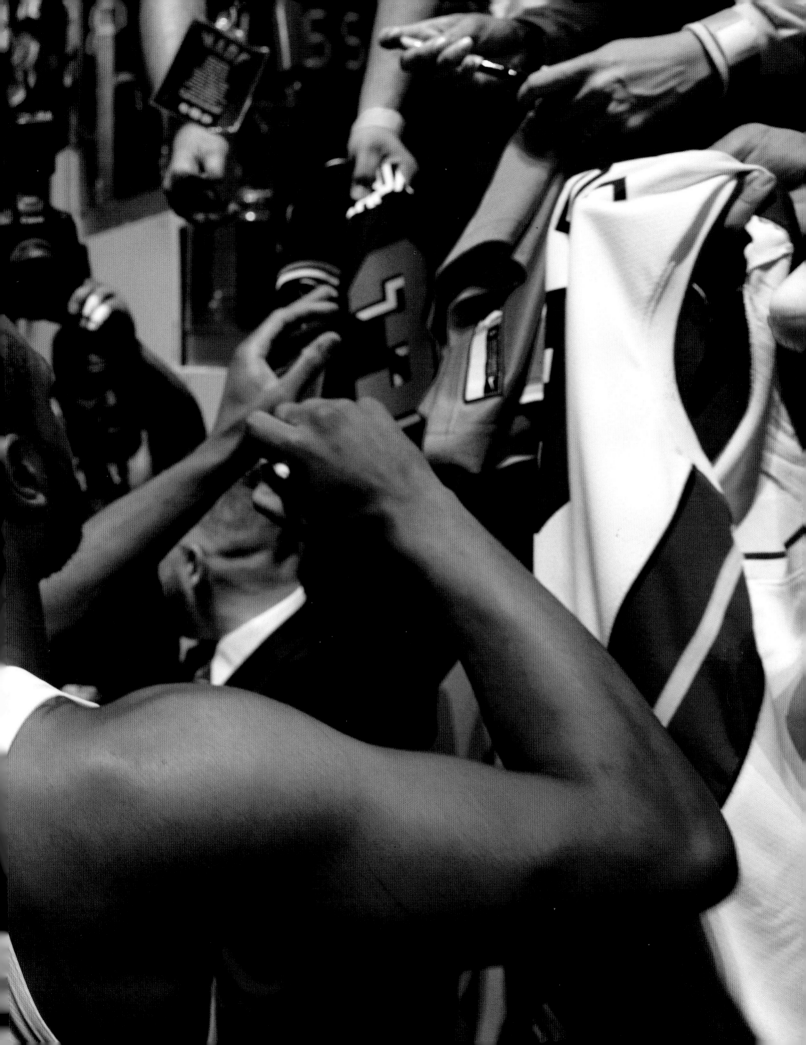

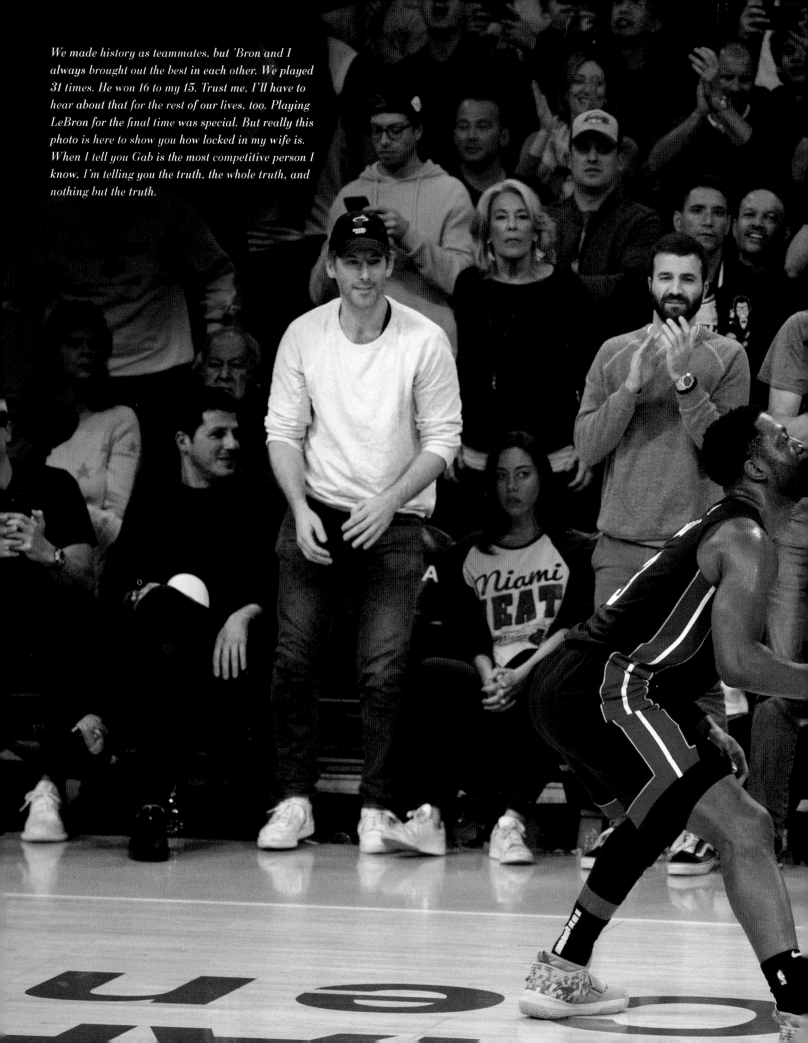

We made history as teammates, but 'Bron and I always brought out the best in each other. We played 31 times. He won 16 to my 15. Trust me, I'll have to hear about that for the rest of our lives, too. Playing LeBron for the final time was special. But really this photo is here to show you how locked in my wife is. When I tell you Gab is the most competitive person I know, I'm telling you the truth, the whole truth, and nothing but the truth.

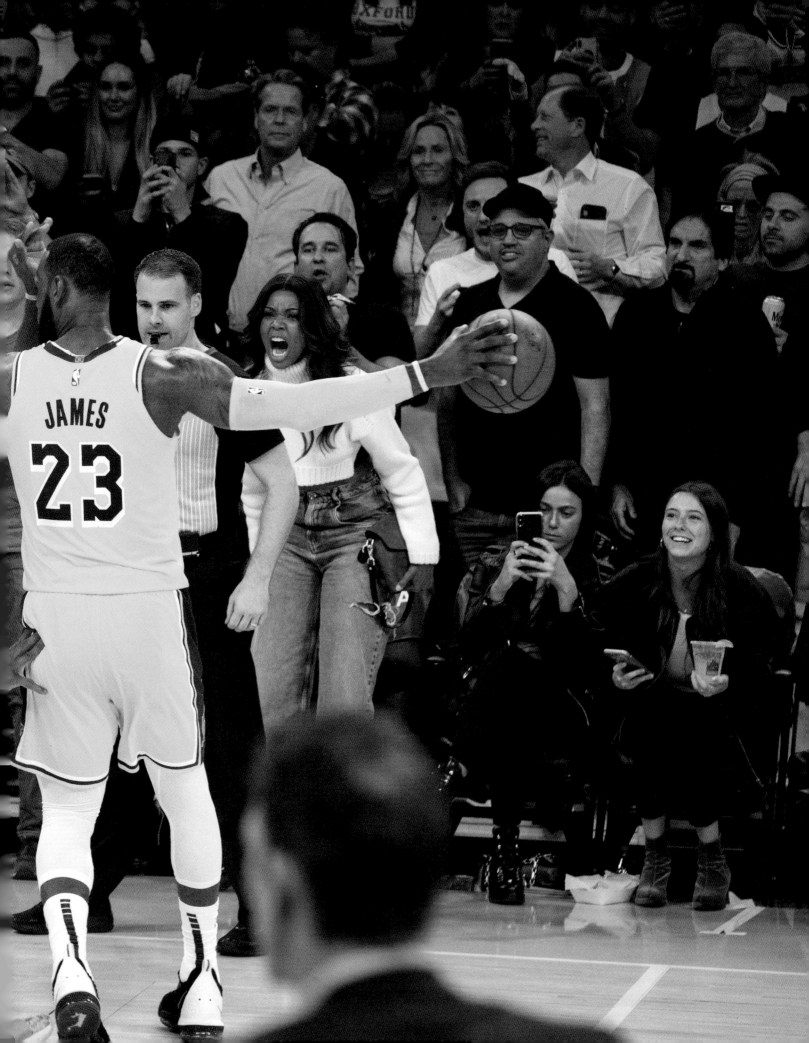

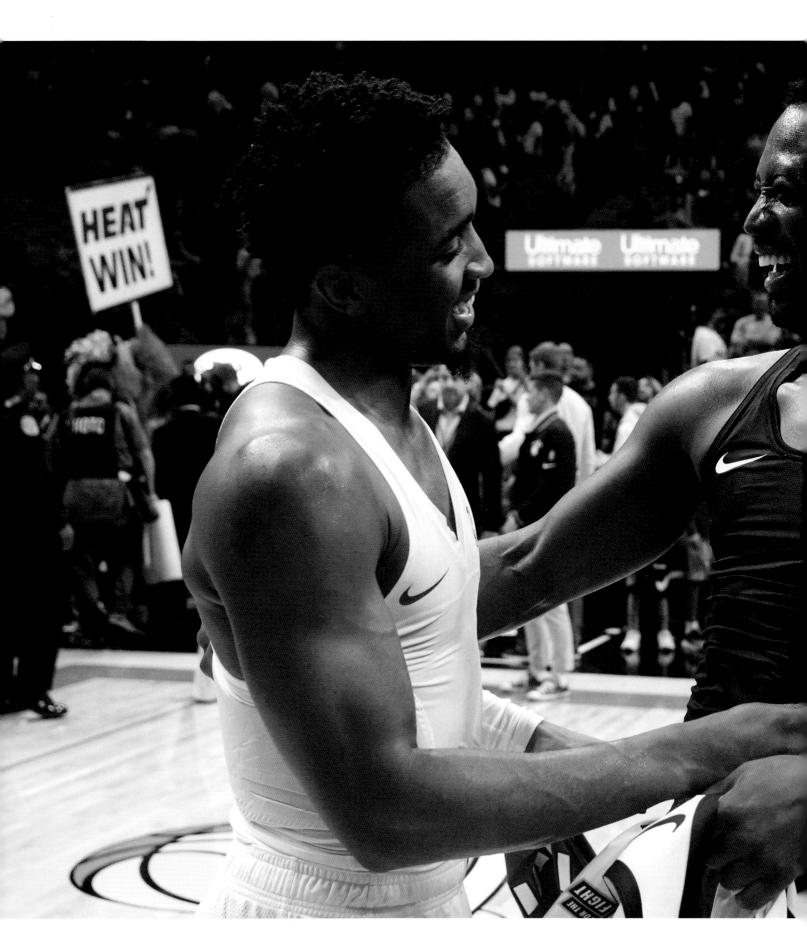

Donovan Mitchell is a sponge.
He's always asking questions.
Our games are similar.
All credit to Donovan. He
reached out to me to ask me
how I became the player I
was rather than trying to just
do it on his own.
We'd talk on the phone for
two hours sometimes. He
would call me up and say,
"Hey, bro, how did you do
that move on me?" And then
he'd go and put the work in.
How could I not respect that?

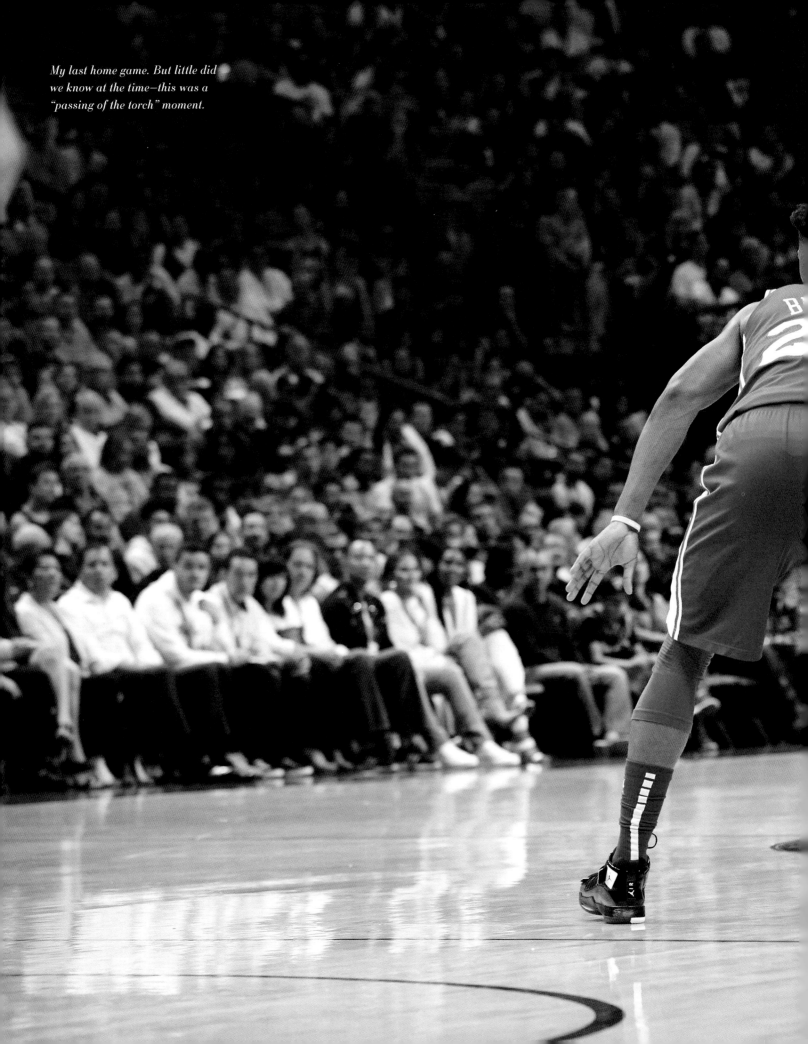

My last home game. But little did we know at the time—this was a "passing of the torch" moment.

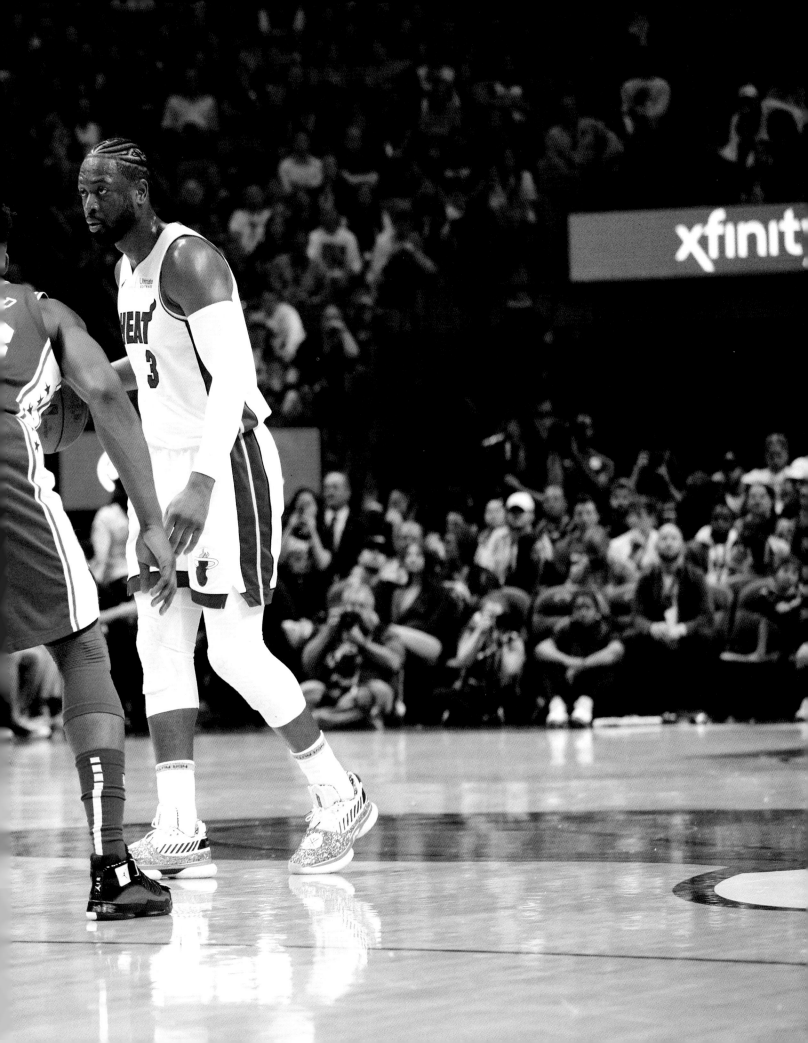

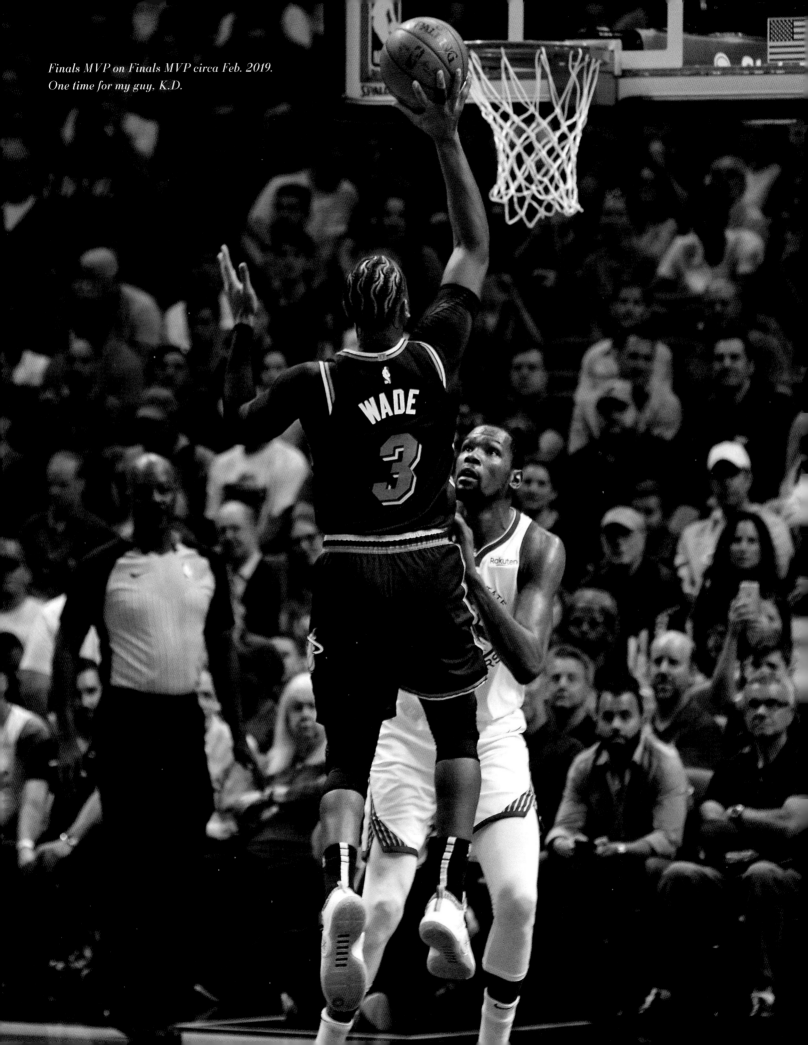

Finals MVP on Finals MVP circa Feb. 2019.
One time for my guy, K.D.

That night, I hit a
GAME-WINNER

I'm still tripping off. I hit a lot of big shots in my career, but few crazier than this.

It was a few weeks from the end of the season, and we were playing Golden State. Whenever the Warriors came to town it always felt like a prizefight. They were the top dogs in the league and they really struck fear in a lot of people just how easily they could overwhelm you.

By the time the fourth quarter came around, we all knew we could take this game. I've been a defending champion before, so I know how teams come at you like they want to rip your heart out. That's how we were that night.

Having the ball in my hands in the fourth quarter has always felt natural. But I knew this was a special moment. We're down two with 10 seconds left to the

Durant-, Curry-, Thompson-, Green-, and Iggy-led Warriors. Speaking of Iggy, he's guarding me. He's one of the best defenders I've ever played against, so the fact that he didn't bite on my drive to the rim isn't all that shocking. I kick it out to Dion Waiters—a guy who is never afraid to take a big shot. Only this time the Warriors double-team him and he kicks it back to me. By now, I know it's not a lot of time left on the clock so I'm just not trying to get caught with the ball in my hands at the buzzer. I take a three. It gets blocked. What happened next is something I'll likely never understand until I can ask God Himself. The ball landed in my hands. I heaved it towards the basket. Buckets.

There's a video of me running around all crazy, but I don't even remember my feet hitting the ground. It was basketball nirvana. Jumping on the scorer's table that night felt so good because I knew I'd only have but so many more chances to do so. But in hindsight, this play was indicative of my life's story. Backed against a wall, all chips pushed to the center of the table. You're either going to run or you're going to fight. I've never run from a challenge.

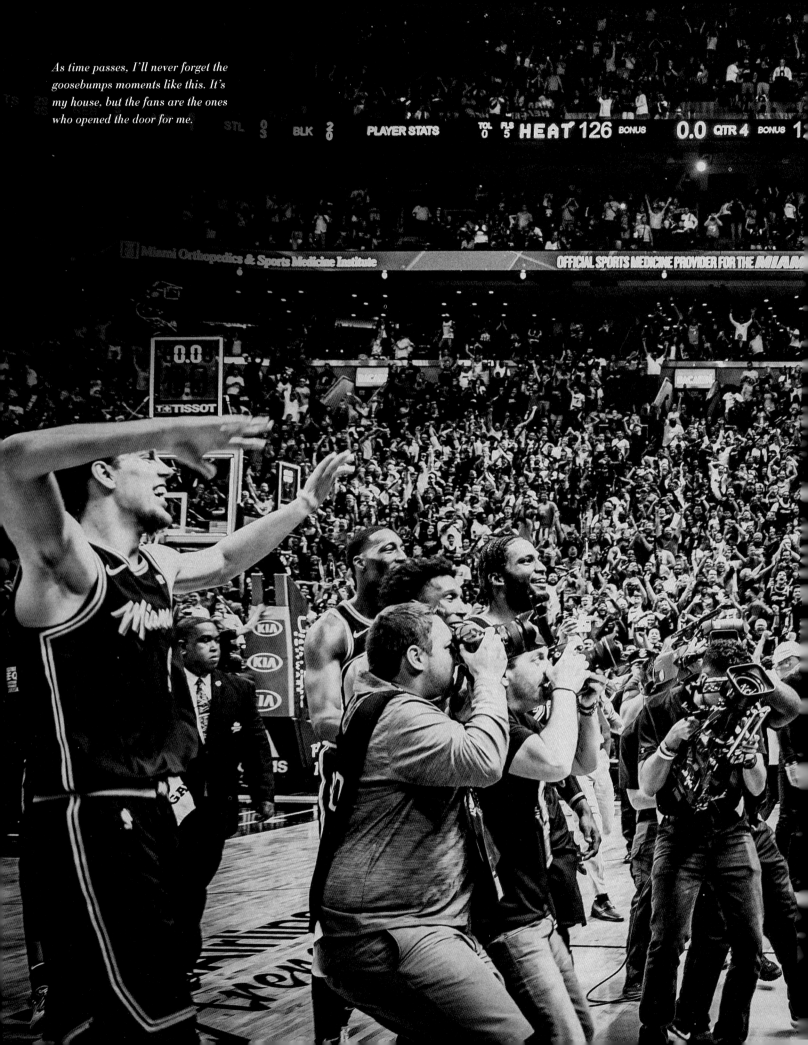

As time passes, I'll never forget the goosebumps moments like this. It's my house, but the fans are the ones who opened the door for me.

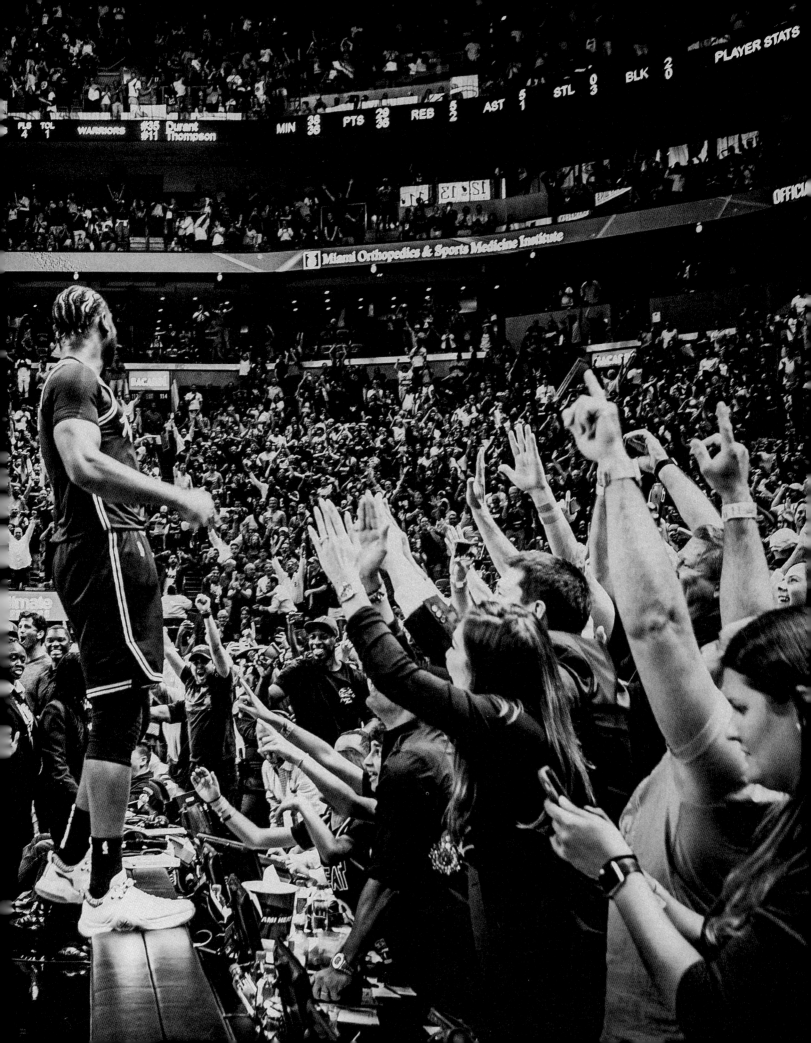

Every great player loves to play in Madison Square Garden. So much history has happened in that building. The first Muhammad Ali and Joe Frazier fight went down here. Bernard King, Willis Reed, Clyde Frazier, Patrick Ewing earned their stripes here. Kobe dropped 62. Jordan gave the city a double nickel in one of his first games back in 1995. Jeff Van Gundy even hung on to Alonzo Mourning's leg not too far from where I'm standing! This was March 30, 2019, my last game in the Garden. I took with me a ton of memories from over the years. Right here I'm just taking it all in. When you're younger, there's comfort in saying "the next time." But eventually, "the next time" becomes "the last time."

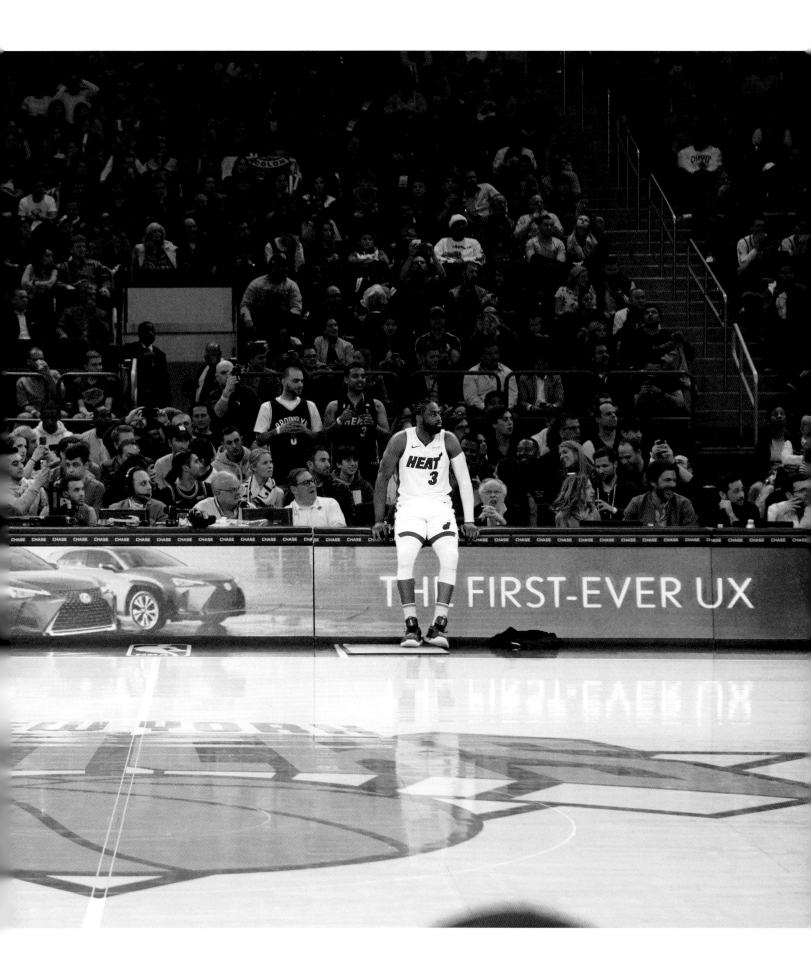

Politicking with the greatest commissioner in all of sports, Adam Silver,
at the PlayMakeHERS Luncheon where I was being honored.

When you come into the NBA, you're not thinking about retirement. That's for old men! Fast-forward to my last year in the league, even then I couldn't imagine how it would go.

A roast is how! At All-Star Weekend, so many of the people who made me who I am showed up to rib me: my parents, two of my brothers in 'Melo and C.P., the guy who drafted me in Pat Riley, Chicago legend Isiah Thomas, Magic Johnson. But I'll tell you what.

I'm grateful as hell that it happened. It's a natural human emotion to know that you're appreciated. And not many things say "we appreciate you" more than getting your own Hollywood star (which actually happened that night). I'll take that moment with me forever.

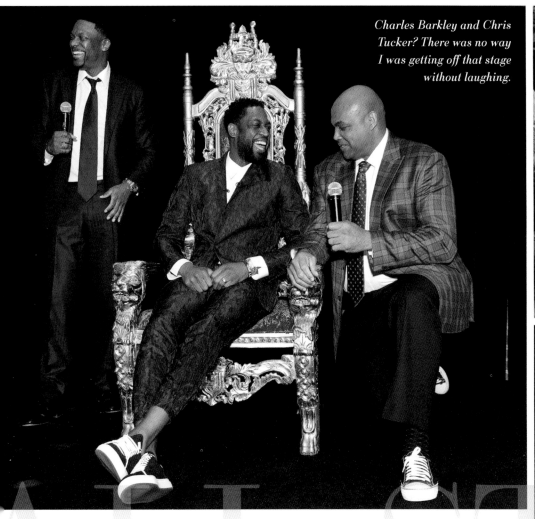

Charles Barkley and Chris Tucker? There was no way I was getting off that stage without laughing.

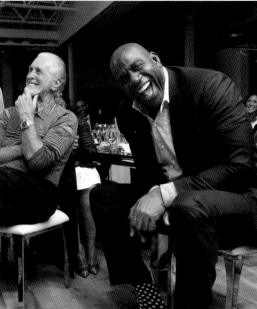

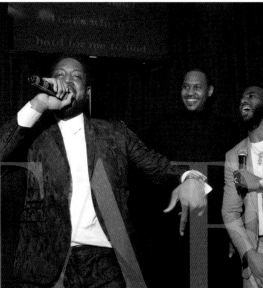

I feel confident saying I'm the greatest NBA karaoke singer to ever live. I'm doing Bell Biv DeVoe's "Poison" right here.

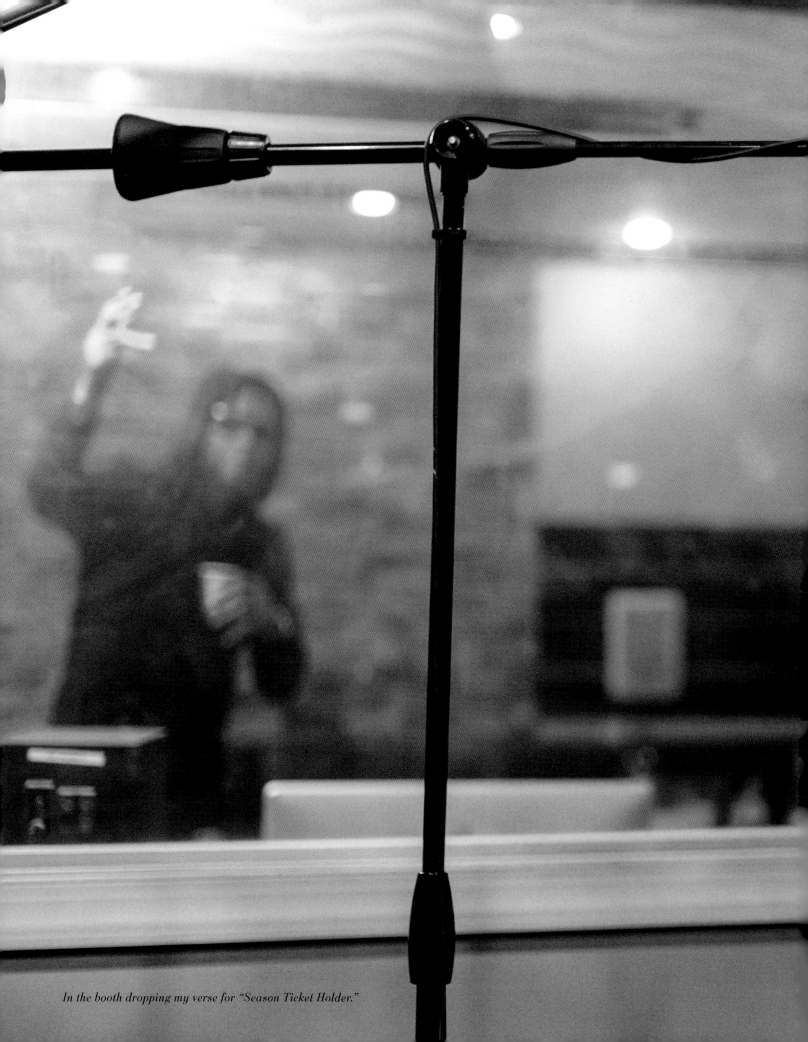

In the booth dropping my verse for "Season Ticket Holder."

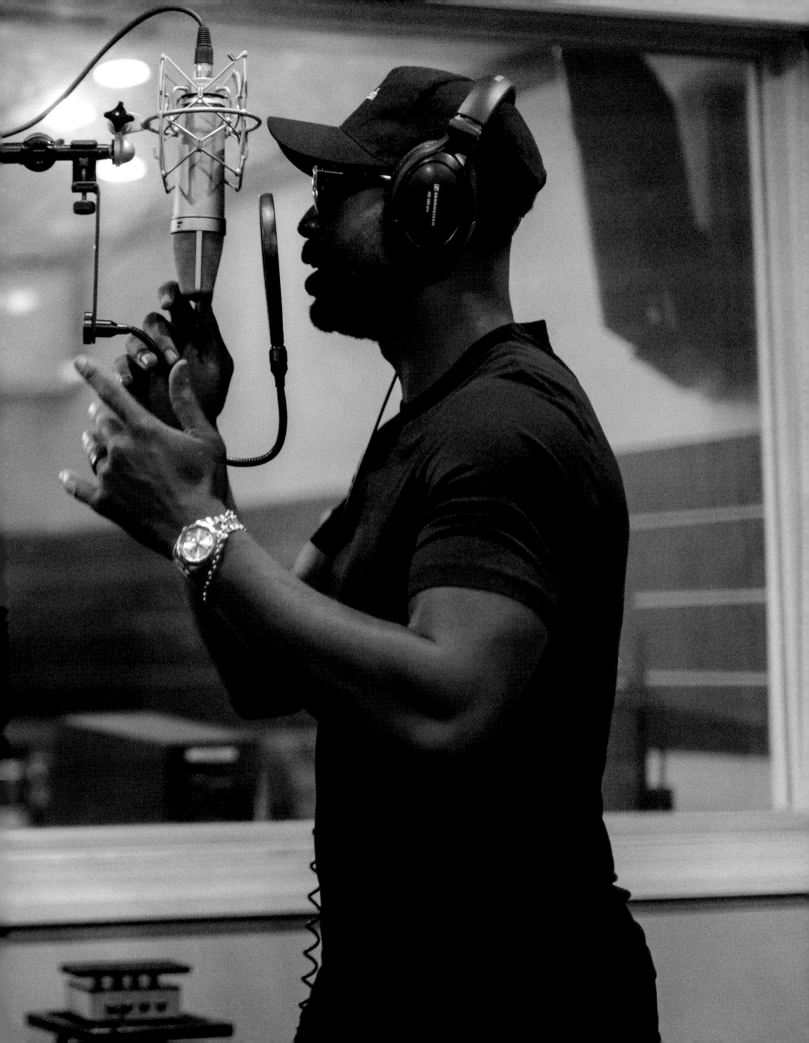

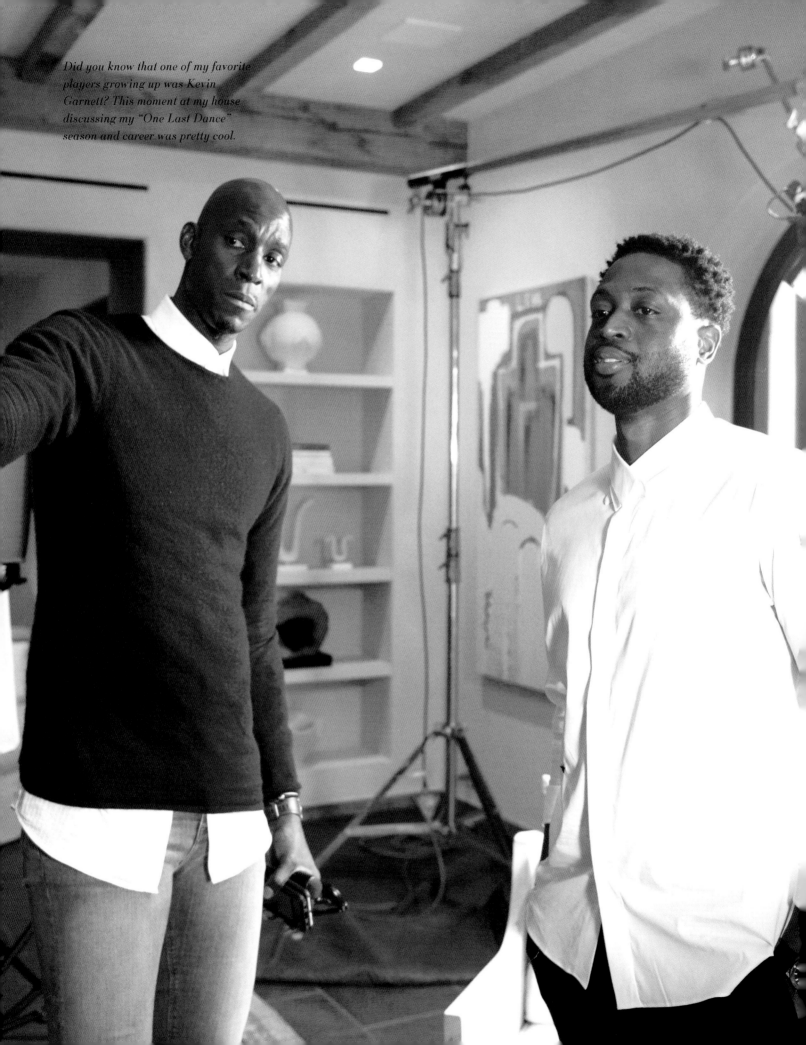

Did you know that one of my favorite players growing up was Kevin Garnett? This moment at my house discussing my "One Last Dance" season and career was pretty cool.

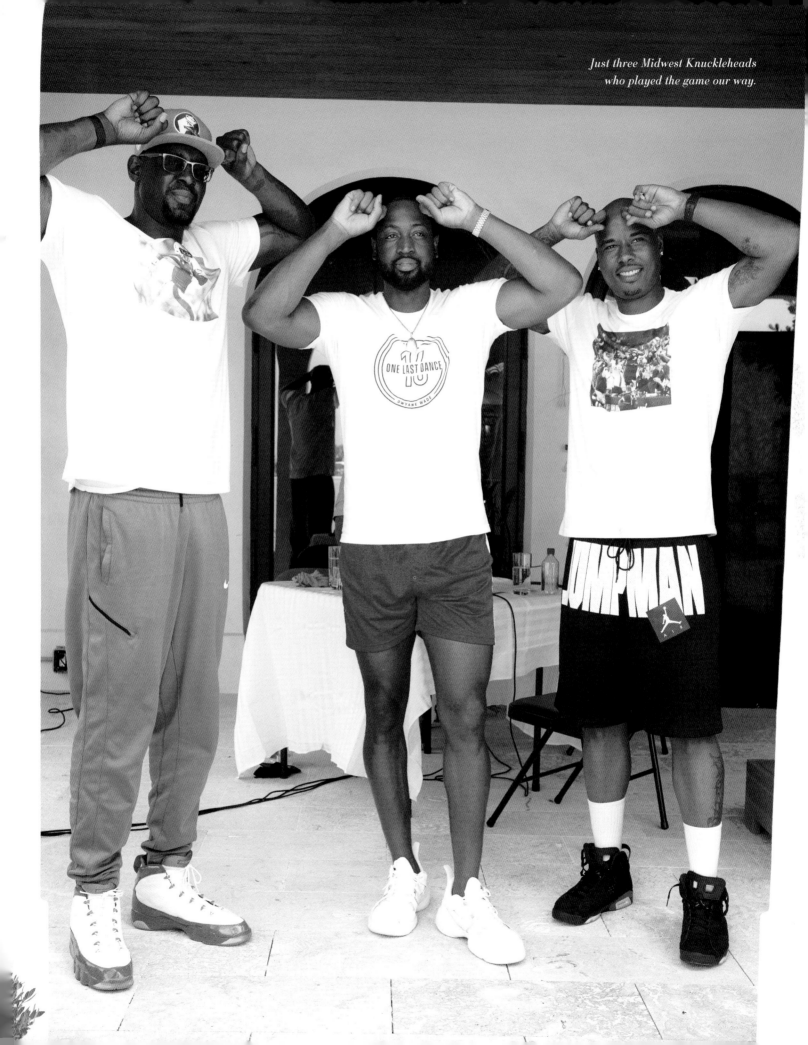

Just three Midwest Knuckleheads who played the game our way.

WADE COUNTY

Basketball, like life, will always bring you back to the beginning. Here I am at Dwyane Wade Day at Marquette in 2019. I can still hear the screaming crowds when we went off to play in the 2003 tournament. To hear that same crowd come back and give me this type of send-off, it just tells me that I always made the right decision.

Marquette is as big a part of my life story as anything. I'll always love Chicago because I'm from there. It's home. But home is also where you experience true love and growth. And the love I get in the 305 is unparalleled. Hearing "Wade County" still trips me out to this day. It was even legally changed to that in the summer of 2010. From July 1 to July 7, Dade County was officially "Wade County." Miami was trying to make sure I re-signed with the Heat. Let's just say the deed more than worked, because not only did I re-up with the team—LeBron and C.B. signed on, too. Mission accomplished.

What I'm most proud of is we helped make that city a basketball powerhouse forever. They have to speak of us in the same vein they do Don Shula's Dolphins or the Jimmy Johnson–led Hurricanes. For that, the city of Miami will always, always have a piece of my heart and soul for as long as basketballs bounce.

You have to understand that knowing I'm having a party based around my retirement tripped me out. I remember deciding I was leaving Marquette to come to the league. Now I'm actually retiring from the NBA. Life comes at you super fast. The only thing you can hope is by the end of it you lived it the way you can be proud of when that ride comes to an end.

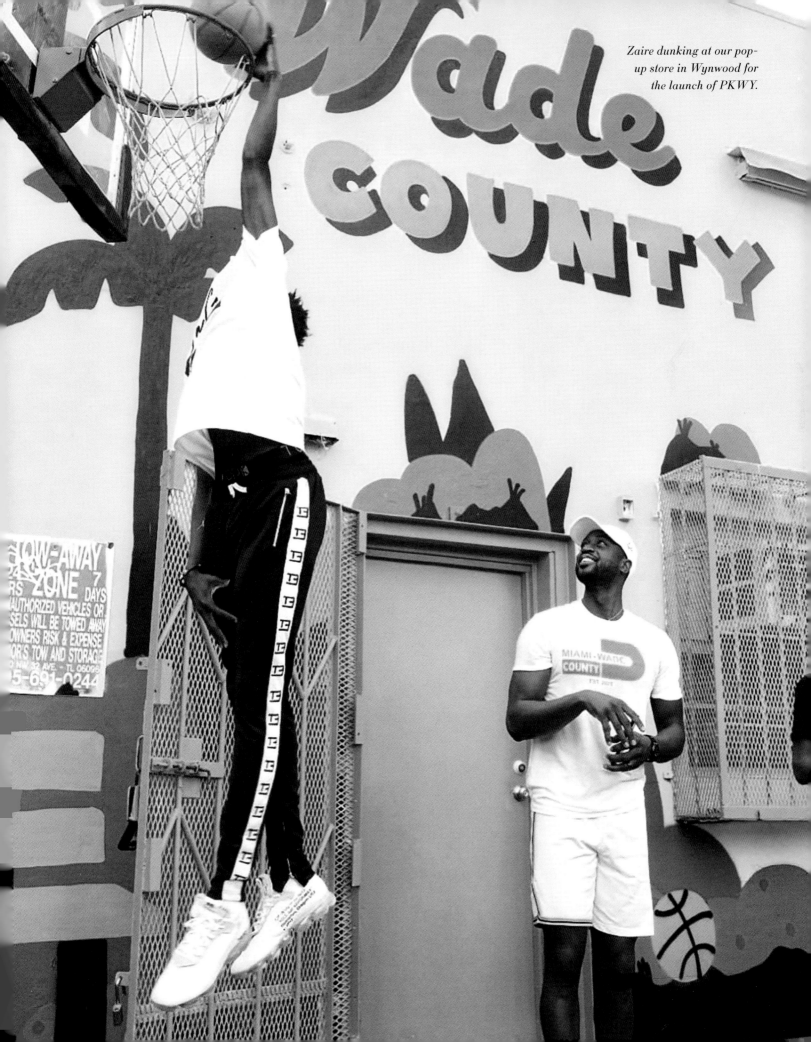

Zaire dunking at our pop-up store in Wynwood for the launch of PKWY.

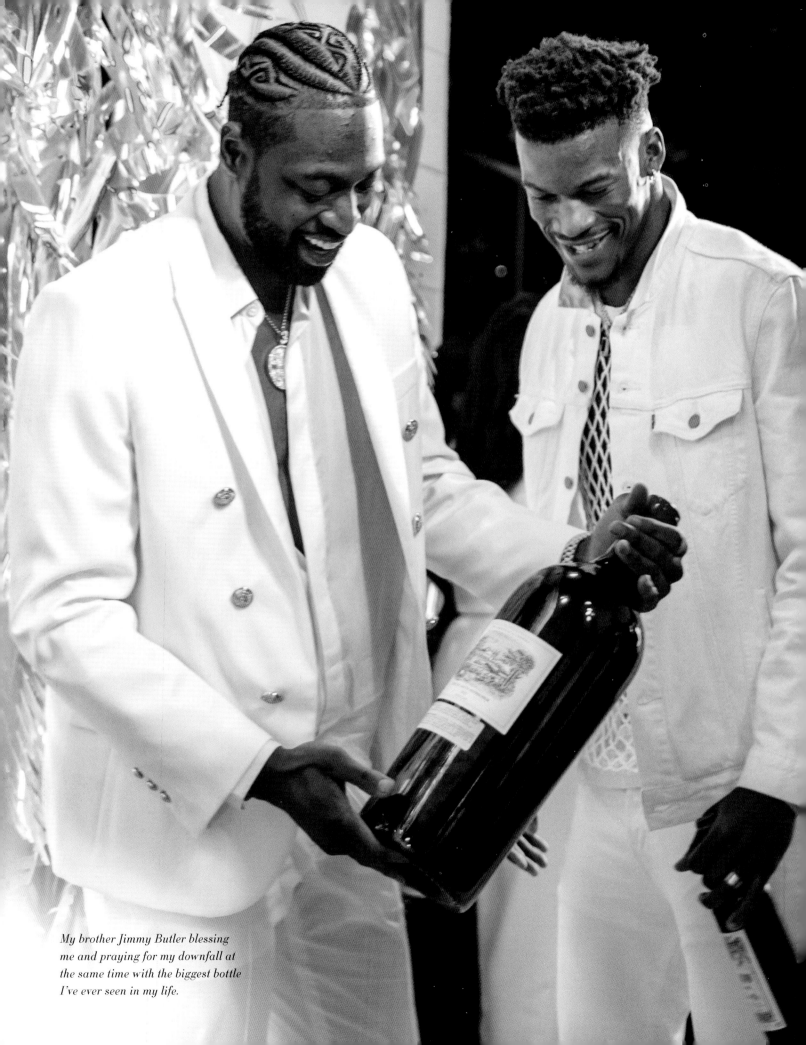

My brother Jimmy Butler blessing me and praying for my downfall at the same time with the biggest bottle I've ever seen in my life.

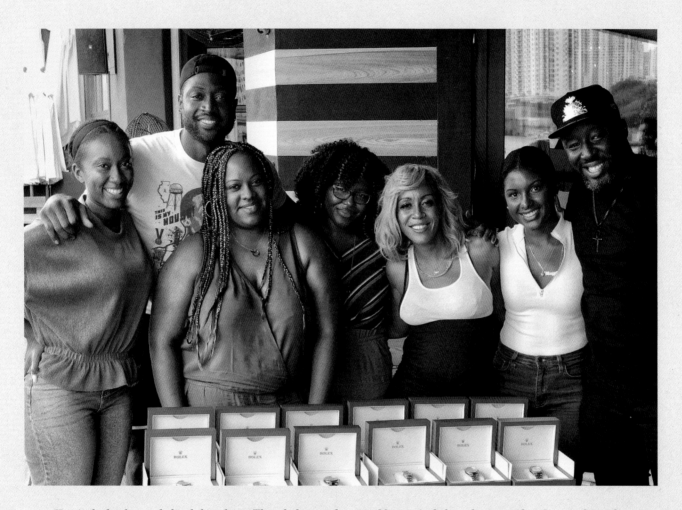

Here's the backstory behind this photo. The whole squad was in Miami. And if you know me then I wanted to salute the team with a gift. I had to make sure they knew I appreciated their presence. I ended up giving them a fleet full of Rolexes. People look at me and see it as if I'm the sole leader. I make a ton of important decisions. But Lord knows I'm not in the position I am now without my team. The least I could do is pay homage to them. All I know is none of us has any excuse to ever be late with those words ever again!

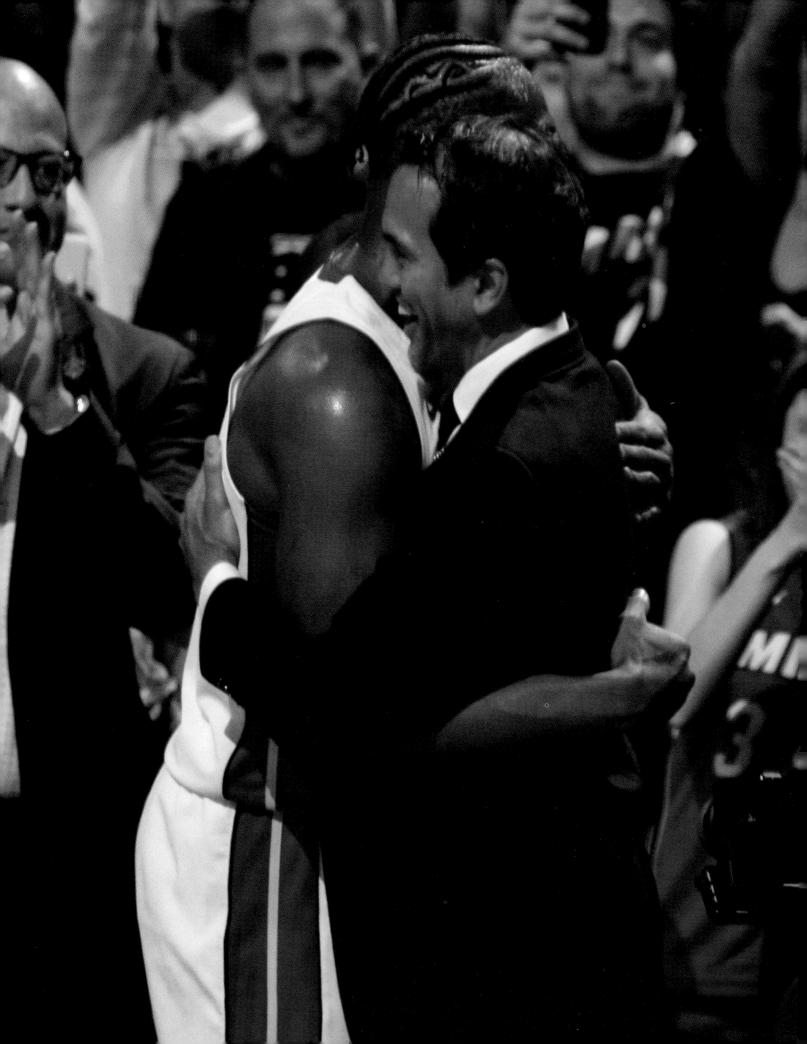

This image is from my last game in Brooklyn as I walked off the court for the last time. Spo's someone I hold an immense amount of respect for. First and foremost, as a man. He's such a brilliant guy in so many ways that have nothing to do with basketball. Don't get it twisted either—he's damn good at his job, too. So much of my career is intertwined with Spo, and likewise with him.

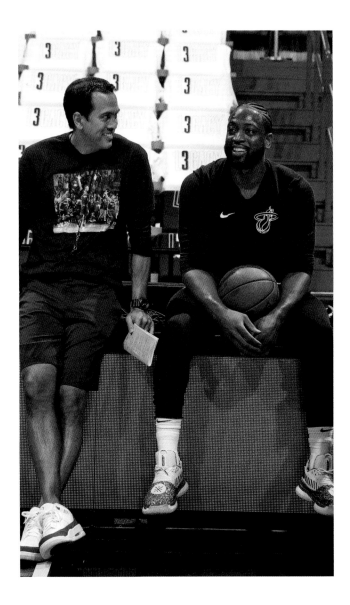

I hurt my knee trying to get up on that table trying to do my "this is my house" thing after that last home game. I don't regret doing so because there was no way I was leaving that arena without talking to my people one last time. There were ups. Downs, too. And there were times when I didn't know how this would end. But only one thing matters. And it's why I'm at peace and happy with my legacy in the game of basketball. From that first game against A.I. in Philly to my very last dribble in Brooklyn, I did it my way.

No, but seriously, I really did hurt myself. I thought I could sleep it off or take a few pain pills and be done. Nah. I don't complain about pain too much because I've dealt with my fair share of injuries in my career, but this hurt for real. I also think it was a mental thing, too, because it was my last game. I legit thought I was going to have to come up with a plan B. I even called people telling them I wasn't playing in Brooklyn. There was a microphone in place just in case I had to speak before the game. It was on brand for me. I always had to overcome some obstacle, and at that moment I had to overcome a lot because most people didn't understand how seriously hurt I was.

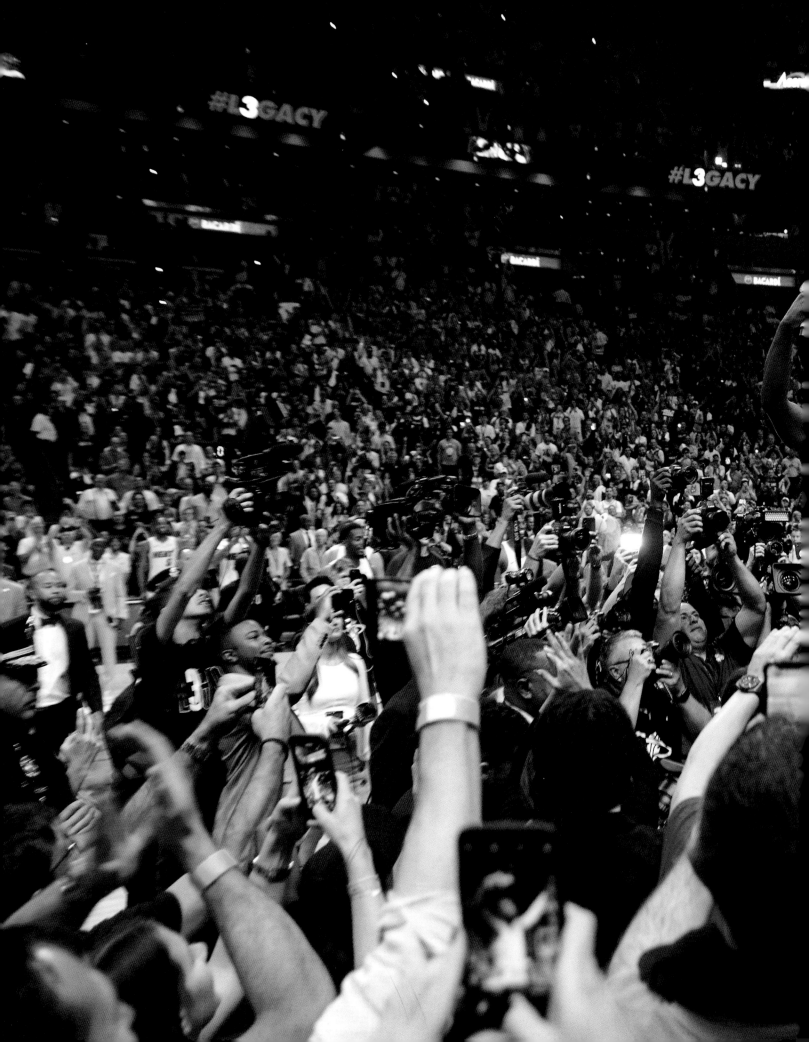

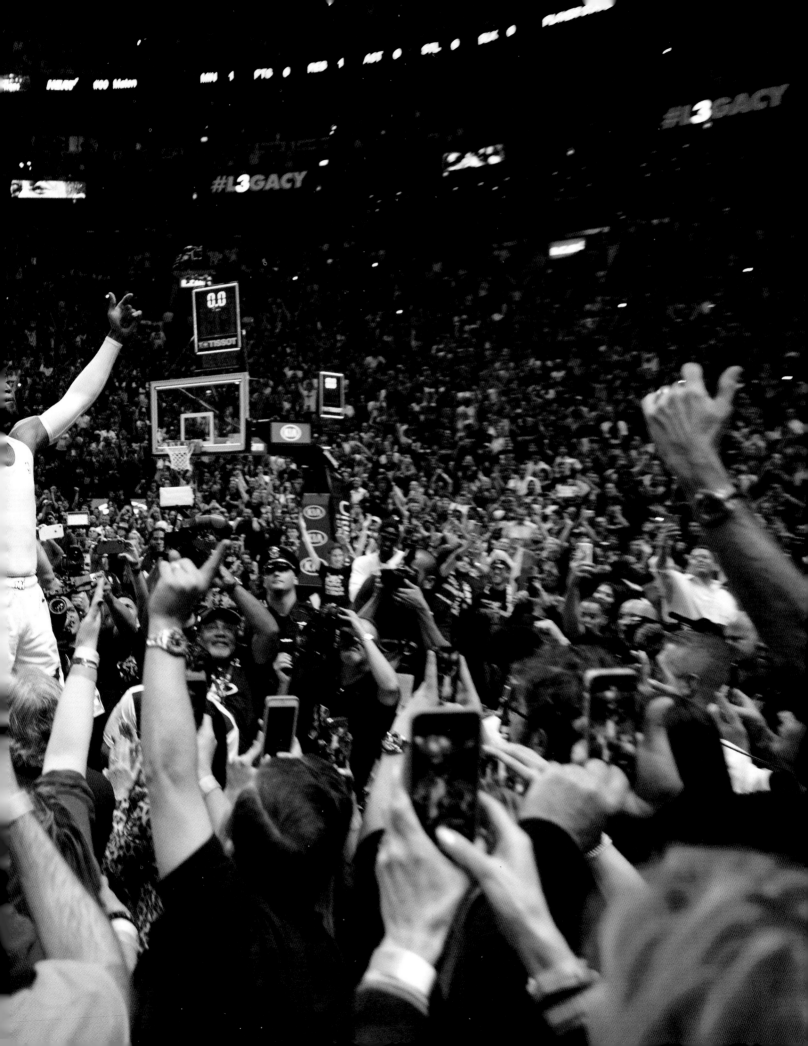

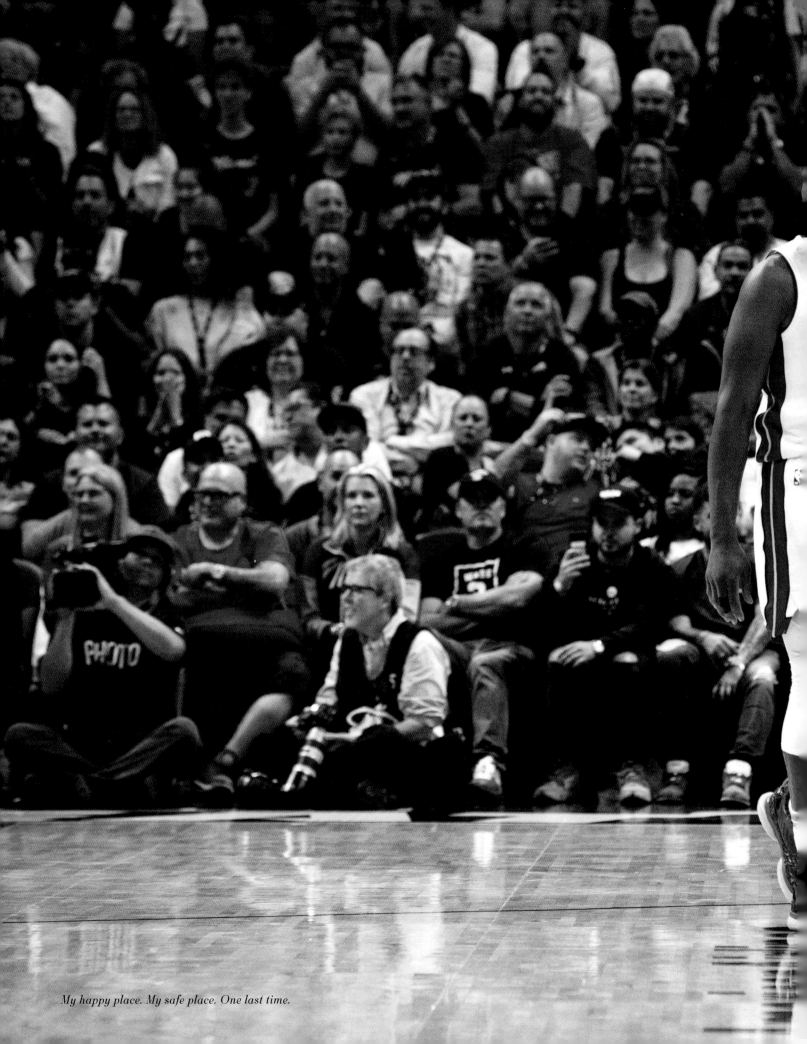

My happy place. My safe place. One last time.

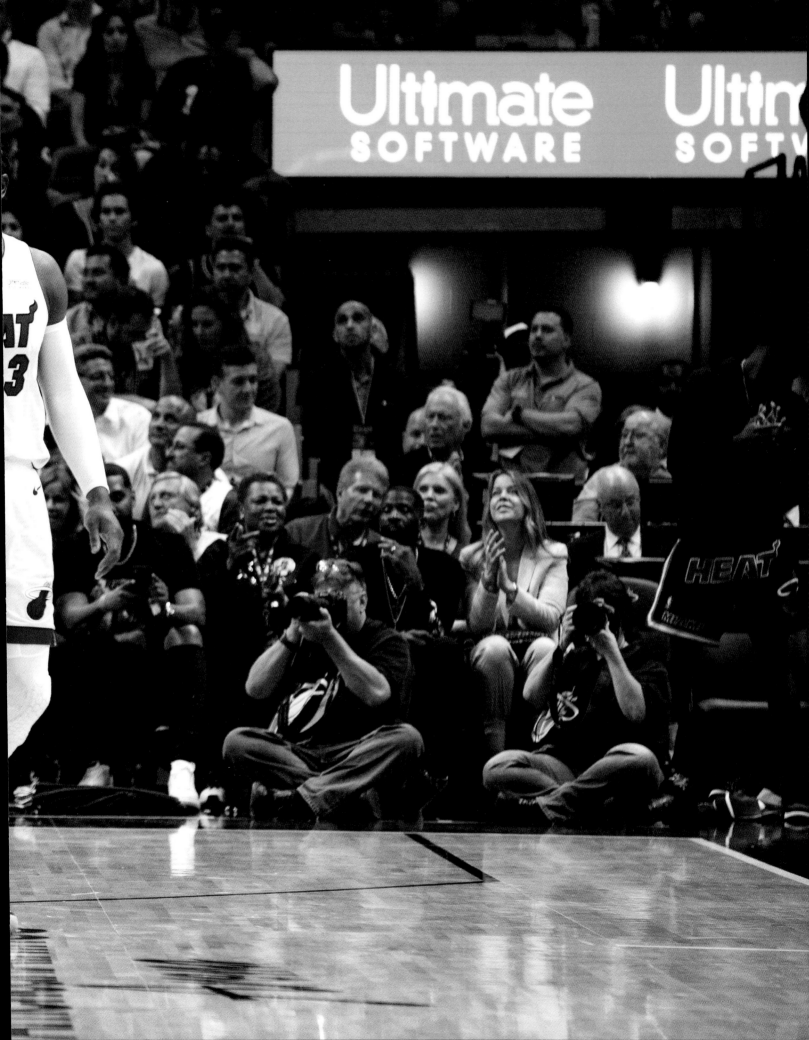

the Indiana series and coming back for the Eastern Conference finals against Boston, when damn near everyone thought he was done for the season, was heart personified. Then the very next year against San Antonio in the Finals in Game 6—Ray Allen doesn't hit that three without C.B.'s rebound and assist. Then he blocked Danny Green to win the game.

And that's just the on-court stuff. Don't get me started on Chris as a father, a husband, and a thought leader who can engage in conversations that will completely change your outlook on life.

If I had it my way, Chris would've been on the floor with me my last home game in Miami. We can't question how and why certain things happen, but I'm happy Chris prioritized his health over the game when blood clots forced him to step away from basketball. He was already a future Hall of Famer, but Chris is one of the fiercest competitors I know, so it was really hard for him to walk away. Especially when it wasn't on his own terms. Chris's situation made me appreciate my ending so much more because I knew it was anything but given.

Chris might be the most genuine guy I know. Yes, he's one of my favorite teammates, but more importantly, one of my favorite people. And on the court, we don't win either of those Big Three titles without him. Him being injured in the 2012 playoffs in

I can't ever thank Chris enough for everything he means to me, but getting a chance to hug him after my final game in Miami meant the world.

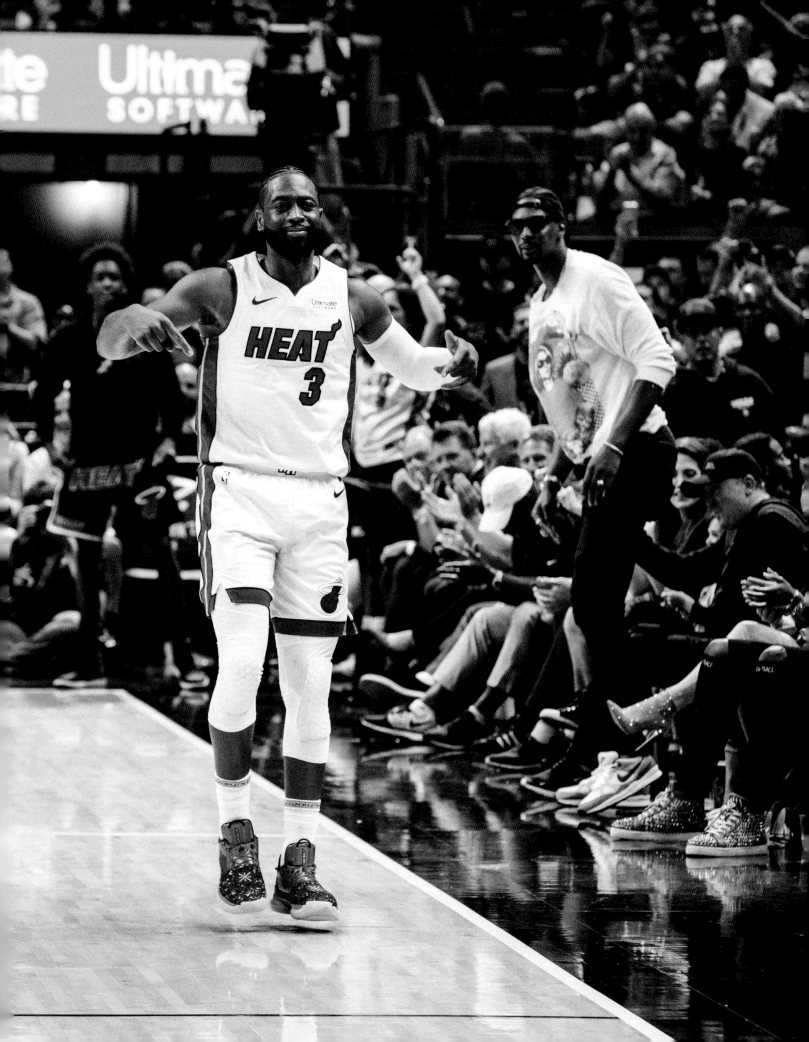

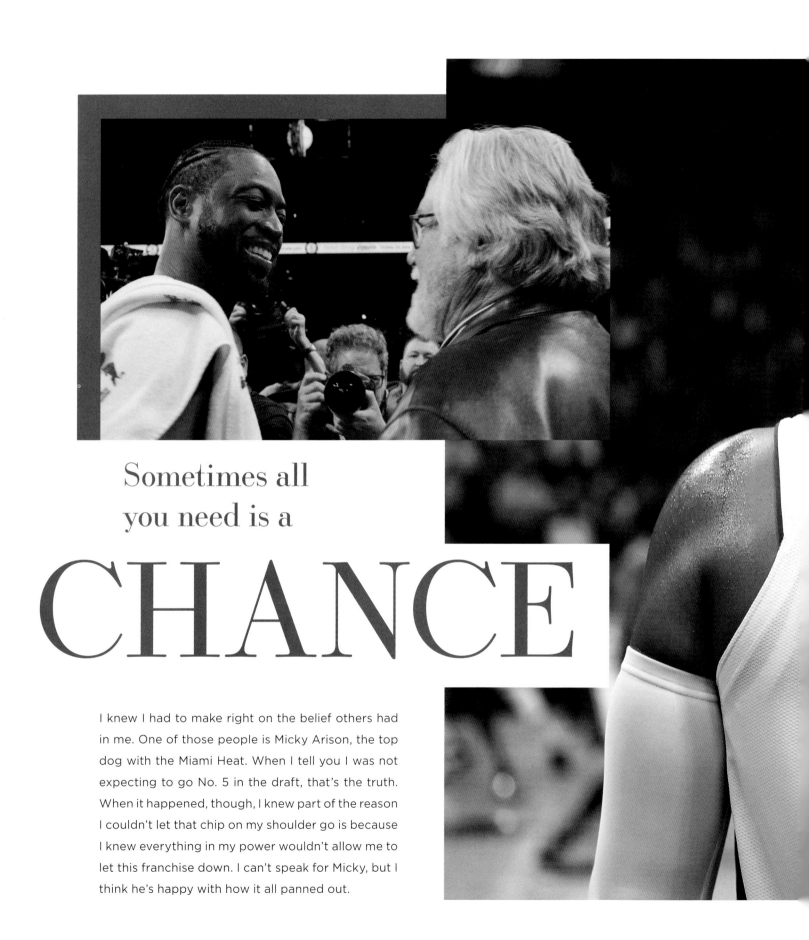

Sometimes all you need is a

CHANCE

I knew I had to make right on the belief others had in me. One of those people is Micky Arison, the top dog with the Miami Heat. When I tell you I was not expecting to go No. 5 in the draft, that's the truth. When it happened, though, I knew part of the reason I couldn't let that chip on my shoulder go is because I knew everything in my power wouldn't allow me to let this franchise down. I can't speak for Micky, but I think he's happy with how it all panned out.

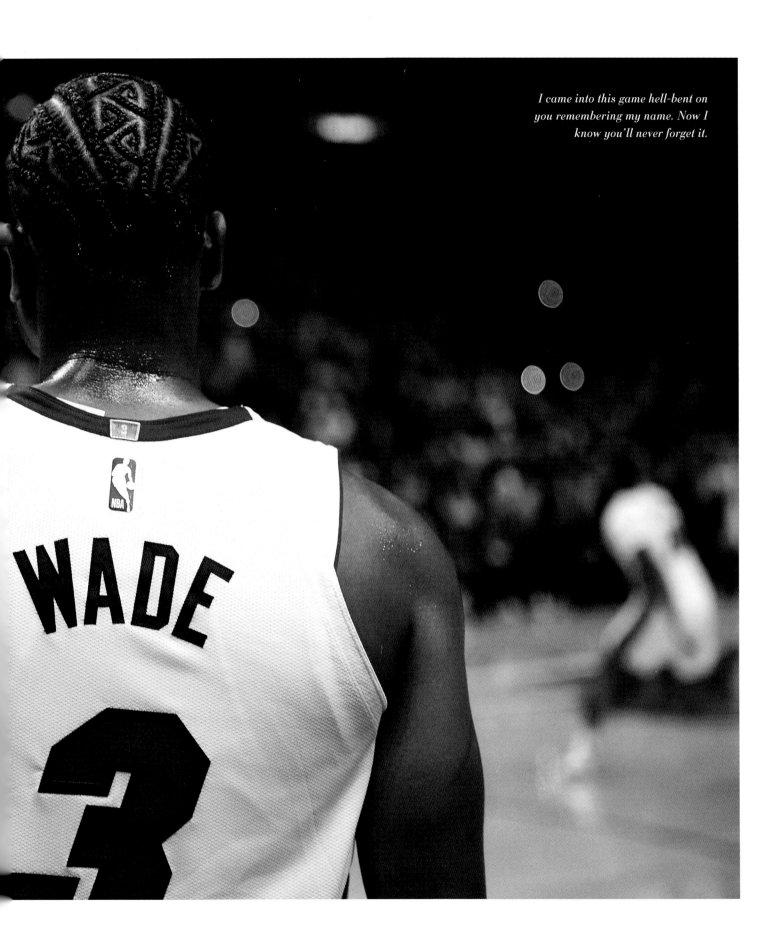

I came into this game hell-bent on you remembering my name. Now I know you'll never forget it.

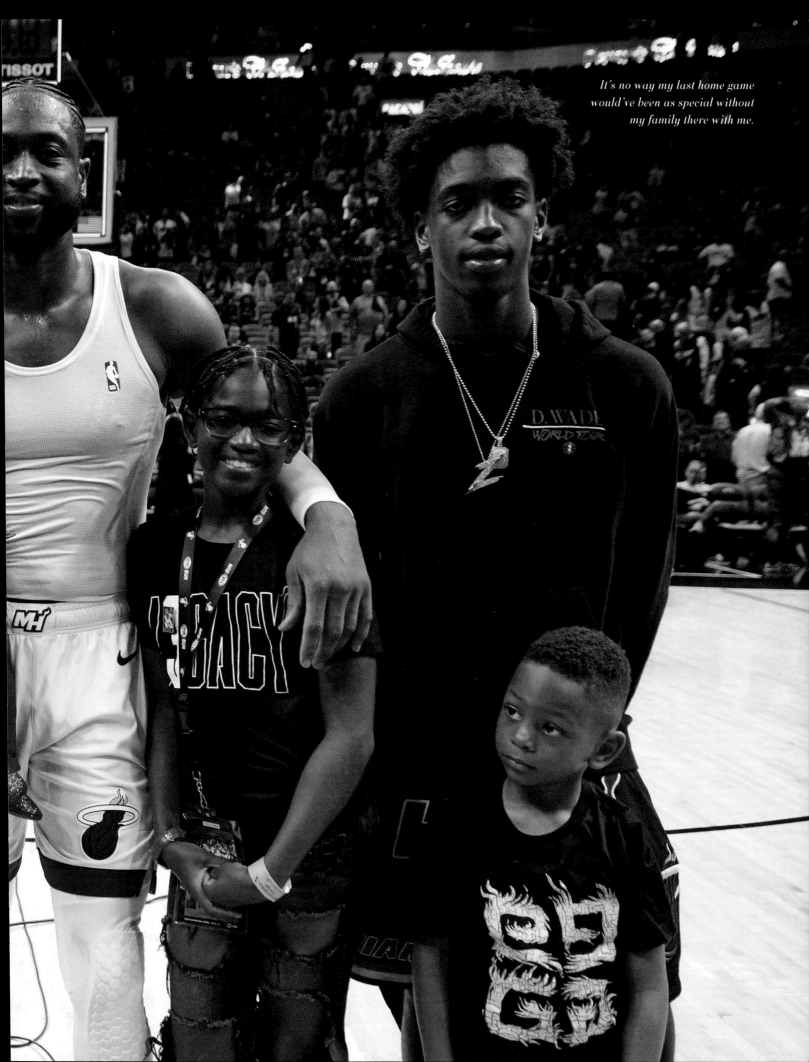

It's no way my last home game would've been as special without my family there with me.

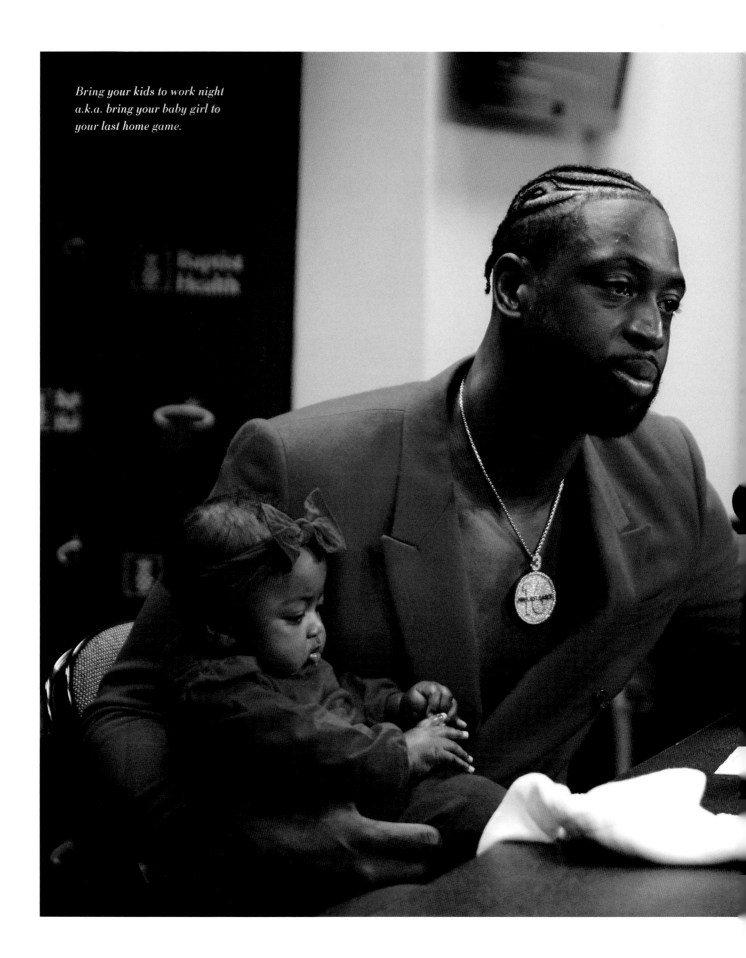

Bring your kids to work night a.k.a. bring your baby girl to your last home game.

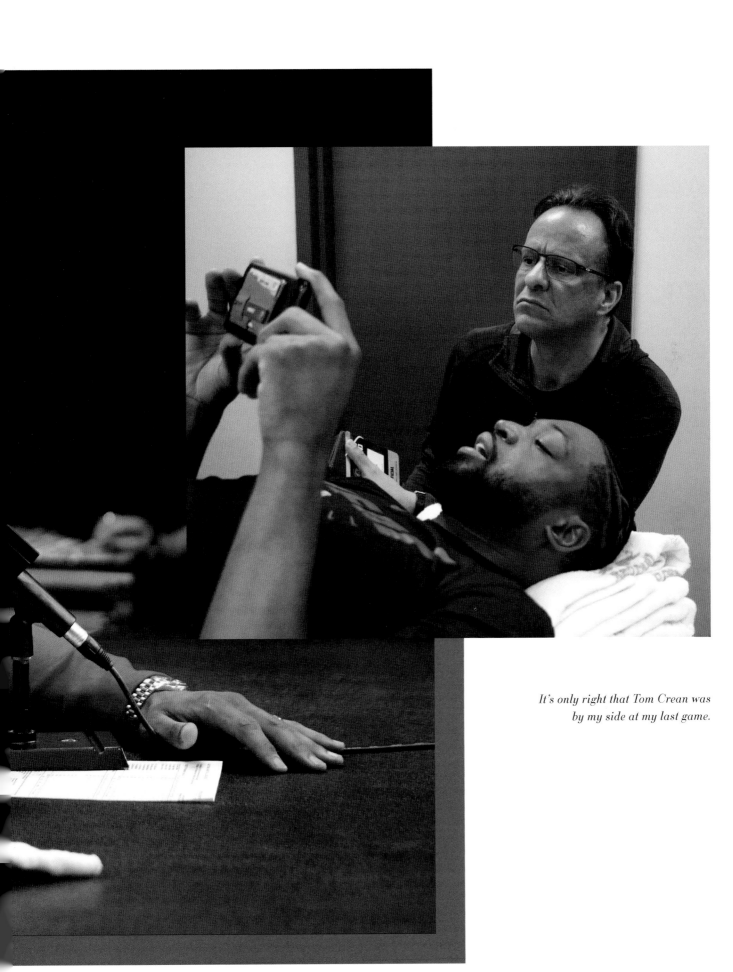

It's only right that Tom Crean was
by my side at my last game.

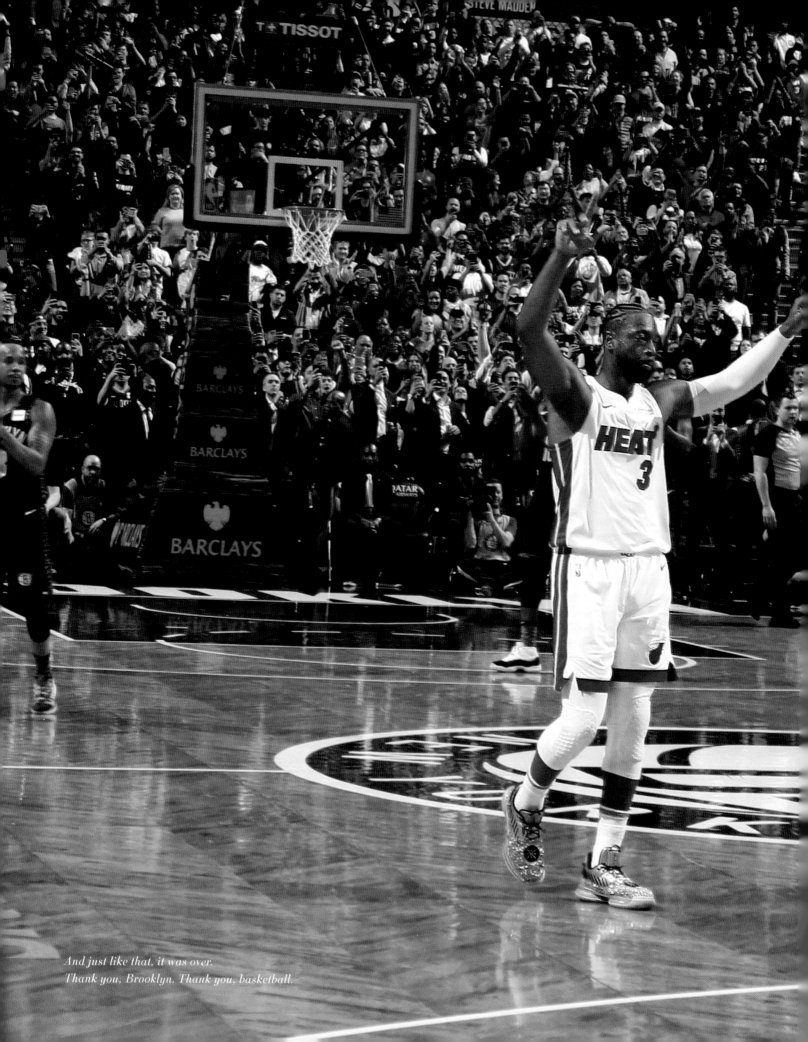

And just like that, it was over.
Thank you, Brooklyn. Thank you, basketball.

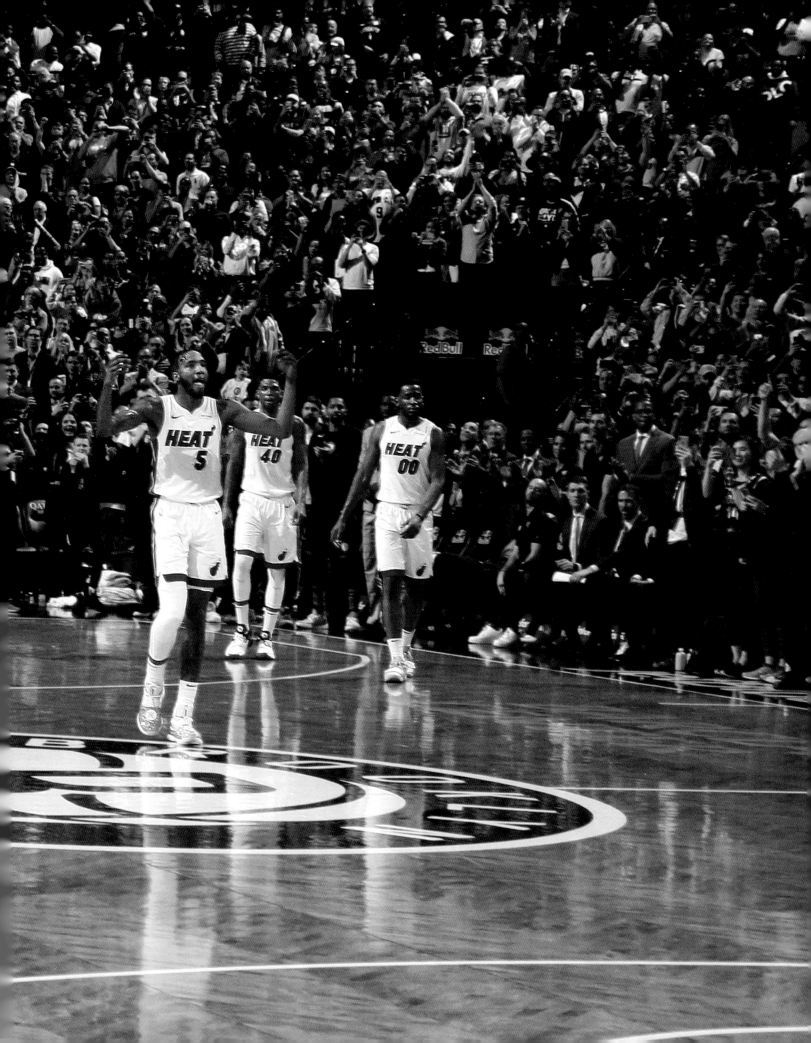

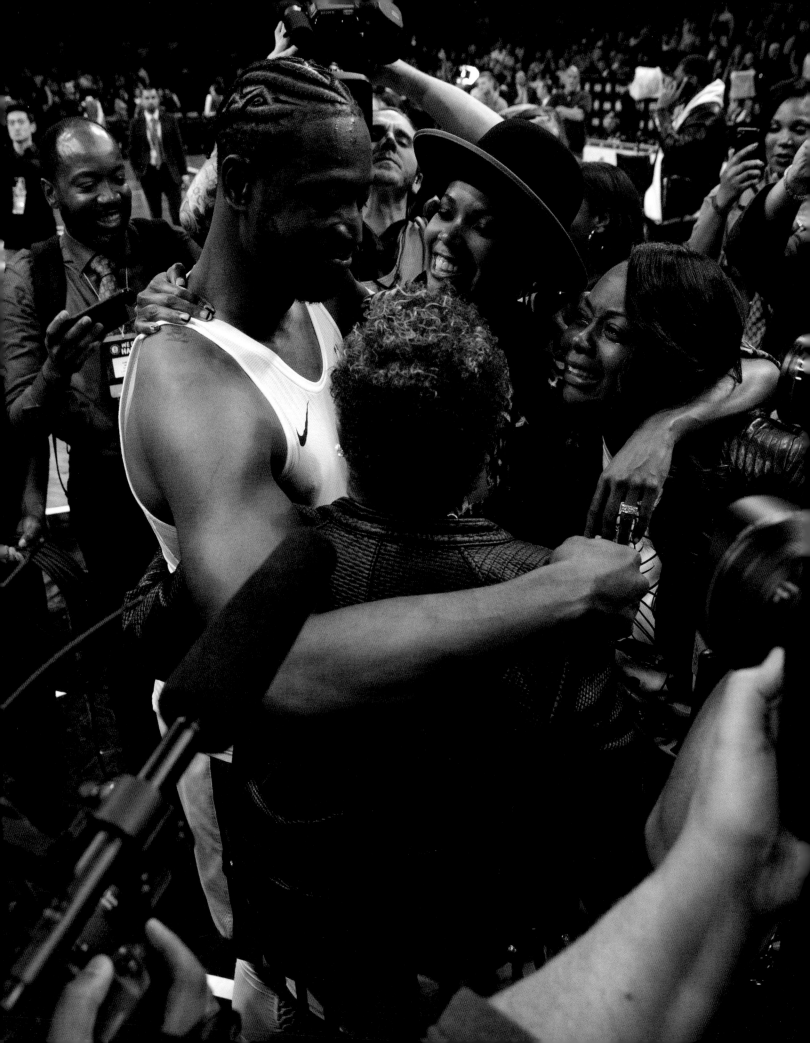

Looking back on it, I don't know if I could've looked myself in the mirror if I didn't play that last game in Brooklyn.

Especially with my brothers sitting courtside. When I look at this picture, I've got so much love in my heart for LeBron, C.P., and Carmelo. All of us, for years, have talked about changing the game both on the court and away from it. Mission accomplished, I'd say. And we're nowhere near done.

But this picture really stands out thanks to 'Melo. At this time, he was going through his own struggles. He wasn't playing, and so many reports were saying so many inaccurate things about him. It was a tough time for him—for all of us because we love 'Melo. He's always been one of the most selfless people I know. To have him come to my last game, especially with it being in New York, that was just another example of his true character. That meant so much to me.

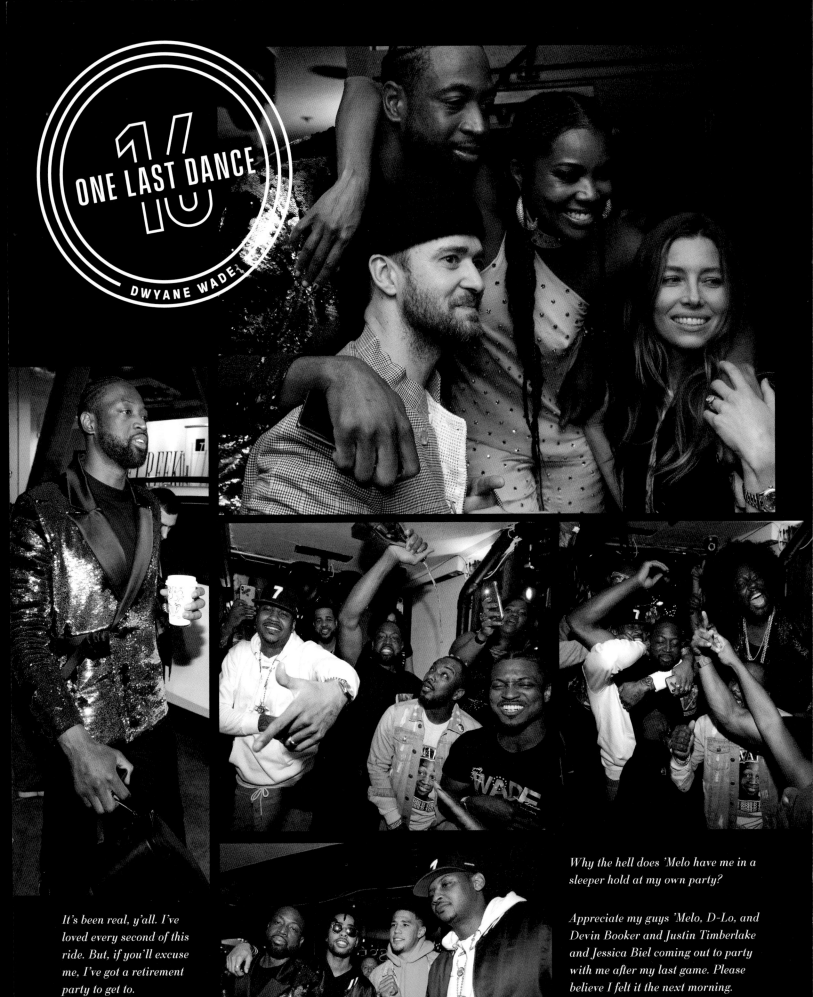

ONE LAST DANCE
16
DWYANE WADE

It's been real, y'all. I've loved every second of this ride. But, if you'll excuse me, I've got a retirement party to get to.

Why the hell does 'Melo have me in a sleeper hold at my own party?

Appreciate my guys 'Melo, D-Lo, and Devin Booker and Justin Timberlake and Jessica Biel coming out to party with me after my last game. Please believe I felt it the next morning.

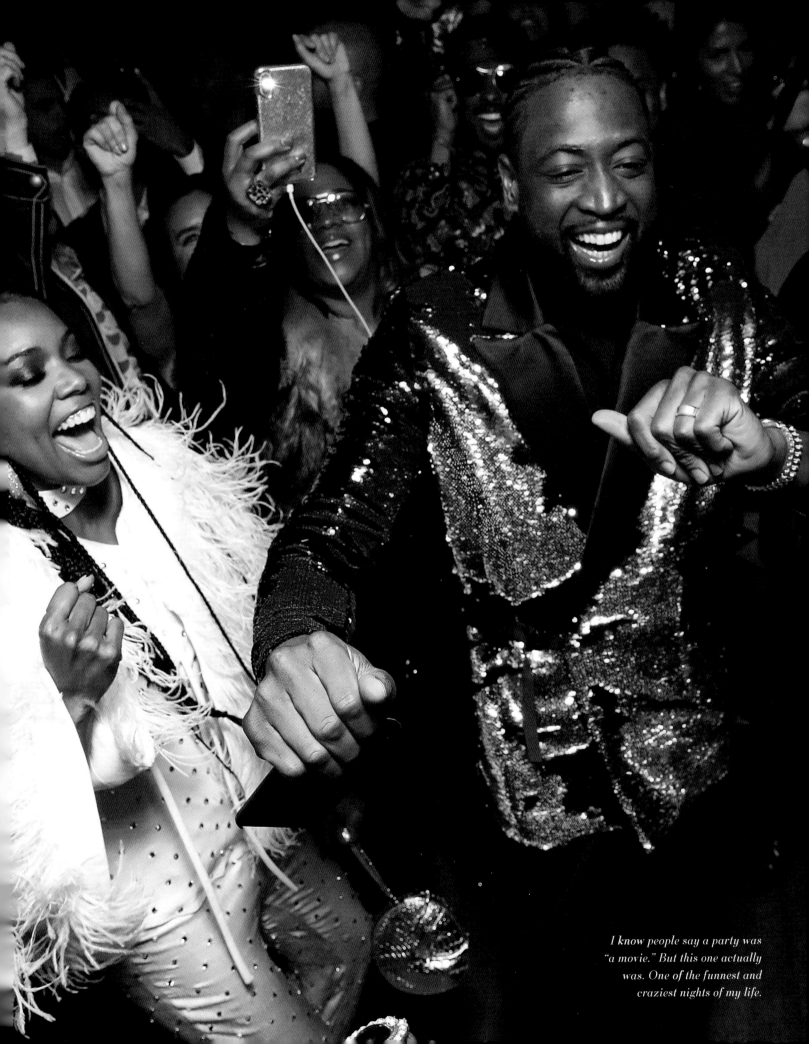

I know people say a party was "a movie." But this one actually was. One of the funnest and craziest nights of my life.

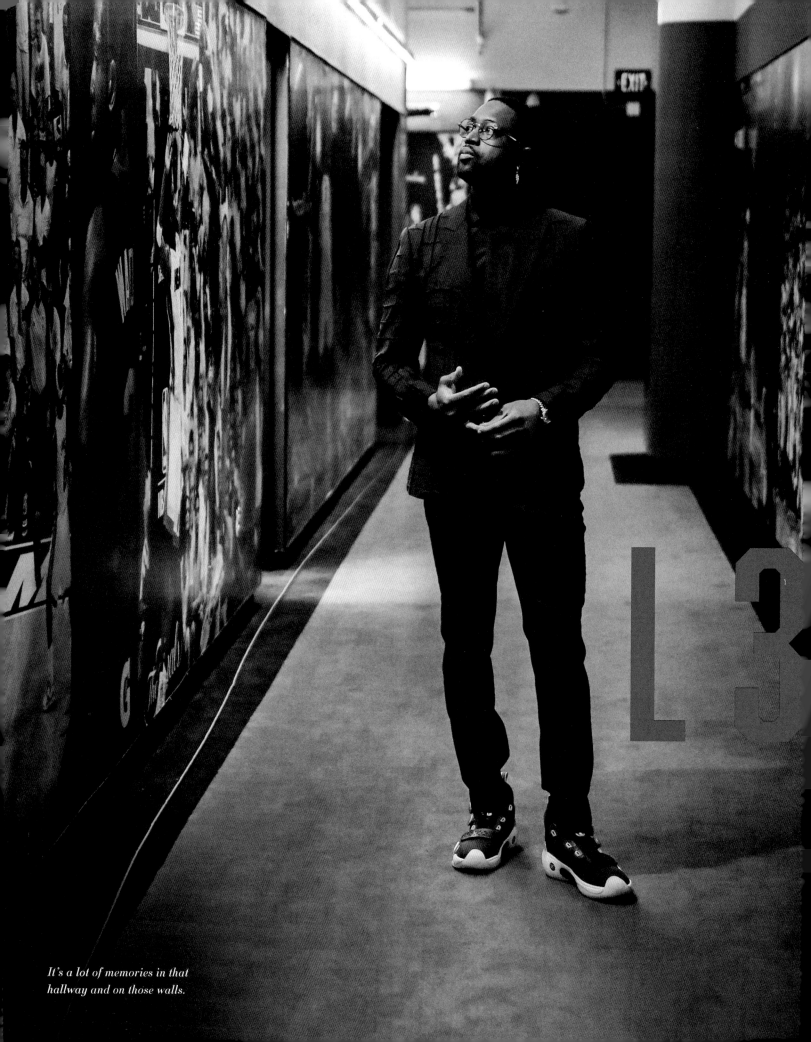

It's a lot of memories in that hallway and on those walls.

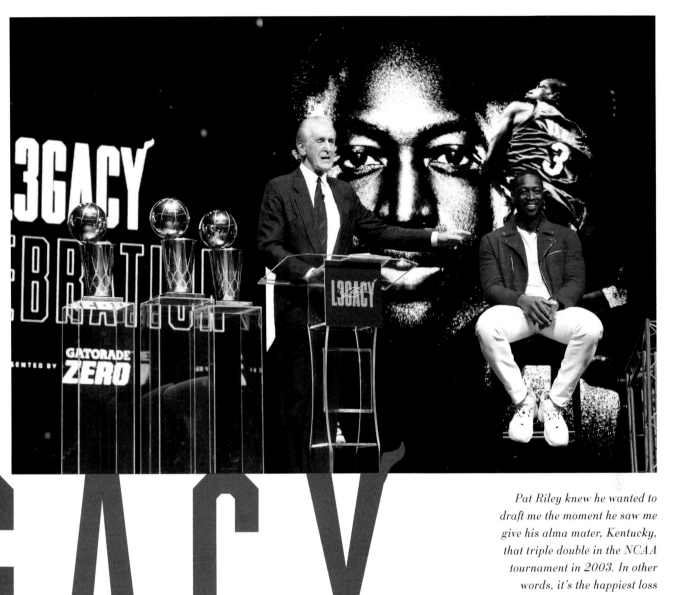

Pat Riley knew he wanted to draft me the moment he saw me give his alma mater, Kentucky, that triple double in the NCAA tournament in 2003. In other words, it's the happiest loss he's ever taken. Glad it worked out for the both of us.

L3GACY CELEBRATION

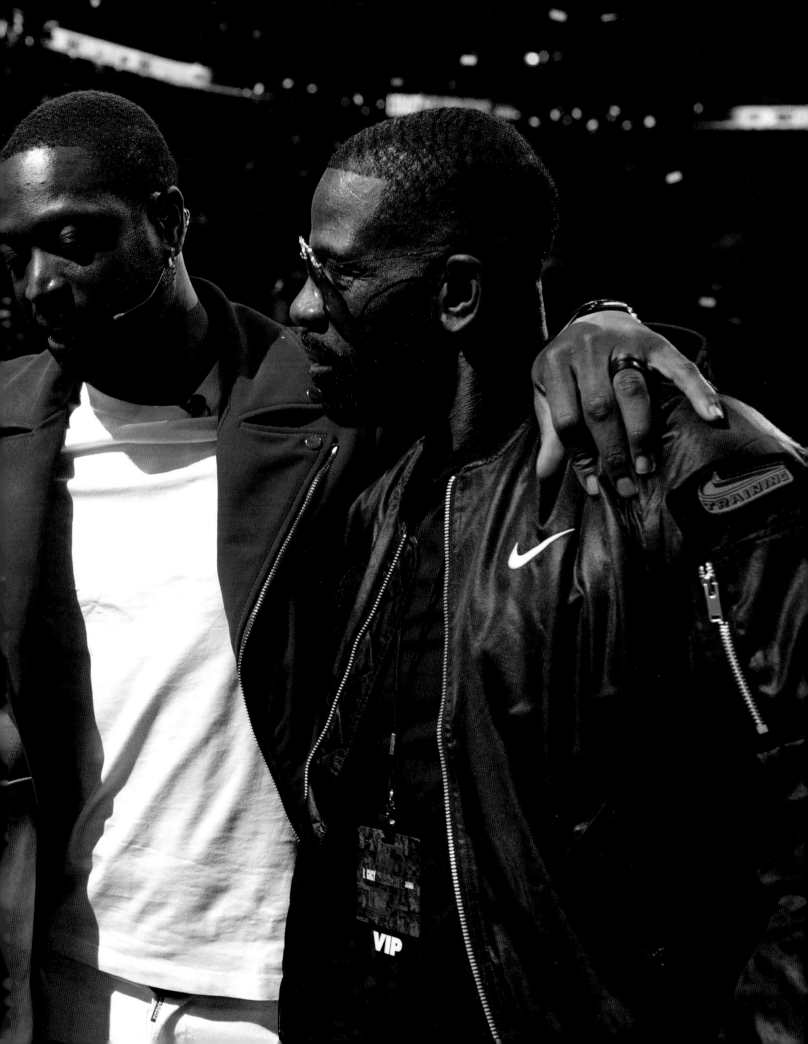

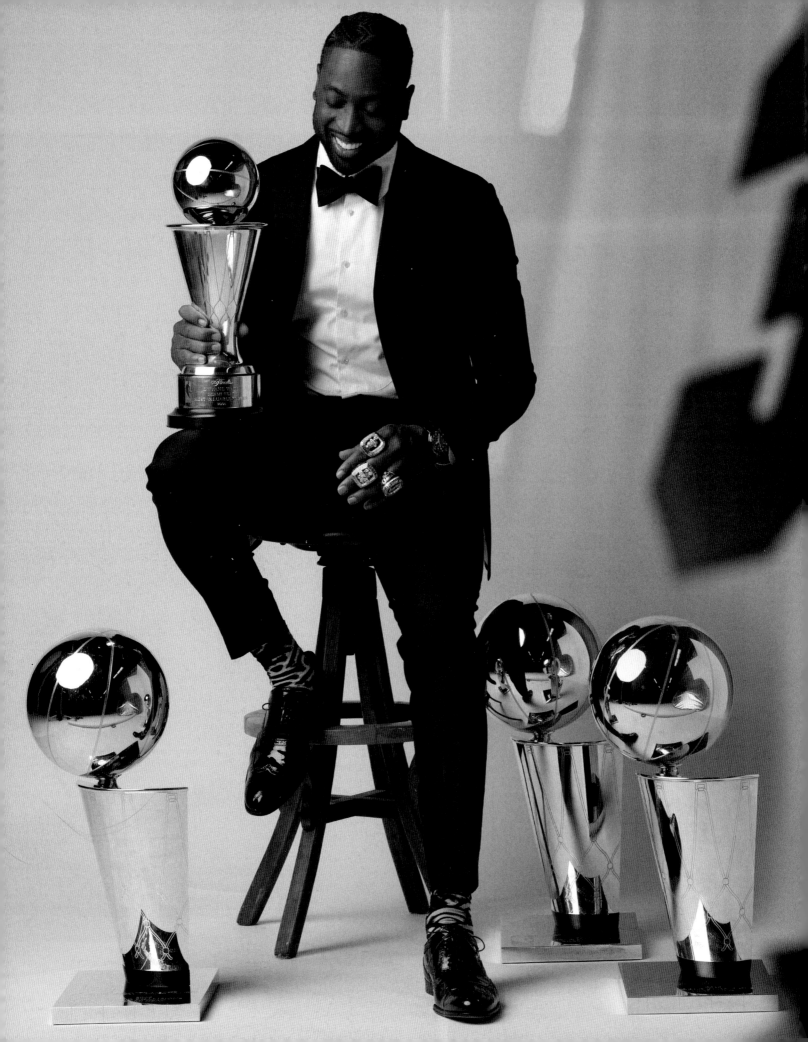

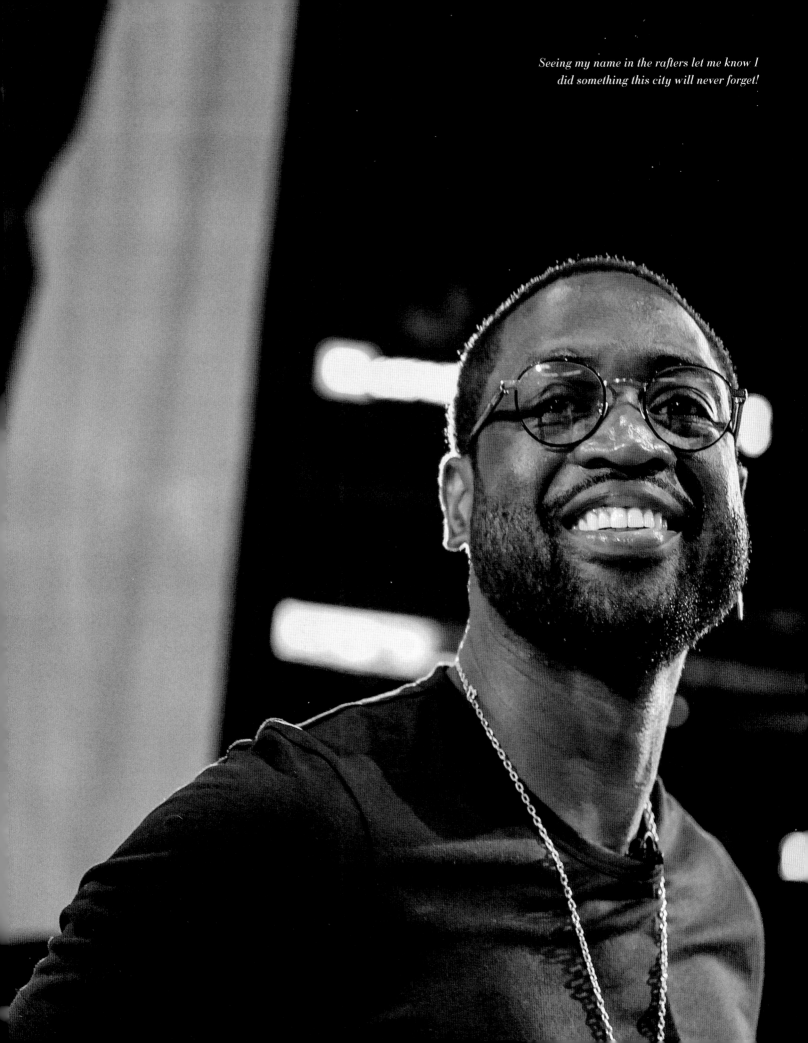

Seeing my name in the rafters let me know I did something this city will never forget!

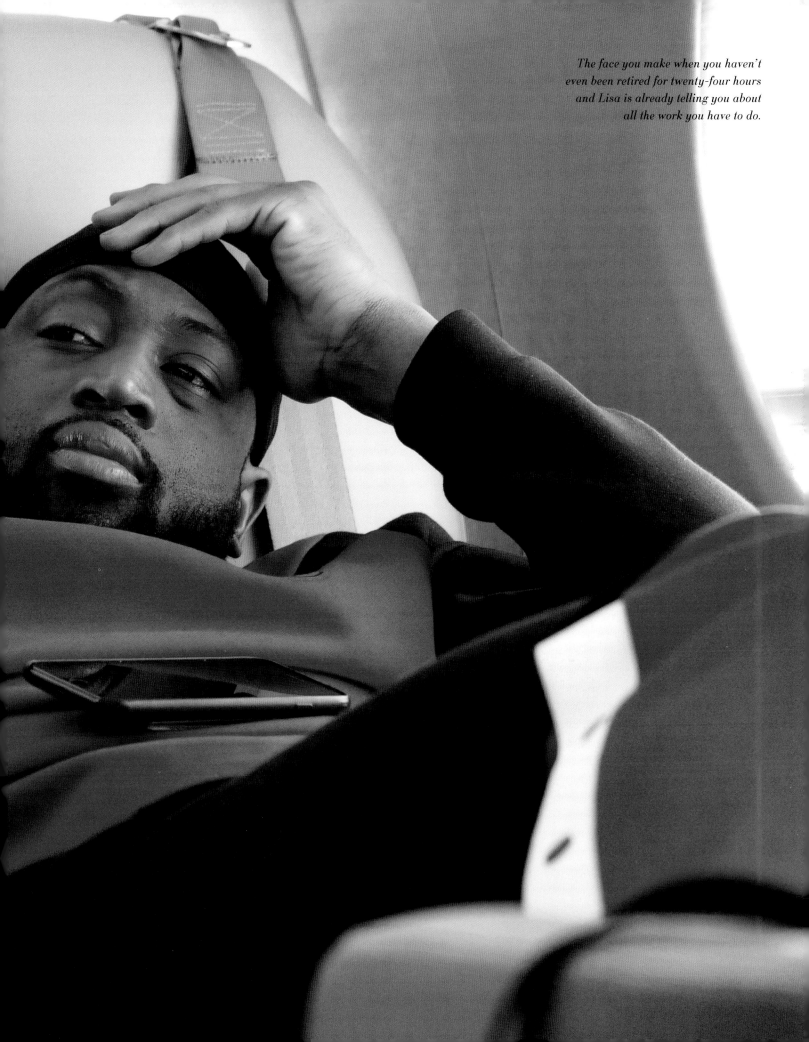

*The face you make when you haven't
even been retired for twenty-four hours
and Lisa is already telling you about
all the work you have to do.*

I leave the game with no regrets!

I gave everything inside of me to the game, and the game gave me everything and more.

When I came into the league I had one goal—to gain respect!

Early mornings!

Late nights!

That's how I gained my respect

The work before the work . . . and after!

I leave the game with no regrets!

I fell in love with the Game of Basketball at the age of nine

It brought out my smile

It brought out my voice

It allowed my confidence to shine bright

It became my armor

It became my why

I leave the game with no regrets!

I want you to know it will never be another you

I want you to know you showed me that if you practice hard enough, your dreams can be true

I want you to know you helped me believe in a better world

I want you to know you single-handedly changed the course of my life

Thank you for being my best friend when I needed it most

Thank you for being a constant in my life

Thank you for showing me fear will not be tolerated

Thank you for the misses, the losses, and the pain!

What we've built is incredibly insane

Thank you Basketball for restoring my family name!

ME OVER

All images courtesy of **Bob Metelus**, except:

Photographs

p. 26: Courtesy of Marquette University
p. 27: John Biever/*Sports Illustrated*/Getty Images
p. 28: John Biever/*Sports Illustrated*/Getty Images
p. 29: Courtesy of Marquette University
pp. 30-31: Al Tielemans/*Sports Illustrated*/Getty Images
p. 32: Jennifer Pottheiser/NBAE/Getty Images
p. 33: Jennifer Pottheiser/NBAE/Getty Images
p. 34: Victor Baldizon/NBAE/Getty Images
pp. 36-37: Doug Benc/Getty Images
pp. 38-39: Victor Baldizon/NBAE/Getty Images
p. 39, bottom right: Scott Cunningham/NBAE/Getty Images
p. 40, top. left: Victor Baldizon/NBAE/Getty Images
p. 40: bottom right: D. Lippitt/Einstein/NBAE/Getty Images
p. 41: Jay Drowns/Sporting News/Getty Images
p. 42: Issac Baldizon/NBAE/Getty Images
p. 43: Andrew D. Bernstein/NBAE/Getty Images
p. 44: Chris Hampson/NBAE/Getty Images
p. 45: Victor Baldizon/NBAE/Getty Images
p. 46-47: Nathaniel S. Butler/NBAE/Getty Images
p. 48-49: Andrew D. Bernstein/NBAE/Getty Images
p. 50: Joe Murphy/NBAE/Getty Images
p. 51: Issac Baldizon/NBAE/Getty Images
p. 52: Garrett Ellwood/NBAE/Getty Images
p. 53, top. right: Jeff Gross/Getty Images
p. 53, bottom left: Garrett Ellwood/NBAE/Getty Images
p. 54, left: Issac Baldizon/NBAE/Getty Images
p. 54, right: Noah Graham/NBAE/Getty Images
p. 55: Ronald Martinez/Getty Images
pp. 68-69: Mike Ehrman/Getty Images
p. 71, right: Issac Baldizon/NBAE/Getty Images

Stock images

pp. 105, 106 (basketball icon): @Valenty/stock.adobe.com
pp. 25, 33, 45, 67, 92, 145, 148, 168, 190, 192, 193, 199, 216, 248, 257,
 background texture: ©Feel This/via Creative Market
pp. 25, 33, 67, 168, 193, 199: Photo Frames/©Feel This/via Creative Market
pp. ii, iii, viii, 32, 53, 112, 113, 114, 115, 117, 156, 287, 290, 291 gold abstract:
 malija/istock via Getty Images
p. 179 (wine stain): yoinSveta/istock via Getty Images